Photoshop Elements®
drop-dead
photography
techniques

Photoshop Elements®

drop-dead photography techniques

GENERAL EDITOR: STEVE LUCK

ILEX

First published in the United Kingdom in 2005 by
ILEX
3 St Andrews Place
Lewes
East Sussex BN7 1UP

ILEX is an imprint of The Ilex Press Ltd
Visit us on the web at:
www.ilex-press.com

ILEX Editorial, Lewes:
Publisher: Alastair Campbell
Executive Publisher: Sophie Collins
Creative Director: Peter Bridgewater
Managing Editor: Tom Mugridge
Editor: Kylie Johnston
Design Manager: Tony Seddon
Junior Designer: Jane Waterhouse
Designers: Lanaway

ILEX Research, Cambridge:
Commissioning Editors: Alan Buckingham
Development Art Director: Graham Davis
Technical Art Editor: Nicholas Rowland

CONTENTS

INTRODUCTION

Although digital cameras have been available now for five or six years, their impact on the non-professional market has only really started to hit home in the last couple of years. It is only within this relatively short timeframe that the p of digital cameras (particularly the recent introduction of affordable digital SLRs) combined with their rapidly falling prices has reached a point where people looking to buy a camera, whether for holiday snaps, weddings, and other special occasions or for more 'serious' creative photography, have considered buying a digital camera as opposed to a film camera. And this is borne out by the fact that consumer digital cameras now outsell traditional cameras. But how has this digital camera revolution affected the way we view taking and creating images?

For some of us, using a digital camera has given us the freedom to take more photos with impunity. If, having reviewed the shot on the LCD screen and not liked what we've seen, we can simply delete it and take another. And while in itself this has led to more creative, experimental, and candid shots, few non-enthusiasts will want to get involved with editing their images on a home PC, rather instead relying on the numerous retailers and online companies that take digital media and return perfectly acceptable prints – prints that are certainly as good as if not better than those we'd get from having our film developed and printed. However for others, digital photography has either unleashed an as-yet unexplored avenue of creativity or rekindled a passion for a hobby that was lost along with rolls of undeveloped 35mm film – and that's who this book is aimed at.

Affordable (yet effective) digital cameras, relatively inexpensive inkjet printers capable of improving on the print quality of most photo developers and a desktop computer that for a few hundred dollars has processing power that would have been the envy of 1960s NASA scientists has for many new and born-again enthusiast photographers replaced the traditional darkroom; you just have to look at the number of digital photography magazines that have appeared over the last year or two to get a sense of how popular photography has once again become. However, there is a difference now. No longer is photography primarily about composing and taking good pictures (although this is still an essential element and one that unfortunately is often overlooked) it is also about what you can do with those pictures once they've been downloaded to a PC. And this is where image-editing programs such as Adobe's Photoshop Elements come in. Image-editing programs, and Photoshop Elements in particular, offer extraordinarily creative possibilities for comparatively little money. However, the learning curve is a sharp one if you really want to create images to be proud of. And, of course, it's not just about learning which buttons to push to run a special effects filter, it's also about understanding artistic merit.

The aim of this book is to provide you with inspiration as well as showing how successful professional and enthusiast image-makers go about the business of creating images that stand out from the crowd. Within these pages we hope you'll find helpful and practical hints and tips, broader techniques that illustrate how images are created, and a wealth of ideas that will hopefully kick start your own innate creativity. Whether you're a novice who's recently been bitten by the digital imaging bug, or a conventional photography enthusiast who has made the switch to digital, we hope you'll find this book a useful source of artistic and practical reference.

the digital studio

CAMERAS AND SCANNERS

Both digital cameras and scanners are devices by which you can 'capture' an image by converting it into the digital binary code (0s and 1s) necessary to enable you to edit your images on your computer. There are a vast number of both devices available on the market and new models are being launched almost daily. We don't propose to offer a comprehensive buyers' guide to cameras and scanners, but simply to provide general 'rule of thumb' advice.

Konica Minolta Dimage A2
(Opposite) Following on from the A1, the A2 has all the useful features of the first, but includes the additional anti-shake technology, a wide-angle lens, and a faster, smoother zoom function.

Cameras

If you've either bought or been given this book, it's likely that you already own a digital camera; and if you're happy with the results you're getting from your camera, then the information here may not be relevant to you. If, however, you feel a little disappointed with the images you've taken so far then here are some areas to consider.

Resolution

Probably the main cause of dissatisfaction with people who are keen to manipulate their images at home with a view to making prints (as opposed to those of us who are happy to hand over the memory card to a local print shop and get perfectly acceptable holiday pictures back) is the way images can appear pixellated, or 'blocky', when printed on a desktop printer. In almost all cases, this is due to insufficient resolution. Thousands of pages in digital photography books and magazines have been written about the 'mathematics' of resolution, and indeed there is a basic mathematical relationship between resolution and print size (*see box 'Resolution vs. Print Size'*). But to make it simple, if you want to produce good-quality A4 prints then we recommend that you use, at the least, a 3-megapixel camera; and bear in mind that if you crop your image a lot the remaining picture information is unlikely to provide a photo-quality A4 print. For more serious enthusiasts who want to produce A3 prints, then unsurprisingly, anything less than a 6-megapixel camera is likely to yield disappointing results.

TIP

If you're looking to upgrade your camera, and are used to a camera with one 'built-in' zoom lens, consider changing to a digital SLR (single-lens reflex), rather than upgrading to the 8-megapixel 'prosumer' cameras available today. A similarly priced DSLR with a 6-megapixel sensor will provide you with far better image quality than an 8-megapixel prosumer. You'll also no longer suffer from shutter lag, and you can add to your kit as your interest in photography changes from say landscapes to portraits to sports.

Nikon Coolpix 5700
Nikon's range of digital SLRs will provide something for everyone (above right). But this highly praised digital camera (below) is recommended for its creative controls and its 8x zoom lens, making it perfect for wildlife and sports photography.

RESOLUTION VS. PRINT SIZE

Camera	Maximum Pixel Size	Print Size (at 300ppi)
3MP	2100 x 1500 pixels	7 x 4.5in (18 x 13cm)
5MP	2600 x 1900 pixels	8.5 x 6in (21.5 x 16cm)
6MP	3072 x 2048 pixels	10 x 7in (26 x 17cm)

Using the Camera's Settings

A further consideration in terms of resolution can be found in your camera's settings. Almost all digital cameras allow you to set the image-recording quality. This is usually expressed along the lines of 'Hi', 'Fine', 'Normal', 'Basic', or perhaps 'Large', 'Medium', 'Small'. Whichever way the settings are described, it should be obvious which setting captures the most information; check with the camera's manual if you're uncertain. We strongly recommend that you keep your camera set to its 'highest' or 'finest' setting. The drawback is that you'll get fewer images on your memory card, but unless you know for certain that you'll only want postcard-sized prints or that your images are for screen display only, you'll regret taking the photo of a lifetime only to discover that the camera was set at 'Basic' or 'Small'.

For those of you with 'prosumer' models or digital SLRs, it's likely that you'll have the option of selecting 'Raw'. If you're intending to do a lot of post-production work on your images, this is the setting to choose. 'Raw' is a totally uncompressed format – in other words, the camera hasn't performed any 'in-camera' processing at all, such as sharpening or enhancing colours. You're unlikely to get an image you can print straight off with this setting, but you will be able to manipulate the image to a greater degree with less image degradation.

While on the subject of settings, we also recommend that you use the camera's preset white balance settings (if available). Again, most digital cameras have an 'Auto White Balance' setting, which in theory should cope with most lighting situations, whether cloudy, sunny, or fluorescent light; however, you'll probably find you get better results using the preset settings.

A word of warning about using the camera's digital zoom (if it has one). Don't be fooled into thinking that you're getting 'super zoom' – all the camera is doing is "enlarging" the existing pixels to give the impression of zoom. Using the digital zoom will result in poor-quality images.

There are of course many other factors to take into consideration when assessing a digital camera: the quality of the lens, ease of use, size and weight, build quality – the list is long. But only you can assess what you need from your camera and how much you are prepared to pay.

Scanners

Because scanners use the same CCD technology as most digital cameras when capturing the image data, much of the advice about digital cameras in many ways also applies to scanners. The better the CCD the better the quality of the scan. For example, the issue of resolution is just as important for scanners as it is for cameras. When gauging a scanner's resolution, ensure you're looking at the 'optical resolution' figure (which will range from around 600 to 3,200 ppi for flatbed scanners (we recommend 2,400 ppi) to between 4,000 (perfectly acceptable) and 5,400 ppi for a film scanner – often incorrectly measured in dpi, which is a measure of output. Many manufacturers make extravagant claims about resolution, with some advertising resolutions of 9,600 ppi or higher; but be warned, these are interpolated figures – in other words, although additional pixels can be added, there is in fact no additional information (or detail).

Colour Depth and Dynamic Range

Another important factor to look for when choosing a scanner is the colour depth capacity, the scanner's ability to record tonal and colour detail. For photo-realistic work, such as the projects covered in this book, it is essential to have at least a 24-bit colour scanner. This means the scanner is able to differentiate between 16.7 million colours (probably the same as your computer's monitor). But many scanners offer greater bit depth – from around 30 to 42 bits – and it's worth considering going for greater bit depth if you can afford it.

Another important consideration is the scanner's dynamic range – its ability to capture dense shadows and bright highlights. For flatbed scanners aim for a dynamic range of 3.0+, while for film scanners go for between 3.8 and 4.0.

Other areas to consider with scanners are: what type of media are you scanning (photos, film, or negatives?), what type of transfer method does the scanner use (USB, USB 2, or FireWire?) and the sophistication of the TWAIN software that comes with the scanner. We strongly recommend that you read as many reviews as possible before making your decision on which scanner to buy.

Perfection 2400 Photo Scanner

This scanner takes consumer scanning to a high level of quality, speed, and ease-of-use with a true resolution of 2400 x 4800dpi – the highest available on a scanner of this kind.

COMPUTERS AND PRINTERS

As cameras and scanners can be perceived as the 'input' or 'capture' devices, so computers and printers can be viewed in turn as 'image-editing' and 'output' devices. Again, this book is not intended to offer exhaustive information on the numerous computers and printers available, but there are some basic areas to consider when buying either.

PAPER

You'll get much better prints (in terms of colour fidelity, sharpness and good skin tones) if you use photo-quality paper in your printer rather than plain paper. Although this is much more expensive, if you intend to display your photos there really is no alternative. It often makes sense to proof your images using plain paper (ensure your printer settings are set up for the right type of paper). You'll find that you miss things on screen (the hand appearing out of someone's head in the background) that leap out at you when you see a print.

Computers

One question a lot of people ask if they don't already own a computer is whether to buy an Apple Macintosh or a PC; although strictly speaking, both are PCs, what we really mean here is a desktop computer running the Windows Operating System. As far as image-editing in general goes, and more specifically using Photoshop Elements, today there really is very little to choose from between the two. Historically, the Apple Macintosh has been the computer of choice for professionals working in areas associated with image editing, however, an increasing number of designers, illustrators, animators, and 'computer artists' are using Windows (and, to a certain degree, Linux and/or Unix) operating systems.

To be honest both main operating systems are perfectly adequate for running Elements. The decision is really one of personal choice. Some people feel that Apple's GUI (graphical user interface) is more intuitive (and less importantly) more elegant. And it's probably still true that the Apple Macintosh Operating System configures peripherals and networks much more easily. Some people also argue that because the Mac has a single video driver it's easier to calibrate a Mac's monitor and keep colour management consistent between Macintosh computers. However, this is all fairly high-end stuff, and for our purposes, PCs are perfectly adequate. On the plus side for Windows, in terms of processing power, PCs are cheaper. Additionally, there's also more support available either over the phone or online if your machine goes wrong, and outside of image-editing there's also more software available.

Keeping image-editing in mind, today's digital cameras can produce very large file sizes, particularly if, as we suggested earlier, you shoot at the highest-quality settings. Because of this, we suggest that your computer should have an absolute minimum of 128Mb of RAM (but 256Mb, 512Mb, or even 1Gb is preferable); at least a 40Gb hard disk, and the ability to burn CDs or DVDs. This last is particularly important. Not only will it enable you to store your images for almost an indefinite period, but it's also equally important to make regular back-ups of your images in case your computer has a terminal breakdown and you lose all your data. Finally, if you're buying a new computer make sure it has either USB2 or Firewire ports. Either of these provides fast rates for copying images from your camera or other peripheral devices to the computer.

Stylus Photo 2100
Designed to fulfil the needs of creative professionals, the Stylus Photo 2100 is a complete photo finishing solution, offering exceptional print quality.

Stylus C46 Inkjet
The Stylus C46 is a good introduction to home colour printing, and a great way to discover the benefits of digital photography.

Monitors

In terms of monitors, well, the bigger the better really. Nearly all monitors now have 24-bit colour (able to display 16.7 million colours), and the larger the desktop you have to work with, the easier it is to have all the necessary Elements palettes and other windows open while being able to preview your image as you work on it. A 17-inch conventional or 15-inch flat screen is adequate.

Printers

There are a number of printer technologies available today – among them inkjet, laser jet, and dye sublimation. The first two are the most popular with amateurs, with the inkjet at present being the more popular for home use – although with less expensive colour laser printers appearing on the market this may be set to change.

Most modern inkjet printers are capable of producing excellent, photo-quality prints. As there are so many on the market, with new models coming out weekly, our advice is to read as many reviews and reports as possible before making your purchase. We do recommend that, if possible, you buy a printer that can print six or even seven colours. Although you'll find the refill cartridges more expensive you'll get much better results than with a printer that prints only four colours.

In terms of resolution, we suggest you look for printers that are capable of printing at 720dpi or even 1,440dpi. Although you're unlikely to print at these resolutions all the time, to make really fine prints, these are the resolutions you should be looking at. Note, however, that for laser printers, because of the different technology, 600dpi is sufficient.

Other areas to consider are do you intend to print A3 (or even bigger than A3)? Will you want to print directly from your camera occasionally? Would a printer that can accept rolls of paper be beneficial? As with most devices associated with digital imaging, you need to think carefully about how you're going to use your printer, and what you want it to do.

HP Design Jet 3 Series
This series combines high productivity, great image quality, and 'intelligent' printing solutions that simplify workflow.

PHOTOSHOP ELEMENTS

First launched in 2001, Adobe's Photoshop Elements is a 'cut-down' version of Photoshop, by far and away the most popular image-editing program for professionals, but prohibitively expensive for most amateurs. Photoshop Elements provides an excellent value-for-money alternative. It has all the main image-editing features that most enthusiast digital photographers need, as well as a number of versatile and useful Quick Fix functions and help 'wizards' for the less experienced.

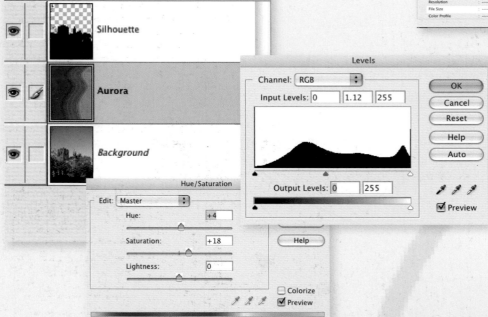

For most photographers, sorting images as opposed to launching in and actually editing, is crucial. Elements' File Browser is an excellent tool. It allows you to view thumbnails of all your pictures, organize them into separate folders, rename entire batches of photos in one go, and view the EXIF data embedded in the image file by your digital camera. This holds helpful information such as, the camera model, the time the photo was taken, what the exposure was, and the focal length of the lens for that particular photo.

The strength of Photoshop Elements, like its bigger brother, lies in its layer-based composition handling. By using Layers, it's possible to perform sophisticated image-editing tasks quickly and easily, and furthermore by adding new adjustment layers individually say for colour or tonal correction, it's easy to undo what you don't like without having to start from scratch each time.

For newcomers to image-editing, Elements has an excellent Help system. This not only allows you to search for terms that you're unfamiliar with, but you'll also find that the names for all the tools are hot-linked to the Help system, and if clicked will take you to the relevant section of the Help system and explain what that particular tool is used for. Also valuable to the novice is the How To palette. This provides step-by-step instructions for many of the most common image-editing and associated tasks, such as how to remove a colour cast, removing red-eye, or preparing an image for the Web.

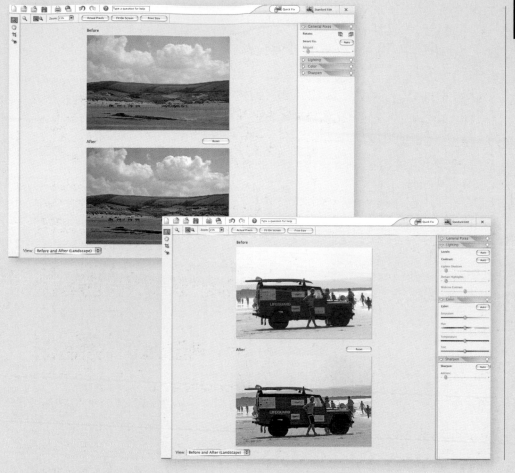

CREATIVE TOOL

As we'll see in the projects, as well as being an excellent and versatile tool for correcting and enhancing photographs, Adobe Photoshop Elements is also an amazingly creative tool that can be used to create wonderful imagery and montages in its own right. Featuring powerful filter and special effects sets and blending mode options, Elements allows you to explore your full creative potential in an intuitive image-editing environment.

Over the next few pages, we'll take a closer look at the Elements work area – its Tool, Menu, and Options bars, the Palette Bin, and more specifically, the Layers palette, before running through some of the more straightforward image-editing techniques.

Camera Raw

Ⓥ Also new to Elements 3, and again an addition that will please the enthusiast photographer, is the ability to import Camera Raw files. As explained on pages 10–11, these so-called 'digital negatives' comprise entirely unprocessed data, and allow for much greater image editing without image degradation. The Raw interface is crammed with powerful adjustment tools, such as White Balance, Exposure, Brightness, Contrast, Luminance Smoothing, and Colour Noise Reduction, all of which effectively allow you to 'retake' your photo with the optimal settings for that particular shot without losing or damaging any of the data information. Once you've got the 'negative' you're happy with, click OK and you can begin to edit the image for final adjustments using the Standard Edit or Quick Fix modes.

Smart Fix and Quick Fix

Ⓐ Other tools that photographers new to image editing will find useful are the Smart Fix and Quick Fix functions, the former again new to Elements 3. The Smart Fix function will automatically correct lighting, contrast, and colour casts with just one click of the button. Alternatively, there's a simple slider that can be used to make more precise adjustments. The Quick Fix functions have been enhanced in Elements 3, and the palette now places the most popular lighting, colour, contrast, and sharpness controls all in one location. You can either click the Auto button and let the computer decide on the level of correction, or use the sliders to increase or decrease the adjustment. Both Smart and Quick Fix functions allow you to preview your adjustments in the form of two windows – before and after. Once you're happy with your edit, you simply save the file.

If your photo requires more remedial work, Elements allows you to switch from Quick Fix mode to Standard Edit mode. In this mode, more precise adjustments to colour, tone, sharpening, and so on can be made, such as bringing up the Levels or Hue/Saturation adjustment boxes, more of which are covered later in the book.

PHOTOSHOP ELEMENTS

If you're new to image editing, image-editing software, and particularly new to Photoshop Elements, you might find the large array of tools, options, palettes, and menus pretty daunting. Don't worry, everybody does. Elements is a powerful piece of software, and you should take time to learn it. Over the next few pages, we're going to take a look at the various tools available and begin with some of the more basic techniques to help you familiarize yourself with the Elements workspace.

The Options Bar

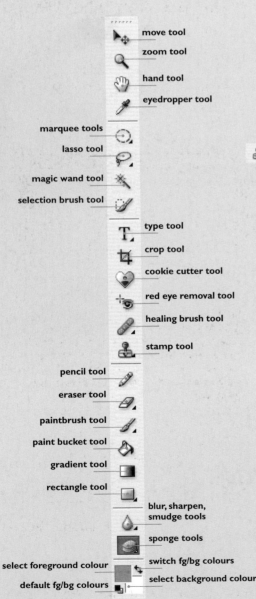

V Perhaps the next most important area of the Elements workspace is the Options Bar, found at the top of your screen, and running at right angles from the Toolbar. The Options Bar allows you to alter the values or functions of the tools. Click on each tool in the Toolbar and you'll see the corresponding options for that tool displayed in the Toolbar. The example here shows the various options for the Clone Stamp tool. The first option is stick with the Clone Stamp, or switch to the Pattern Stamp. So first off, we see that the Options Bar allows us to select a tool variation within the tool group. Next in this particular example, are found the various preset brush sizes that can be applied to the Clone Stamp, and whether or not you want a soft or hard-edged brush. This will of course depend on how large an area you're cloning and how important edge detail is. The next box is an alternative way of selecting the size of the Clone Stamp tool. The Mode box allows you to select the way in which you want any cloned area to appear in your image. You'll notice that as you get more familiar with Elements that these correspond to the Blending Mode options, which we'll be discussing later. For the very great majority of occasions when using the Clone Stamp tool you'll leave the Mode on Normal.

Toolbar labels:
- move tool
- zoom tool
- hand tool
- eyedropper tool
- marquee tools
- lasso tool
- magic wand tool
- selection brush tool
- type tool
- crop tool
- cookie cutter tool
- red eye removal tool
- healing brush tool
- stamp tool
- pencil tool
- eraser tool
- paintbrush tool
- paint bucket tool
- gradient tool
- rectangle tool
- blur, sharpen, smudge tools
- sponge tools
- select foreground colour
- switch fg/bg colours
- select background colour
- default fg/bg colours

Options bar labels:
- stamp clone tool
- brush size
- opacity
- tick box
- stamp tool
- brush style
- brush mode
- tick box

Size: 4 px · Mode: Normal · Opacity: 100% · Aligned · Use All Layers

The Toolbar

< Let's begin with a quick run down of Elements' tools by looking at the Toolbar. Located on the left-hand side of your screen, the Toolbar is a preset selection of icons, which when clicked, allow you to select a tool (or variation of that tool). Elements 3's Toolbar differs from previous versions in that it comprises a single column of tools, rather than the double column that some of you may be familiar with. If you prefer to work with the double column, simply undock the Toolbar by clicking at the top and moving it slightly out of position.

The tools are often described as falling into three categories. The first are the environment tools, among them Move, Zoom, and Hand tools. These don't directly affect your image, and are primarily used for orientation. The next group of tools are the selection tools, such as the Marquee tools, the Lasso tools, and the Magic Wand. Again on their own, these tools do not make direct adjustments to your images, but allow you to select specific parts of an image that you want to edit. The next group of tools are the active or functional tools. These allow you to make changes directly to your image, and included among these are the Type, Crop, Cookie Cutter, Red-Eye Removal, Healing Brush, and Clone Stamp tools. Also included in the active group are the Pencil, Eraser, Brush, and Paint Bucket tools. Other tools that fall loosely into the active group are the Gradient, Blur/Sharpen/Smudge, and the Doge/Burn/Sponge tools. At the very bottom of the Toolbar you'll find the Color Picker. This sets the foreground and background colours, and later in the book, you'll discover the various ways in which this tool can be used.

As you familiarize yourself with these various tools, you'll notice that some icons have little black arrows in the bottom corner. This indicates that there are other variations or similar tools within that selection. For example, Blur/Sharpen/Smudge are all found in one location. You'll also notice that if you leave your cursor over one particular tool for a short period of time, the name of that tool will appear in blue, underlined lettering. If you then click on the name of the tool, Elements will take you to the Help system, where you'll be given a brief description of the tool's function.

The Palette Bin

Formerly found at the top right of your screen in previous versions of Elements, when it was called the Palette Well, in Elements 3, the Palette Bin is found running down the right-hand side of your monitor. It can be opened and closed by clicking on a narrow, highlighted arrow half way down the Bin. The Palette Bin provides quick access to the How To, Styles and Effects (which also includes the array of Filters available), Layers, and Undo History palettes. Of all these, the most important is the Layers palette, which we'll be discussing in some detail on pages 26–27. As well as opening and closing the entire Palette Bin, individual palettes can be opened or closed by clicking on the white arrow preceding the palette name.

The Photo Bin

Again new to Elements 3, the Photo Bin is another collapsible window that allows you to easily keep track of the images you have open on your desktop, allowing to quickly batch edit your images using either the Quick Fix or Standard Edit modes.

The Shortcut Bar

Elements' Shortcut Bar is similar to the shortcut bars found in word-processing and other image-editing programs. Holding the cursor over each icon shows what shortcut can be achieved. Of note are the 'Type a question for help' dialog box, and the Quick Fix and Standard Edit buttons. The former is another addition to Elements 3 and is aimed at the novice who needs hints and tips as they edit an image, while the last two have been discussed in some detail in pages 14–15.

The Menu Bar

Again, familiar to those who use word-processing and painting programs, the options in the Menu Bar range from opening a file, through saving for the Web, to bringing up specific colour or tonal dialog boxes. Again, you'll become much more familiar with the Menu Bar as you work through the tutorials.

ADJUSTING BRIGHTNESS LEVELS

The Levels command is a powerful Elements feature. It allows you to adjust highlights, midtones, and shadows progressively and, if handled with care, without damaging the data of your photo. And in addition, although mostly used to raise the brightness values of images, Levels can also be used to adjust colour, often in creative ways.

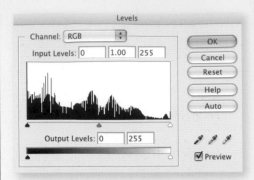

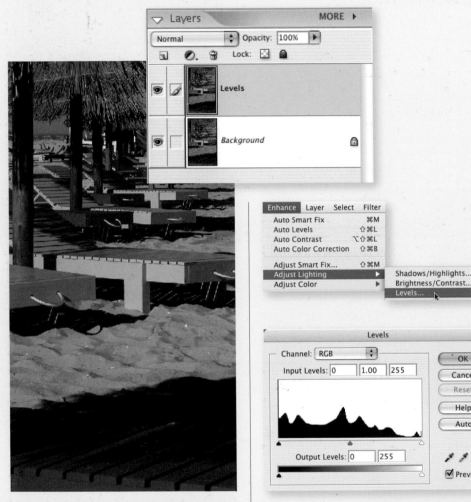

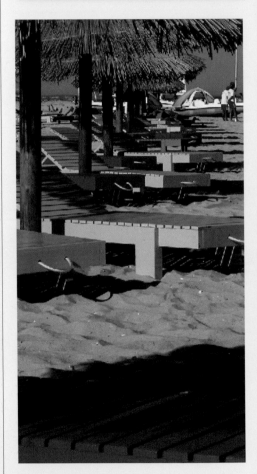

1 This image of sunbeds is not working well. The camera has underexposed the image, and furthermore, a red cast seems to have crept in, possibly due to inaccurate white balance. Let's begin by duplicating the background layer and calling it Levels. To do this, either go to *Layer > Duplicate Layer*, or in the Layers palette, drag the 'background' icon on the 'Create a new layer' icon at the top left of the Layers palette.

2 To bring up the Levels dialog box, we select *Enhance > Adjust Lighting > Levels*. The core of the Levels dialog is the histogram. This is a visual representation of the brightness of the image. The histogram comprises 256 vertical bars ranging from 0 (black) to 255 (white). The overall shape of the histogram represents the number of pixels for any given brightness value. We can tell that this image is dark because of the slight preponderance of the pixels to the left-hand (black) side of the histogram. The few, but bright, highlights are represented by the short spike at the far right, above the white triangle.

3 Let's begin by seeing what Elements' Auto command can do with this image. To do this, we click on the Auto button in the dialog, or select *Enhance > Auto Levels*. Although it has removed a small amount of the red cast, the brightness hasn't really been affected.

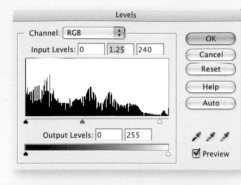

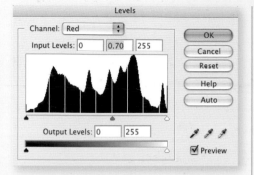

BLACK-AND-WHITE POINTS

The Levels dialog contains three eyedropper icons at the bottom right-hand corner. The left, when selected, allows you to select a pixel and make that pixel and all the others with a lower brightness value black, while the right eyedropper does the opposite. By clicking around with both, it's easy to create some quite dramatic lighting effects.

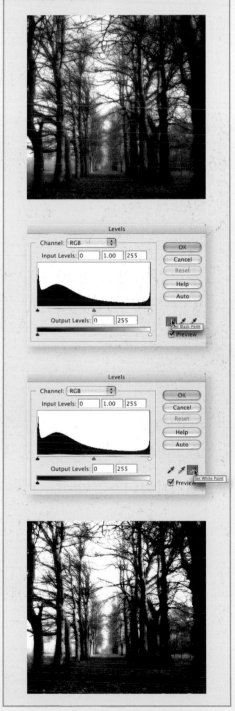

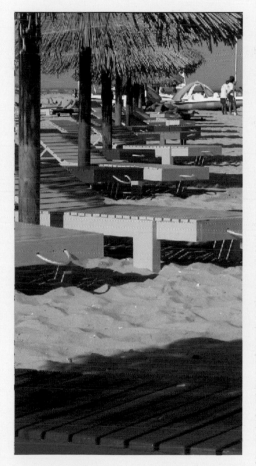

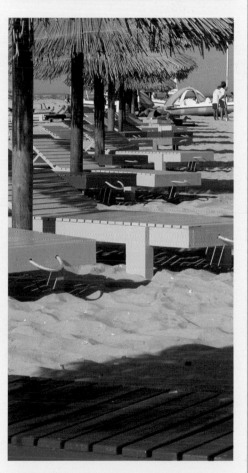

4 Taking over manual control, we can be a bit more aggressive with the midtone point by moving the centre triangle to the right until we're happy with the result. However, although we've now got a much better exposed image, we still have to get rid of the red cast.

5 Surprisingly, the Levels command can do quite a good job of adjusting colour as the Auto fix indicated. This time we've selected the Red channel in the Levels dialog and moved the midtone point quite a long way to the right, effectively reducing the level of red in the midtones. As we continue to move the slider, we can see the red cast slowly disappearing. The final result is a much more accurately coloured image.

MAKING COLOUR ADJUSTMENTS

In this section, we're going to look at the various ways Elements allows us to adjust colour – whether it's to correct a colour cast or for more creative colour change. The first is usually achieved by using the Color Variations command, while for more subtle corrections and creative adjustments the Hue/Saturation commands are the tools of choice.

Variations

The Color Variations command is a simple to use but powerful tool that provides a good choice of alternatives which you can preview before making a final decision on the adjustment.

1 This image of a Portuguese post office with an unusual white phone booth outside has an unpleasant green cast and looks overexposed. It's often worth trying the Auto Color Correction to see what Elements can do to fix problems like this. The result isn't too bad. The green cast has been corrected quite well, but the image still appears overexposed.

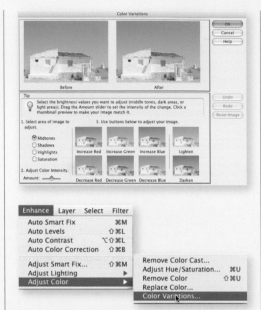

2 Now let's see how the Color Variations command can help. Returning to the original image, the Variations dialog window gives you a choice of reducing or adding an overall colour to the image. Ensure that Midtones radio button is selected. It's unlikely that a problem with colour cast is caused by inaccurate Shadows or Highlights. Unsurprisingly, we can see that the Decrease Green option is going to get us closer to what we want. Each time you click on a Decrease or Increase window, the After window to the right of the original image will show that adjustment. In this example, we clicked Decrease Green three times, before reaching our goal.

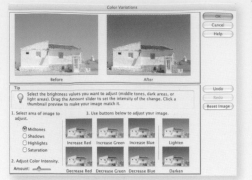

3 Having fixed the colour cast, we click on the Darken window to correct the overexposure, and the result looks good. We've won back a deep blue Mediterranean sky, and the building and telephone booth look a much healthier white.

Hue/Saturation

While the Color Variations is an excellent tool for correcting overall colour casts, in this next example, the colour corrections required are too subtle for the Variations tool, so we need to use the Hue/Saturation commands to really fine-tune the colours.

1 This scene of bluebells in a wooded area has caused the camera's white balance all kinds of problems. The intense foliage has created a green cast and the path running through the middle has taken on a slightly strange-looking reddish hue.

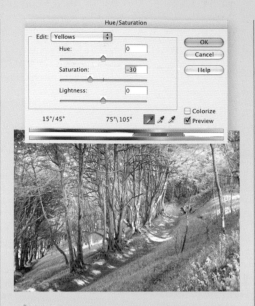

COLORIZE

As mentioned earlier, the Hue/Saturation command can also be used in creative ways, an example of which is the Colorize radio button. This lakeside scene works on two levels – the depth of the blues in the sky and water, but also the symmetry of the reflections of the trees. Clicking the Colorize button takes out the colour from the photo, and in this case, replicates a sepia effect. However, you don't have to settle for Elements' default. You can manually adjust the Hue and Saturation sliders to achieve alternative colourations.

2 We access the Adjust Hue/Saturation dialog via *Enhance > Adjust Color*. The window shows three sliders; the first two, Hue and Saturation, are the ones most often used, while Lightness is rarely touched. Used in combination, the Hue/Saturation sliders allow you to adjust the strength of specific hues. You'll also notice the Master button at the top. If you wanted to make an image more or less colourful across the entire spectrum, then that's the setting you want, but that's not what we want to do here.

4 Returning to the Hue/Saturation dialog, and selecting and reducing Yellows by −30 gives us much more of the result we're after. The green canopy, while staying green, no longer imbues the whole scene with a green glow, and the trunks of the trees look far more natural.

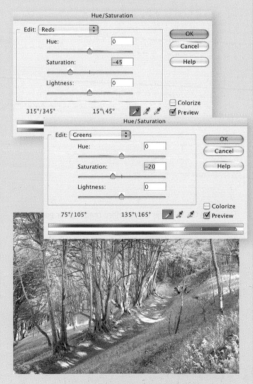

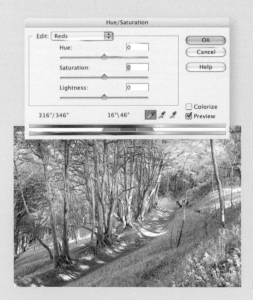

3 We're specifically looking to reduce the amount of green in the image. So by clicking on the Master button, we're offered a selection of colours to choose. Here, we've selected Greens and reduced the saturation by −20. However, somewhat surprisingly, the image hasn't really been greatly affected. We still have a strong green cast.

5 Finally, we need to get rid of the reddish hue on the path. As this is likely to be the only area of the image that has this hue of red, it's probably safe to simply select Reds and reduce the saturation. But we can also click on the right-hand eyedropper to the bottom right of the box and select a specific part of the path. That way we're sure to reduce only that specific hue of red.

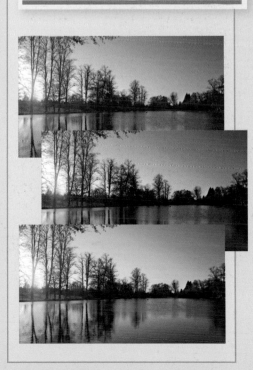

MAKING SELECTIONS

To be able to add impact to your images or create drop-dead photomontages, it's essential to be able to make accurate selections of elements or areas of photos. That way you'll be able to apply adjustments to predefined areas of your photos or select certain elements so that they blend in with other parts of other images in a realistic way. There are various ways of making selections in Elements, and which you use depends on the type of selection you're making. The tools that are most commonly used for making selections in Elements are the Magic Wand, the Lasso, and the Marquee tools.

The Magic Wand tool

The Magic Wand tool comes into its own, when the element you're trying to isolate is sitting on a fairly uniformly coloured background.

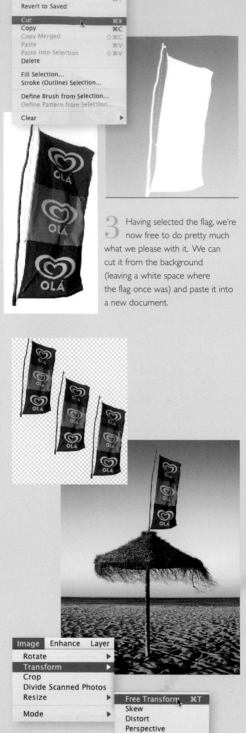

3 Having selected the flag, we're now free to do pretty much what we please with it. We can cut it from the background (leaving a white space where the flag once was) and paste it into a new document.

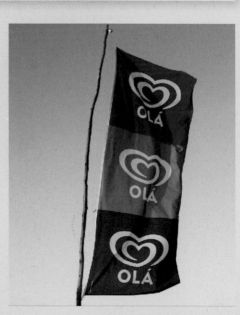

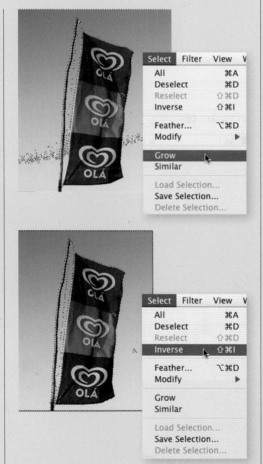

1 In this photo of a 'Hello' flag from Portugal, the expanse of clear blue sky behind it makes it an ideal object to cut out using the Magic Wand. After selecting the Magic Wand, leave the Options Bar at the default settings. Leaving the Anti-Alias button ticked helps to soften the selection if you want to place it in another image.

2 With the Magic Wand, click in any area of the sky, and you'll see that with the quite high default Tolerance of 32 a fair amount of the sky is selected right away. Using the Grow command, almost all but the lower part of the sky is selected. By holding down the Shift key, we can add to the selection until all the sky is selected. Once the entire sky is selected, by going to *Select > Inverse*, we effectively select everything other than the sky.

4 We can either paste the flag into a new document with a white background or one with a transparent background. And, of course, we can paste it in as many times as we like. Alternatively we can paste it into an existing photo and scale it by going to *Image > Transform > Free Transform* and using the corners of the bounding box to resize the image. So in this example it looks vaguely surreal, but perhaps not beyond the realms of possibility.

The Lasso Tools

Performing complicated selections, such as cutting out people from their backgrounds, is often required when making photomontages. The most effective tool for this kind of work is the Polygonal Lasso tool.

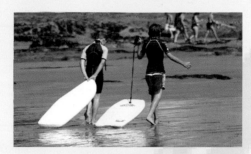

1 As you can see from this image, attempting to cut out one of the boys coming back from a hard day's body surfing would be impossible using the Magic Wand method. Attempt to click on the background and eventually quite a lot of the boy's hair, shadows on the legs, and so on would also be selected.

2 Instead we're going to select the Polygonal Lasso tool, and feather the selection by 1 pixel. This will help soften the outline when we come to make the outline selection.

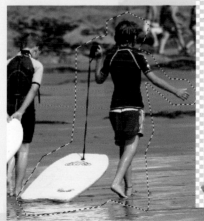

3 We could begin by zooming right into the surfer and begin to make the selection. Alternatively, it might be easier to make a very rough selection first using the Polygonal Lasso tool, make a copy using Ctrl/Cmd+C, and paste (Ctrl/Cmd+V) into a new transparent document. This may make navigating around the figure easier.

4 Once the figure has been placed into the new transparent document, the next step is to zoom to about 400% into part of the figure, and carefully trace around the outline. The Polygonal Lasso tool by default draws in straight lines, so when drawing around a curved outline, click to make a new point. After a short while, it becomes quite easy to control the number of steps you need to make. Lots of short steps for curved lines, and fewer longer steps for straighter edges.

5 This particular selection took about 10 minutes to make, and works relatively well; in isolation cut-outs always look a little fake. Here we've also added a shadow to put the figure into some context.

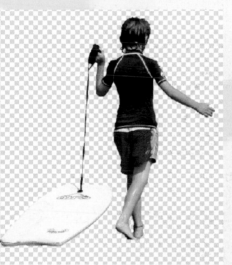

MAKING SELECTIONS

The Lasso tool

The Lasso tool is a freehand tool that uses the movement of the mouse to trace an area you want to select. However, as we all know controlling a mouse to within a few pixels accurately is almost impossible, so for this reason the Lasso tool is best used to select large areas rather than for tracing around a clearly defined border.

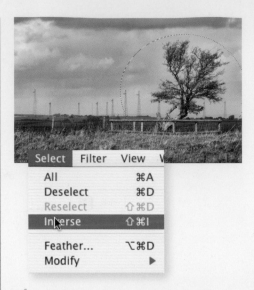

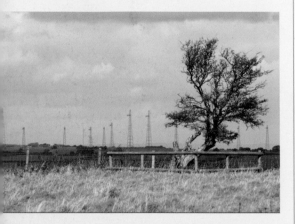

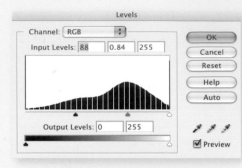

1 Although quite an interesting composition, this image, entered for a competition entitled 'Evolution', lacks a bit of punch. We could make tonal corrections across the whole image to give it a bit more drama, but what we're going to attempt to do is to leave the tree and the communication masts unaffected so that their juxtaposition is made more apparent.

3 We then repeat the process, but this time selecting the grass, and again using Levels to add more tone.

4 In this step we've used another selection tool, the Elliptical Marquee, to make a selection around the tree. After inverting and feathering the selection, we've used the Levels to darken slightly the rest of the image.

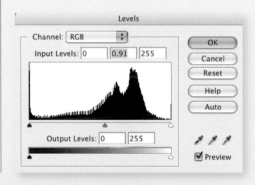

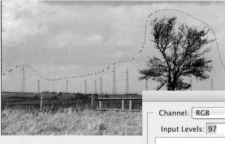

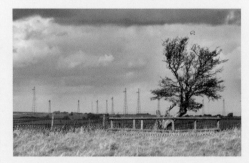

2 The first thing we're going to do is add some drama to the sky. We achieved this by using the Lasso tool to make a fairly random selection of the sky, feathering the selection by 100 pixels, and then using Levels to darken the selection.

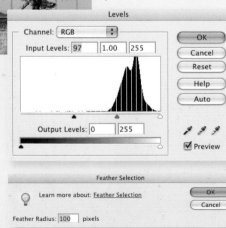

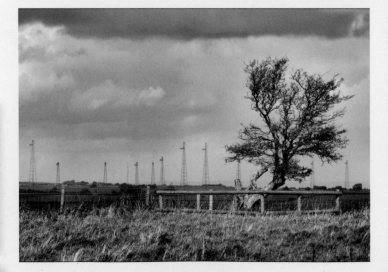

5 The final image shows an almost imperceptible halo effect around the tree, which helps it to stand out from the now much more dramatic foreground and sky.

The Magnetic Lasso tool

The Magnetic Lasso of all the Lasso tools is perhaps the least widely used. Although an incredibly clever tool in that it can 'see' the edge of the element you're trying to select, it does often make mistakes and requires a lot of practice to really get to grips with it.

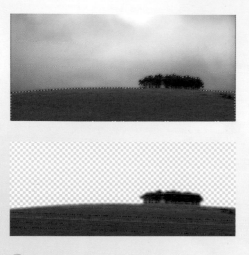

3 The completed selection shows how well the Magnetic Lasso has selected the sky and tops of the trees. The next step is to feather the selection by 5 or 6 pixels to create a soft edge, copy the selection and paste it into a new transparent document.

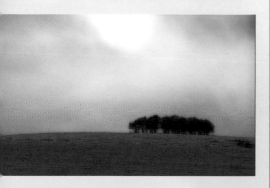

1 In this example, we're going to use the Magnetic Lasso tool to replace the stormy sky in this image, with a blue, cloudy one. The clearly defined edge between the sky and the ground makes this an appropriate image to use the Magnetic Lasso.

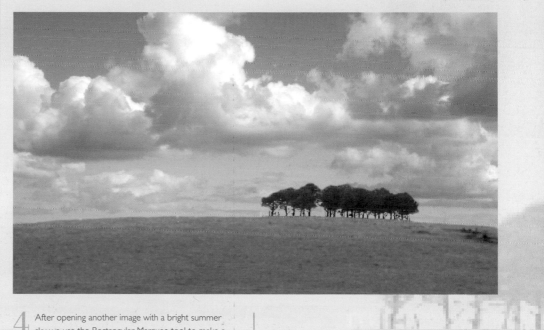

2 Starting at the far left of the image, all we need to do is to click once to place an initial anchor point, and then simply drag the icon roughly along the border between the grass and the sky, and the Magnetic Lasso automatically selects the edge. There's no need to click to place additional anchor points, as the tool does that automatically. If it does go wrong, we can simply retrace over the selection, hit Back Space, and the tool will delete the erroneous anchor point. It is possible to manually lock down anchor points by clicking the mouse.

4 After opening another image with a bright summer sky, we use the Rectangular Marquee tool to make a selection of the sky. We copy and paste the sky into a new layer on the grass and tree document. Next we zoomed into the trees and with a fine Eraser brush carefully rubbed away the old grey sky to reveal the blue one underneath. Finally with the grass and tree layer selected we used Levels and Hue/Saturation adjustments to brighten the foreground.

MAKING SELECTIONS

Selection Brush

Of all the selection tools, perhaps the most forgiving is the Selection Brush. It allows you to check and return to your selection to fine tune it until you're happy with it.

2 Having drawn the outline, we increase the size of the brush to quickly fill in the rest of the Mask.

1 Here we're going to use the Selection Brush to quickly cut out this portrait. Select the brush and check that the Mode is Set to Mask in the Options Bar. First we going to select a fairly small brush with a hard edge to draw round the outline of the girl and her hat.

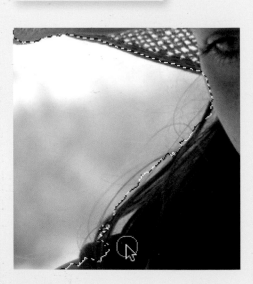

3 Once we're happy with the mask, we can go to the Options Bar and change the Mode to Selection. This instantly shows the more familiar 'marching ants' selection. But here's where the forgiving aspect of the Selection Brush comes in. The selection can easily be edited. For example, we need to tidy up the selection around the girl's shoulder. By selecting Inverse, we can use the Selection Brush to literally push the 'marching ants' away and closer to the edge we want.

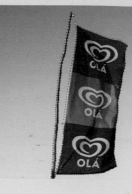

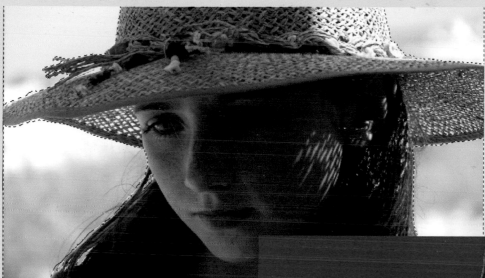

6 The great thing with the Selection Brush is that it can be used in conjunction with any of the other selection tools. Take our first selection of the Portuguese Olá flag.

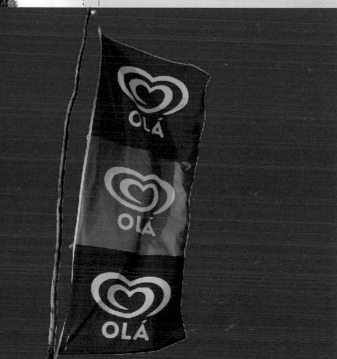

Select Filter View W

All ⌘A
Deselect ⌘D
Reselect ⇧⌘D
Inverse ⇧⌘I

Feather... ⌥⌘D
Modify ▶

Grow

7 If we switch to the Selection Brush and set the mode to Mask, we can instantly create a Mask of the flag, which we could then edit if we so desired. And furthermore, by selecting Inverse…

8 … we can cut the background away.

4 By toggling the selection using Inverse we can tidy up all around the selection until we're happy with the fine tune.

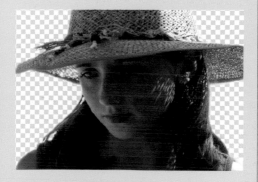

5 As soon as we're happy with the selection we can delete the background, leaving us with a cut out portrait that we can either place into another background or put in front of a solid colour to emulate a studio shot.

UNDERSTANDING LAYERS

If you take a quick look at some of the projects later in this book, you'll see that one thing common to all of them is the use of layers. Layers are a vital part of all image-editing and image-creation. At their most basic level, they allow you to add parts of one image to another and move it about, essential when creating montages; alternatively they allow you to make subtle but meaningful adjustments to your images, such as adding contrast or adjusting brightness.

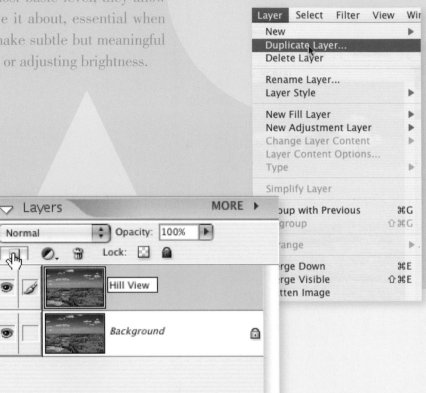

The Layers palette

1 Let's begin by taking a detailed look at the Layers palette. By default the Layers palette is made available as part of the Palette Bin when you open an image. The first thing to know is that if you click on the Layers palette tab you can drag the palette away from the Palette Bin and place it anywhere on your desktop. You may find it more convenient to work with the Layers palette other than at the default right-hand side of the screen. Clicking on the small red button found at the top left of the palette returns the Layer Palette to the Palette Bin.

2 The Layers palette itself comprises a thumbnail of the image you have opened for editing. You'll notice that to the right of the thumbnail there is a small padlock. This indicates that that particular layer is locked and cannot be edited. It's a sensible precaution to leave the Background image locked and work on a copy of the image, as this way you can always return to your initial image if things don't go to plan. To duplicate an image, drag the thumbnail image over the 'Create a new image' icon at the top left of the palette window. It's good practice to name layers as you create them. That way you'll find it easier to navigate your layers as you create more and more.

An alternative way of duplicating the layer is to go to the Layer menu and select Duplicate Layer.

Next to the 'Create a new layer' icon is the 'Create adjustment layer' icon. We'll be looking at adjustment layers in more detail on pages 30–31. But as the name suggests, adjustment layers are a sophisticated way of editing your images. Next to the adjustment layer icon is a waste bin.

To delete a layer, simply drag the layer into the bin and you'll be asked if you want to delete that layer. Above these three layers is the Blending Modes menu. Again we'll be looking at blending modes in more detail on pages 32–33, but fundamentally the Blending Mode options affect how one layer interacts with the layers in front of (or above) them and behind (or beneath) them. Next to the Blending Modes option is an Opacity box. This sets the opacity (or transparency) of a particular layer – in other words it dictates how visible the layer behind it is (see box *Opacity*).

To the left of the thumbnail image you'll see a small paintbrush icon; this indicates which layer is active, in other words the layer that any adjustments will affect. Next to the paintbrush icon is an eye icon. Clicking this icon renders that particular layer invisible. This is useful when you want to see the layers behind (or beneath) the selected layer. For example, if you have placed part of an image over the top of your background image during the creation of a montage, clicking on the eye icon will show you the background image without the additional new element.

3 In this mock-up of a Portuguese postcard, the accompanying screengrab of the Layers palette shows the five individual elements that were used to make up the card – the four image layers and the text layer. Although, because in this particular example the images aren't blending in to one another, in reality you'd be more likely to use a page make-up program such as InDesign or PageMaker to do this kind of work; however it shows how the Layers palette is structured. When we look at making adjustment layers (see *Adjustment Layers, pages 30–31*) and blending images together (see *Blending Modes, pages 32–33*), that's when the power of Elements' Layers palette really comes into its own.

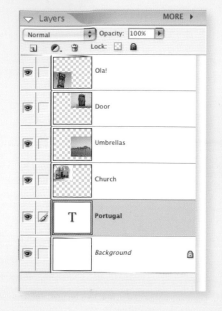

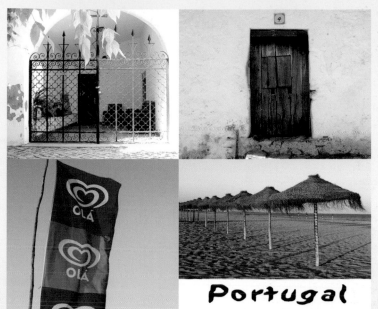

OPACITY

In themselves layers wouldn't be particularly useful if you couldn't see layers behind (or beneath) other layers; and that's the significance of Opacity. In this schematic drawing, for us to see the 'sun' in front of the 'sky' and the 'sail' in front of the 'sea' and 'sand', the layers have to be in a strict order (A). If we mix up the order of the layers (B) then parts of the image are obscured. However, if we set all the layers' Opacity to 50% (C), then all the elements of the drawing remain visible, no matter what layer they're on. However, the colours of each element will be affected depending on which layer it lies over or under. (D)

A B C D

ADJUSTMENT LAYERS

Adjustment Layers provide a powerful yet flexible way of editing images. Their flexibility lies in the fact that adjustments – whether to colour, tone, or contrast – can be revisited at any time during the course of editing and either fine tuned or dispensed with altogether if the result they're yielding is not desired. In this example we're going to use Adjustment Layers in an attempt to salvage an underexposed and slightly flat landscape.

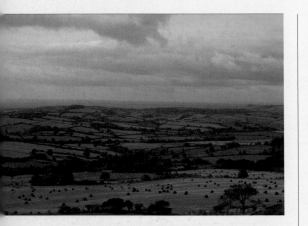

1 This image was shot in the late afternoon and there's little evidence of warm autumn sunlight to lift what could potentially be an attractive landscape shot of the south of England's Jurassic Coastline, in Dorset. Furthermore a blue cast seems to have crept into the photo, perhaps indicating that the camera's auto white balance couldn't quite cope with the lighting situation.

2 The first thing we need to do is to attempt to add some brightness to the scene using a Levels adjustment layer. Click on the 'Create adjustment layer' icon and select Levels. The first adjustment is to the RGB master levels. Here we've brought the black and white points (the two end triangles) in towards the centre slightly, so that they sit under the ends of the histogram. This adds contrast by making the lightest colours white and the darkest black.

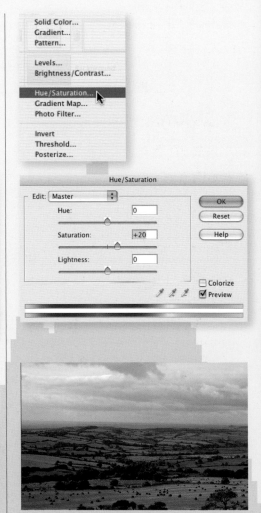

3 Now, let's assume that the image was to be reproduced in a tourist guide. This type of guide tends to go for strong saturated colours, so the next stage is to strengthen the colours. Again we click on the 'Create adjustment layer' icon and bring up the Hue/Saturation dialog. In this instance we've bumped the colour up to 20 – quite a strong adjustment.

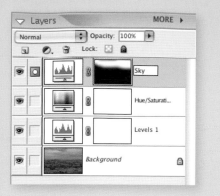

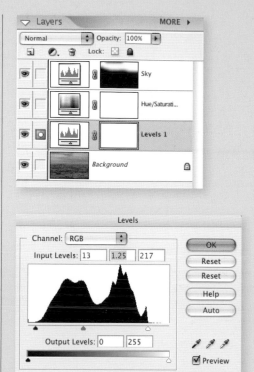

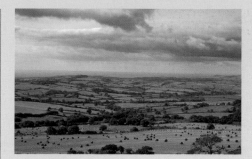

Increasing the brightness of the midtones however
has slightly washed out the colour, so we next return
to the Hue/Saturation adjustment layer and bump up the
colours again.

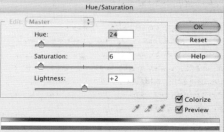

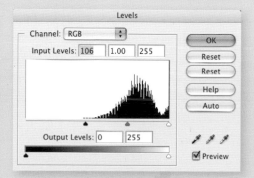

By adding more contrast to the sky, the image has
become quite gloomy again. And here's the beauty of
adjustment layers. We can return to the Levels adjustment
layer, and this time we've moved the central triangle to the
left, so increasing the brightness of the midtones.

The image is beginning to look a bit more respectable,
but adding drama to the sky would help. To do this we
made a rough selection around the cloudier area of the sky
and feathered the selection by 100 pixels. When we bring
up another Levels adjustment layer, you can see how the
thumbnail image shows only that area of the sky is selected,
and therefore only that area will be affected. In this instance
we've moved the black point quite a long way to the left and
added much more contrast to the sky.

And to demonstrate the flexibility of adjustment layers,
it is possible to quickly see how an image looks in
greyscale. Here we've simply returned to the Hue/Saturation
adjustment layer and clicked the Colorize button and
experimented with the Hue and Saturation sliders.

BLENDING MODES

As we've already discovered, Elements' powerful toolset combined with its layer-based composition handling make it a wonderfully versatile and creative program. But that versatility and creativity is strengthened even more by Layer Blending Modes. Entire books have been written about Blending Modes, so here we'll simply provide a brief overview of what each mode does. The best way to learn how Blending Modes work in the 'real world' is through experimentation.

We start by selecting two patterns from Elements' wide selection of patterns. We've chosen one greyscaled pattern (the base colour) and one colour pattern (the blend colour) as this combination will best show the effect of the Blending Modes on the two layers.

Dissolve
Again, when using Dissolve with Opacity set to 100% we can only see the colour layer. But as we reduce the Opacity, we notice that random pixels from the colour layer begin to disappear, revealing the pattern underneath. In this example, with Opacity set to 50%, we can see how 50% of the pixels from the colour layer have disappeared, resulting in a speckled effect.

Multiply
Multiply, as it name suggests, multiplies the base colours with the blend colours, which results in a darker colour, as shown here. Mulitply any colour with black and you get black, but multiplying any colour with white leaves the colour unchanged.

Normal
With Opacity set to 100%, as we've already shown on page 27, we wouldn't be able to see the pattern (or base) layer showing through the colour (or blend) layer. Reducing the Opacity to 50% makes the blend layer semi-transparent allowing the base layer to show through. The result is a purple-coloured pattern.

Darken
The first mode not to require a reduction in opacity for us to see both layers, Darken compares the colour values of both layers and selects which ever is darker. Unsurprisingly, the purple of the blend layer shows over the lighter greys of the base layer, while the black of the base layer replaces the purple of the blend layer.

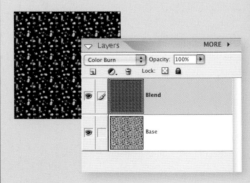

Color Burn
This mode compares the colours of both layers and darkens the base colour to reflect the blend colour by adding contrast. If one of the colours to be blended is white then there is no change.

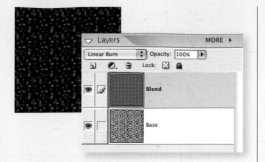

Linear Burn

Like Color Burn, Linear Burn compares the colours of both layers and darkens the base colour to reflect the blend colour, but this time by decreasing the brightness.

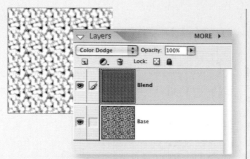

Color Dodge

The opposite of Color Burn, this mode compares the colours of both layers and lightens the base colour to reflect the blend colour by reducing contrast. And, as you would expect, blending with black results in no colour change.

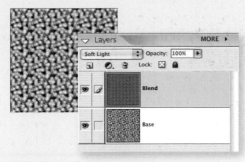

Soft Light

Soft Light uses 50% grey as its defining point. If the colour of the blend image is darker than 50% grey the colour is darkened (or burned), if lighter than 50% grey the colour is lightened (or dodged).

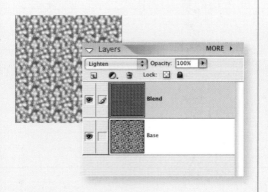

Lighten

Unsurprisingly this does the exact opposite of Darken. This mode compares the base and blend colours and whichever is brighter becomes the resultant colour. So here we have no black showing from the base layer, but the pattern is retained because of its white elements.

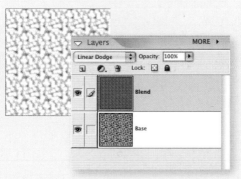

Linear Dodge

The opposite of Linear Burn, Linear Dodge compares the colours of both layers and lightens the base colour to reflect the blend colour by increasing the brightness..

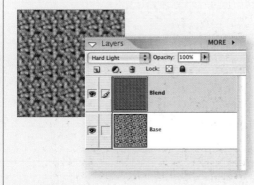

Hard Light

Similar to Soft Light, Hard Light also uses 50% grey as the defining point; but this time if the colour of the blend image is darker than 50% grey the colour is multiplied, if the colour is lighter than 50% grey the colour is screened.

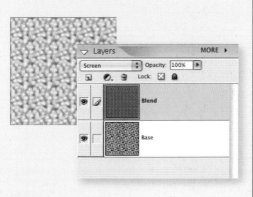

Screen

This is in effect the opposite of Multiply. The base colour is multiplied with the inverse of the blend colour, resulting in a lighter colour. So in this instance screening with black leaves the colour unchanged, while screening with white results in white.

Overlay

This uses a combination of both Multiply and Screen. It uses Multiply in shadows and Screen in highlight areas.

Vivid Light

Vivid Light applies contrast to affect the change. If the blend colour is darker than 50% grey than the colour is darkened by adding contrast; if the blend colour is lighter than 50% grey then the colour is lightened by reducing the contrast.

BLENDING MODES

Exclusion

Basically, this is the same mode as Difference, but with less contrast.

Linear Light

Just as Vivid Light uses contrast to lighten or darken a colour, Linear Light uses brightness. If the blend colour is darker than 50% then the colour is darkened by decreasing the brightness, and if the colour is lighter than 50% grey, the colour is made brighter.

Hard Mix

Hard Mix posterizes colours based on the blend colours. If the blend colours are lighter than 50% grey, then the base colours are brightened, if the blend colours are darker than 50% grey then the base colours are darkened.

Hue

This mode uses the Saturation and Brightness of the base colour with the Hue of the blend. Here we can't see the purple of the blend colour because the Saturation and Brightness of the base colour override it.

Pin Light

This mode replaces the base colours depending on the brightness of the blend colours. If the blend colour is lighter than 50% grey, then base colours darker than the blend colour are replaced. If the blend colour is darker than 50% grey, the base colours lighter than the blend colour are replaced.

Difference

This compares the brightness of the base and blend colours, and then either subtracts the blend colour from the base colour, or the base colour from the blend colour.

Hue

This mode uses the Saturation and Brightness of the base colour with the Hue of the blend. Here we can't see the purple of the blend colour because the Saturation and Brightness of the base colour override it.

Saturation

This works in the same way to Hue, but uses the Hue and Brightness of the base colour, with the saturation of the blend colour.

Colour

Similar to the previous two, but because this mode use the Hue and Saturation of the blend colour, the purple colour becomes visible.

Luminosity

This uses the Hue and Saturation of the base colours with the Brightness of the blend image. This results in the colours of the base pattern being used with the shape of the blend layer.

BLENDING

You'll see Blending Modes being used in a variety of ways during the course of this book, but the only way to really get to understand them and know what they can do for you is to experiment. The permutations of Blending Modes are endless, and therefore so too are their creative possibilities. However, they can also be used in more straightforward corrective ways. Let's have another look at a bluebell image, and instead of using Levels and Hue/Saturation adjustments, we'll use Blending Modes to try to add more punch. The first thing to do is brighten the image; simply duplicating the image and running a Screen blending mode has lifted it quite considerably (1). Now to add some more contrast we simply run an Overlay blending mode (2). Within a matter of seconds we've improved the image quite drastically by simply using two blend modes (3).

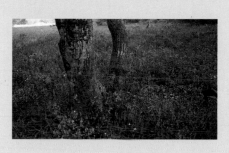

PAINTING WITH BLENDING MODES

Perhaps of less significance for photographers, but still worth noting is that the various Blending Modes also apply to brushes and other tools. In this example, various brush sizes with a variety of bright colours were randomly drawn over a bright blue background. As you can see, the way the lines interact with one another as they cross over is dictated by the blending mode. Again, the best way to understand how these work is to experiment.

FILTERS AND LIGHTING EFFECTS

Elements 3 now features many of the advanced filters, lighting, and other effects found in the full version of Photoshop. Some of these are incredibly powerful and you'll see how they can be put to good use in many of the projects found in this book. Here we're going to take a look at how a few of these filters can be used to enhance photos rather than to necessarily create special effects.

Of particular interest to photographers is the addition of the Photo Filter set to Elements 3. These replicate the effect of using coloured filters on the end of the camera's lens. Let's see how these work.

1 The Photo Filters are accessed in the same way as the other adjustment layers that we've already looked at.

2 After selecting a Photo Filter Adjustment Layer, you'll be prompted to give the layer a name (alternatively you can choose the default 'Photo Filter 1'). At this stage you can also select the Opacity and even the Layer Blending Mode; however as you can go back and change these later, it's probably not worth doing that at this stage, unless you already know those specific settings.

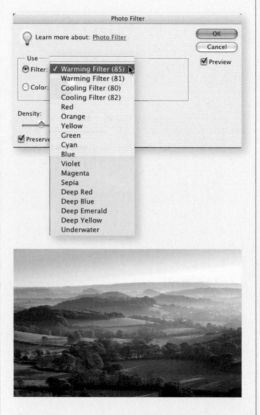

3 Once you've named the layer and clicked OK, another dialog window will appear. This features 18 preset colours to choose from, some of which are calibrated to emulate real colour conversion filters. For example, in this example we've chosen Warming Filter (85). The 85 refers to real filter charts and indicates that the filter will decrease the colour temperature from 5,500K to 3,400K, that is make everything slightly rosy.

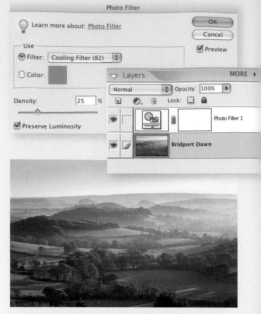

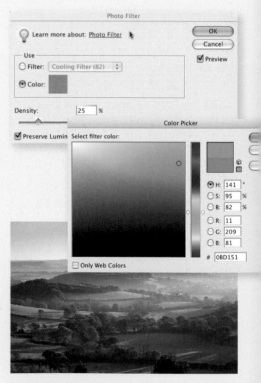

4 As an Adjustment Layer, if you don't like the effect you've achieved with your initial filter selection, simply double-click on the Adjustment Layer in the Layers Palette and you'll be taken back to the filter selection dialog window. This time we've selected Cooling Filter (82). Again this refers to a real-world filter conversion which effectively raises the temperature by 100K, creating a cooler bluer light.

5 If you're not happy with any of the preset colour filters, it's possible to select your own colour. Clicking on the Color radio button in the Photo Filter dialog window will bring up the Color Picker. From here you can select any colour you want and apply it to your photo.

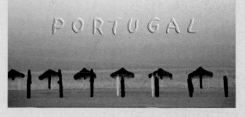

1 Having opened the image of the umbrellas, we select the Palette Knife effect via *Filter > Artistic > Palette Knife*. This brings up a window with not just the Palette Knife effect, but also thumbnail images of all the Artistic effects. But we're going to stick with the Palette Knife. To the right of the window are three sliders that control various aspects of the effect, and it's worth experimenting with these and previewing the changes they make in the preview window to the right of the dialog box. Once we're happy with the settings, click OK.

2 As well as being able to apply effects to your images, Elements can also add a variety of borders to your images. Clicking on the Styles and Effects palette brings up two pull-down menus. To access the borders you select Effects in the right-hand menu and Frames in the left. You'll also notice if you select other pull-down options that you can access the various filters that we selected before via the Filter menu command. Here we've selected Ripple Frame. Simply double-click on the frame of your choice and Elements runs a series of actions that automatically applies the border to your image.

3 And of course Elements also has various effects that can be applied to text layers. After typing in your text, select Text Effects in the left-hand pull down menu of the Styles and Effects palette and double-click on your selection. Again, Elements will run a series of actions that puts the text into the style of your choice.

ALTERNATIVES

The creative possibilities of Elements' dozens of effects and filters is astounding. Once you begin to play around with what these effects can do, you'll quickly discover those that work well and those that are less valuable; and combined with Layer blending modes and the mass of editing tools at your disposal, it quickly becomes apparent that Photoshop Elements is an incredibly powerful imaging tool.

effects with scale

PARISIAN GIANT

Confusing the scale of people and objects is a camera trick that has been around since the dawn of photography. Let's see how we can take that trickery a step further....

TIP Even with so few layers, it's worth giving them names as you create them to avoid confusion. Double-click the name in the Layers palette to change it. You'll find navigating your documents much easier that way.

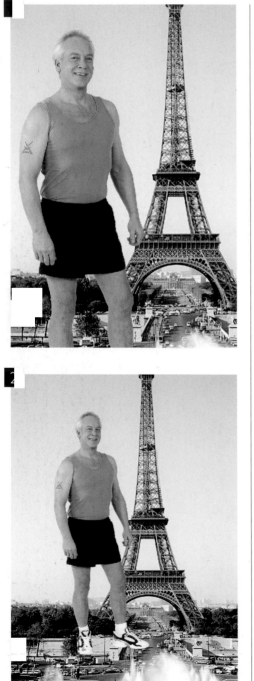

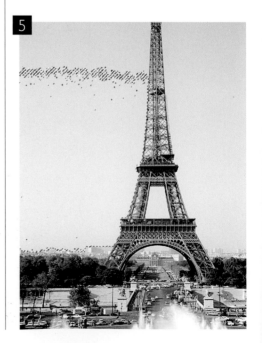

1 Here's the way we'd approach this trick with a conventional camera: we'd just get the person to stand in front of the scene, and click the shutter. The eye isn't fooled for long; we quickly realize that the man is in the foreground, the Eiffel Tower in the background, and that's all there is to it.

2 With Elements, however, we can photograph the man separately and cut him from his background. Now, as a separate layer ('Man'), we can position him within the scene as if he's standing on the same plane as the tower. But it's still not very convincing; the two elements look artificial, and there's little sense that he's really in the frame.

3 We can fix this by tucking the man behind the Eiffel Tower, which will make him look very much more part of the scene. But the tower is a fiddly, awkward object, full of holes – how can we make the man appear to be behind it? Begin by hiding the man (click on the eye next to his name in the Layers palette) so just the background is visible.

4 As you'll see, when you click on the small icon, the man disappears from the main image on your screen, leaving just the background image visible. To ensure that you can begin working on the background image, make sure you click on it.

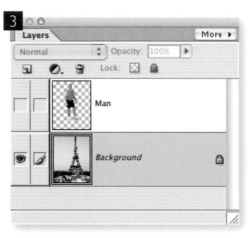

6

5 We now need to separate the tower from the sky. Using the Magic Wand tool, click in the sky beside the tower. A patch of sky will be selected that matches the colour we first clicked on. But there's still an unselected patch at the top: we need to add that to our selection.

6 To add to a selection, hold the Shift key and click with the Magic Wand tool at the top of the sky. That portion will now be added to our original selection.

7 We now need to select the rest of the sky. We could do this by holding the Shift key as we click on every other visible portion of sky – but with all those holes in the Eiffel Tower, that would be an horrendous task. There's an easier way! Go to the Select menu, and choose Similar.

8 Now, all the colours in the picture that match those we first clicked on will be selected – including the sky seen through the tower.

8

7

| Select | Filter | View | Wi |

All	⌘A
Deselect	⌘D
Reselect	⇧⌘D
Inverse	⇧⌘I
Color Range...	
Feather...	⌥⌘D
Modify	▶
Grow	
Similar	
Transform Selection	
Load Selection...	
Save Selection...	

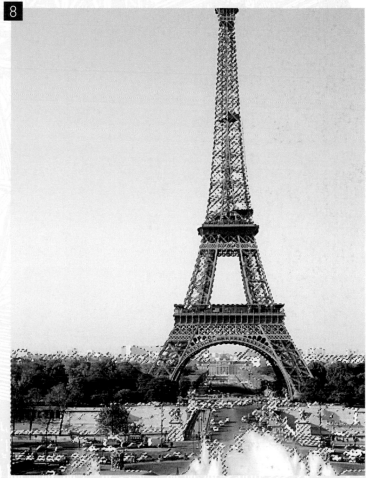

PARISIAN GIANT

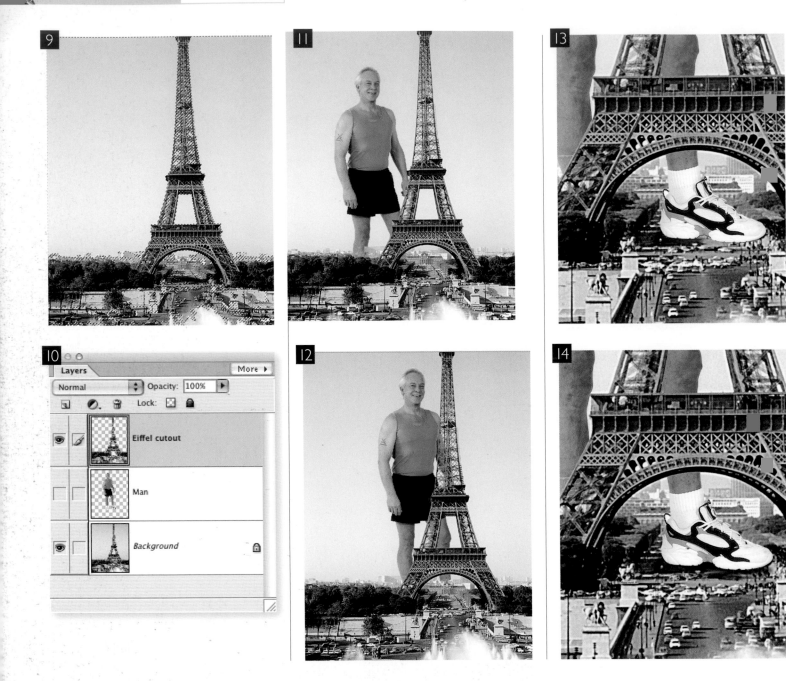

TIP Selecting the sky with the Magic Wand requires an appropriate Tolerance setting for the tool. This is chosen from the tool Options Bar, at the top of the screen: the higher the tolerance, the greater the amount of sky that will be selected. Begin with a value of 32, which works for most purposes. Remember, you can always hold the Shift key to add to your selection.

9 But what we have selected at the moment is the sky: what we want is the tower – the precise opposite of what's already selected. Go to the Select menu again, and choose Inverse: this will reverse the selection, so that everything except the sky is selected.

10 Now choose *Layer > New > **Layer via Copy*** to make a new layer from this selection. In the Layers palette, drag it to the top so that it appears in front of our man and rename it 'Eiffel cutout'.

11 When we click the eye icon next to the man's layer in the Layers palette, we can see that he is now tucked behind the tower – and, already, he looks far more part of the picture. But there's more to it than that.

12 We can now move the man around, and he'll always appear behind the tower: all that sky has disappeared from the layer copy, making the Eiffel Tower a truly transparent object. But there's a problem at the bottom: his leg stands behind the distant buildings, which makes him appear to be too far away. We need to bring that leg forward.

13 Switch to the Eiffel cutout layer, and carefully erase the buildings where his foot appears through the archway. Now his leg is brought firmly in front of those background buildings, and he looks as if he's standing directly behind the tower.

14 All we need to do now is to add a shadow beneath his foot to make it look more firmly planted on the ground. You can paint this directly on the tower layer, but to avoid making mistakes, it's best to make a new layer, and paint on there. Use a soft-edged brush, set to black, and paint at 50% Opacity for more control.

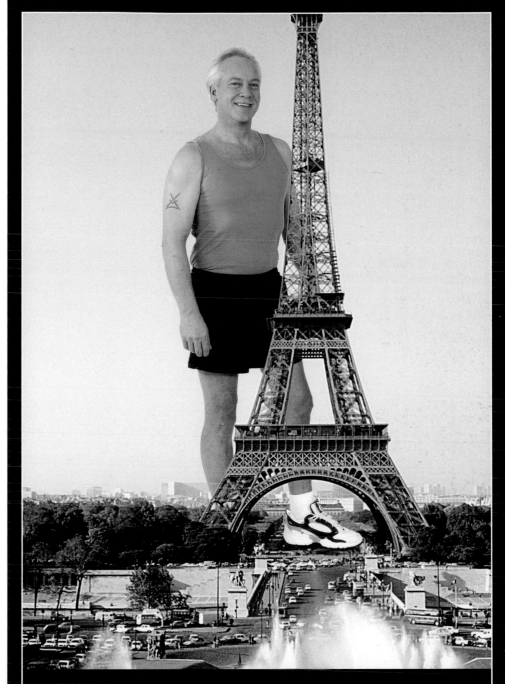

And here's our Parisian giant in all his glory: the effect is much more satisfactory than the opening shot – he looks like he is standing just behind the Eiffel Tower, but in front of the buildings in the background.

MATCHBOX CITY

If you've ever been or known a six-year-old boy, you won't be easily surprised by anything found in a matchbox. But what about a whole city? To make this effect work best, start with a cityscape photographed from a reasonably high and distant vantage point, so that the buildings already appear relatively small rather than towering over the viewer. It's easy to set up and shoot the matchbox yourself.

1 This shot of central San Francisco was taken from the top of the Westin St. Francis hotel. It's a bit misty, but that can be fixed with the usual adjustment tools. Don't do this yet: it'll be easier and more efficient to tweak both images at the end of the task, when we can compare their tone side by side.

2 A hand holding the matchbox will help to make it seem real and immediate, as well as providing another indication of scale to heighten the incongruity. For the hand, one option might be to use a small and suitably muddy hand with a backdrop of a school desk. In this case, a sheet of white paper has been used for a plain background that we can cut out later if necessary. Frame the matchbox carefully so that its angle and lighting match the cityscape as closely as possible.

3 Using the Move tool (shortcut V), drag the cityscape onto the matchbox photo. It becomes a new layer called Layer 1, as we can see by opening the Layers palette from the Palette Bin. First we'll change the layer's name to 'City', and then its blending mode from Normal to Overlay so that we can see the matchbox through the city.

Holding Shift to preserve the aspect ratio, drag the corner handles to scale the image so that a group of buildings fits reasonably neatly into the open part of the box. To adjust perspective where necessary, hold Ctrl in Windows or Cmd on the Mac and drag a corner to distort. The cursor shows a grey, tailless arrow.

TIP It's easiest to combine the two images convincingly if the matchbox is lit as seen here, with the part under the lid disappearing into shadow and the visible inside edges in a position where the buildings would cast shadows onto them. Turn the matchbox in relation to the light source so that you can make this the case while also matching your city photo.

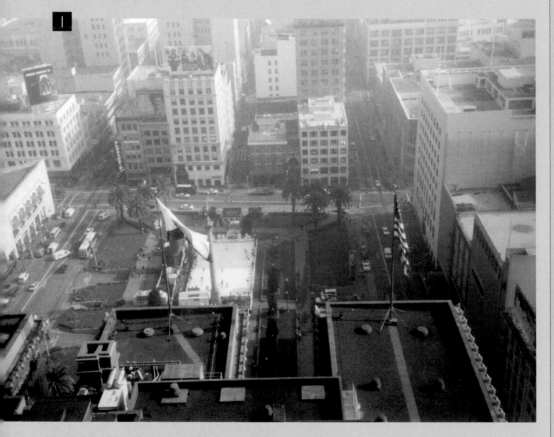

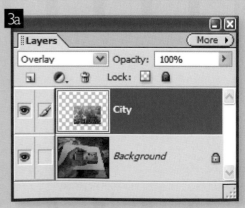

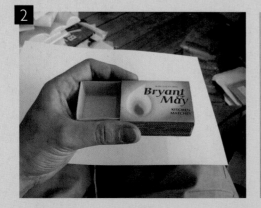

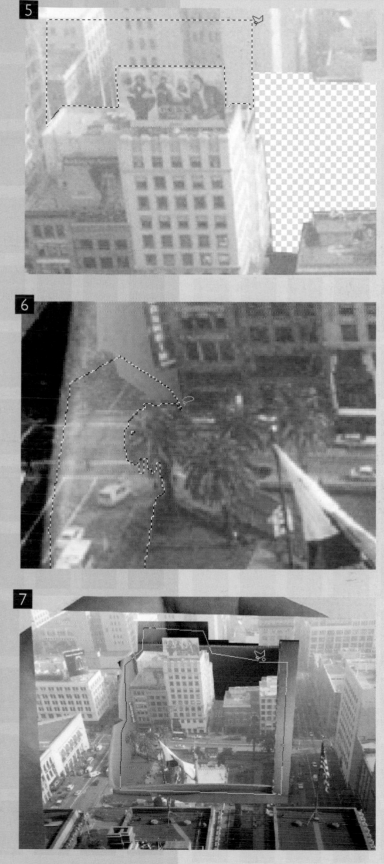

4 The hard part is cutting out the buildings. There's little point in trying to do the job with a single selection. Instead, take it one chunk at a time. Zoom in to 100% or more for accuracy, and use the Polygonal Lasso tool: press L for the Lasso, then click the Polygonal icon second from left in the Options Bar. We can now click, let go, and click again to draw a series of straight lines around an area – ideal for straight-sided buildings. Draw around just one section that we need to remove, for example between two buildings, including a few small features to preserve realism. Then clear the area (shortcut Delete in Windows, Backspace on the Mac) so that it becomes transparent.

5 Where the city image is light in tone, it may be easier to turn off the Background layer (click its eye icon in the Layers palette) while you select and clear areas.

6 Revert to the standard Lasso tool (click the first icon in the Options Bar) to draw freehand around irregular shapes such as the palm tree here. While using it, holding Alt will switch to point-to-point mode where you need a straight line, such as along the edge of the matchbox.

7 Once you've cleared away an area all around the buildings, you need to delete the remainder of the city image outside this. Use the Polygonal Lasso to draw roughly around the cleared area, staying within its bounds, then invert the selection (shortcut Ctrl+Shift+I in Windows, Cmd+Shift+I on the Mac) and clear.

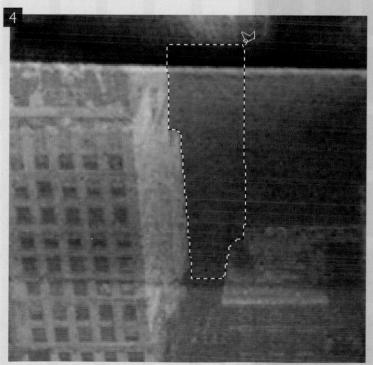

MATCHBOX CITY

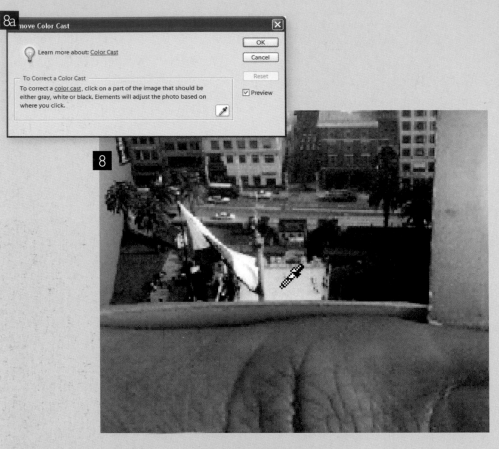

8a — Remove Color Cast

Learn more about: Color Cast

To Correct a Color Cast

To correct a color cast, click on a part of the image that should be either gray, white or black. Elements will adjust the photo based on where you click.

OK Cancel Reset ☑ Preview

8 The city and matchbox will most likely have different colour casts, particularly as we shot the matchbox under artificial light. A quick way to address this is using Color Cast Correction. With the city layer active, go to *Enhance > Adjust Color > Color Cast*. We're then instructed to click the eyedropper on an area of the image that should be white, grey or black: in other words, colour-neutral.

White is often the easiest to identify, but don't click somewhere that's already pure white because the exposure has blown it out, such as on the flag. Instead, we're going to choose a spot that represents the image's colour cast: here, the image is generally bluer than the matchbox photo, and this is typified by the colour of the ice rink behind the flag. Click a few different points and judge the results by eye.

9 Now we can run Auto Contrast or make a manual Levels adjustment to finish off either or both images. For a final touch to integrate the city with the matchbox, we can also add some shadows. The shadows of the buildings would fall on the inside of the matchbox, so click Background layer in the Layers palette. We can paint shadows onto this manually, using a black medium soft brush in Multiply or Hard Light mode. Alternatively, we can use the following method to save ourselves some work.

Holding Ctrl in Windows or Cmd on the Mac, click Layer 1: this loads its non-transparent area (the buildings) as a selection. Drag the selection, or nudge with the cursor keys, a suitable distance in the direction the shadow should fall, in this case down and to the left. Feather the selection by a couple of pixels (Ctrl/Cmd+H) to soften the shadow. Now we hold Alt as well as Ctrl or Cmd while clicking the 'City' layer again: this subtracts the original selection, leaving only the area where the shadows should go.

We can now easily identify any areas that shouldn't be included, such as the lower section of the box, which would be in front of the buildings. Remove this by holding Alt and drawing around it with the Lasso.

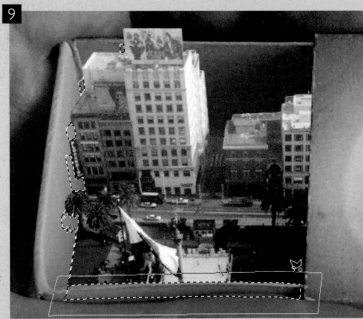

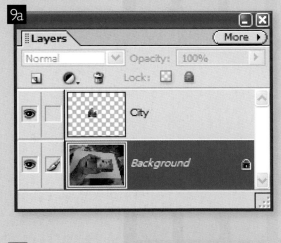

9a — Layers

Normal Opacity: 100%

Lock:

City

Background

9b — Feather Selection

Learn more about: Feather Selection

Feather Radius: 2 pixels

OK Cancel

10 To darken the selected area, open Levels (shortcut Ctrl/Cmd+L) and drag the middle Input Levels slider to the right.

Shadows cast by the matchbox onto the city are slightly more complicated. Here, the building on the far right would be in the shadow of the box lid, but the shadow must follow the shape of the building: parallel with the lid across the top, which lies in the same plane, then diagonally across its front elevation, which is at right angles. We can draw this shape by hand with the Polygonal Lasso, and then shade it the same way using Levels again.

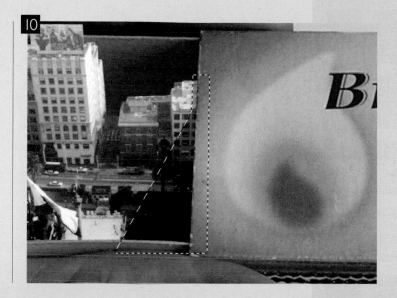

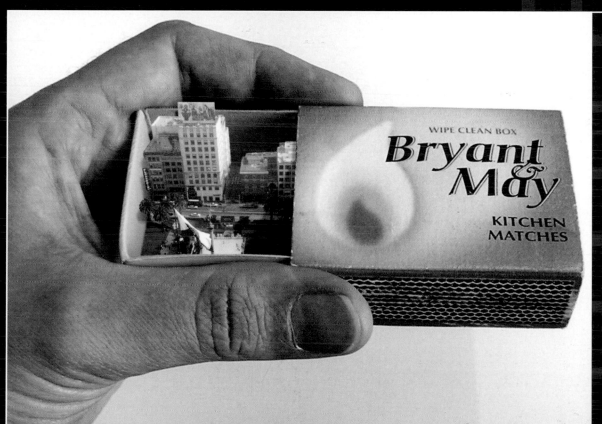

We were pretty pleased with our final image; but a backdrop of a school desk or notebook would have worked really well, too. It would be great to create a similar effect with say a herd of giraffe or bison – the possibilities are endless.

BEHIND CLOSED DOORS

In Elements, it's easy to play around with the scale of objects to create interesting or wacky images. One way to do this is to duplicate certain elements in an image and repeat them at different scales. Here's how.

1 Here's our starting image, quite nicely proportioned and composed. What we want to do is make copies of the doors on the right wall. However, there's some cleaning up to do first in order to give us a nice blank surface on which to work.

2 Using the Polygonal Lasso tool (press L for the Lasso, then click the Polygonal icon second from left in the Options Bar) make a selection that traces the corner edge of the wall from the top to the bottom of the image, and just to the right of the steps.

3 Next, hold the option key down to subtract from the bottom part of the selection. We're going to follow the existing edge of the floor and extend it right across the bottom of the wall, and then we make a rough selection of the lower part of the original selection and we're left with the selection we need.

4 Now using the Clone Stamp tool (shortcut S), we're going to clone out the wall detail giving us a blank surface to work on. Take samples by holding the option key down and clicking on a plain part of the wall, then painting that sampled point over the parts of the wall you want to delete using a medium, soft brush. To smooth any irregularities, apply the Gaussian Blur filter to the wall selection using a value of 1 or 2. Repeat if necessary.

5 To keep things simple, next we erase the drop in level of the floor. Make a selection that traces the edge of the floor around the corner of the wall. Extend the selection along the back wall and down over most of the floor at the bottom left of the image.

6 Using the Clone Stamp tool again, we erase the bottom of the wall and the drop using samples from other parts of the floor. Here we've also cloned out the portion of the wall detail that wraps around the front face using a small brush radius.

7 So that we get the perspective right, draw a set of vanishing lines on a new layer using the Line tool option from the Custom Shape tool set (shortcut U). Trace and extend vertical and horizontal lines that are already in the image, such as the door frames, wall edges, and floor.

8 Make a selection for the door using the Polygonal Lasso tool. Trace just the outline of the top of the door cutting off the inside of the reveal – when we move the door lower down, the reveal shouldn't be visible at that angle. Also cut off the steps. Copy and paste the selection so that the door becomes a new layer.

9 Switch to the Move tool (shortcut V). Make sure Show Bounding Box is enabled in the Options Bar so that you can scale and distort the door to the desired size and perspective. Shift-drag a corner handle to scale it down proportionately. Now we rotate the door so that the bottom edge is parallel with the floor/wall edge by dragging outside the bounding box.

10 Hold the Cmd key and drag the top left corner of the box to distort the door using the perspective guides we drew earlier as a guide. Drag the top middle handle to skew the door and make the vertical edges parallel with the guides. We'll need to tweak the rotation, skew, and distortion to get the desired results because changing one will affect the others.

11 To make the smallest door, duplicate the door layer by dragging it to the 'Create a new layer' icon at the top left of the Layers palette. Use the transformation handles on the bounding box (make sure the Move tool is selected) to scale and distort the door into the desired perspective. Finally, trim away the parts of the door that overlap the floor using the polygonal selection tool and the delete key. You can also trim the top edge of the smallest door to allow for the lower viewing angle.

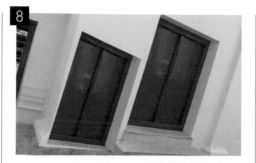

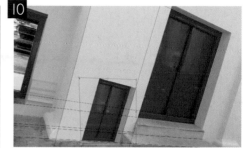

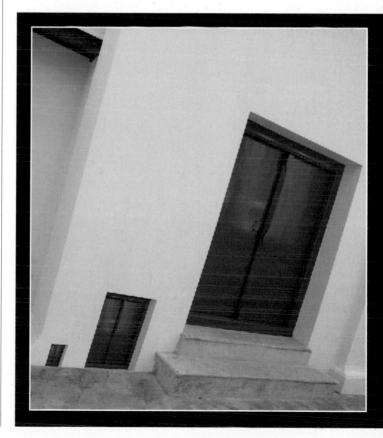

In the final image, we have cropped the image and cloned out the window to the far left. The final result is a very curious building indeed.

Having fun with size, proportion, and scale can lead to some pretty amazing results when combining images in Photoshop Elements. Here, we'll show you how to take a few simple images and create a giant man on the moon fending off an asteroid.

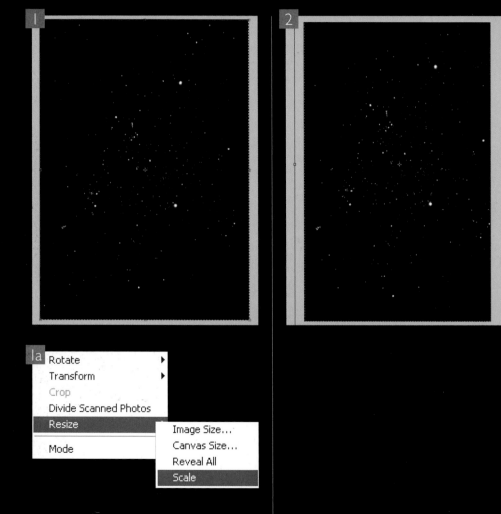

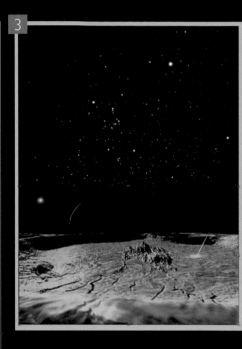

1 We'll start first with the stars image, this will be our outer space scene background. However, we want the stars to be a little larger within the current canvas areas. Choose *Select* > *All* (shortcut Ctrl/Cmd+A) from the menu to select the entire contents of the background layer. Then select *Image* > *Resize* > *Scale* from the menu. A bounding box will appear around our selected background area.

2 Hold down the Shift key on the keyboard. This will ensure that as we scale the contents of the bounding box the aspect ratio of the horizontal to vertical is preserved and any scale adjustments will preserve the current proportions. Click on a corner point and drag it outward to increase the size of the bounding box contents. Let go of the Shift key and then click and drag anywhere inside the bounding box to reposition the contents on the canvas.

3 Open up the moon image. Select the Move tool (shortcut V) from the Toolbox. Click on the moon image with the Move tool and drag it over into the stars file to bring it in as a new layer. Now rename the layer 'moon'. Because we are using the Move tool, you'll notice that a bounding box appears automatically around the current layer's contents.

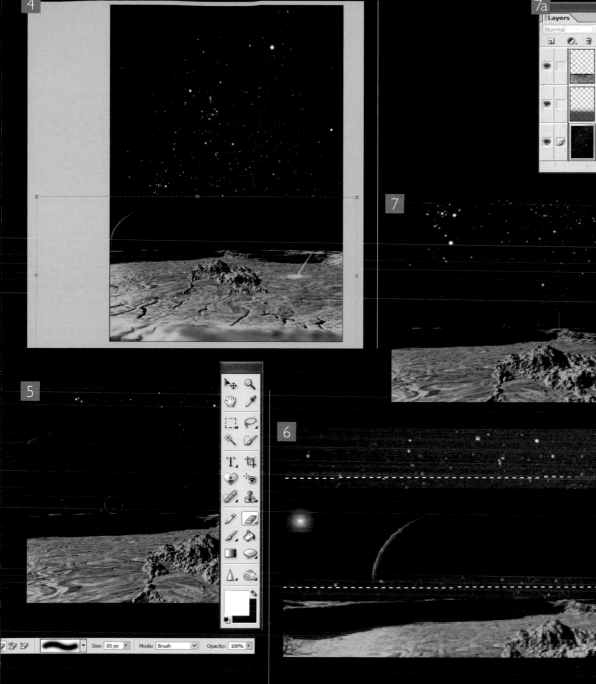

To orientate the moon image with the stars image, we need to click inside the moon's bounding box and drag the image a little to the right. Select the middle bounding box handle on the right side and pull it outward to increase the horizontal scale of the box contents. Click and drag to the left inside of the box to move the contents of the box over to the left a little.

Drag the box down slightly and select the Eraser tool (shortcut E) from the Toolbox. As soon as you select the Eraser tool, the bounding box will disappear, applying the scale function to the box contents. Choose a hard, round brush preset from the Options Bar and ensure that the Opacity is set to 100%. Zoom in closely on the horizon of the moon's surface. Carefully begin to erase the black area just above the surface, coming right up to the edge of the surface, but being careful not to remove any of it.

Use the Lasso tool (shortcut L) to draw a rough selection around any remaining sky area on the moon layer and press the delete key to delete it. Choose *Select > Deselect* (Ctrl/Cmd+D on the keyboard) to deselect the Lasso selection.

Click the 'Create a new layer' icon at the top left of the Layers palette and drag the new layer below the moon layer; rename it Gradient. Select the Gradient tool from the Toolbox (shortcut G). In the Options Bar, select the Linear Gradient and the Foreground to Transparent option, with Opacity set to 50%. Hold down Alt/Option and click on a dark shadow on the moon surface to sample it, specifying it as the current foreground colour. On the Gradient layer, click and drag upward, slightly above the horizon line to create a dark haze effect on the background. Click and drag more than once if the effect isn't drastic enough.

GIANT MAN VERSUS ASTEROID

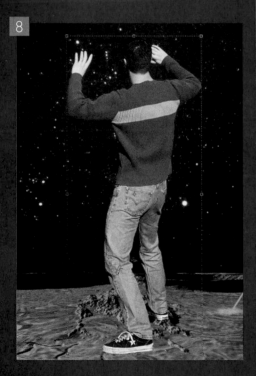

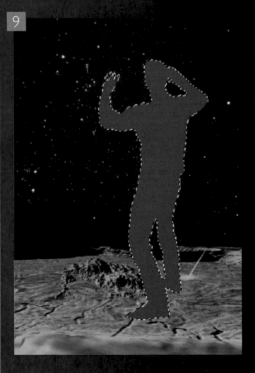

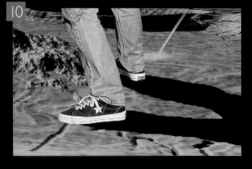

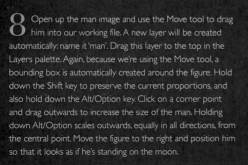

TIP When creating a shadow layer, the Multiply blending mode is usually the best candidate for simulating the way in which shadows darken colours naturally. Multiply mode analyzes the colour information present within the RGB channels, then it multiplies the base colour by the colour on the layer. The result is always a darker colour, unless the colour on your layer is white, then there is no change at all.

8 Open up the man image and use the Move tool to drag him into our working file. A new layer will be created automatically: name it 'man'. Drag this layer to the top in the Layers palette. Again, because we're using the Move tool, a bounding box is automatically created around the figure. Hold down the Shift key to preserve the current proportions, and also hold down the Alt/Option key. Click on a corner point and drag outwards to increase the size of the man. Holding down Alt/Option scales outwards, equally in all directions, from the central point. Move the figure to the right and position him so that it looks as if he's standing on the moon.

9 His vivid colour makes the man look a little out of place, so hold down the Ctrl/Cmd key and click on his layer icon in the Layers palette to generate a selection surrounding him. Next we need to create a new layer by clicking on the new layer icon as before, and name it 'colour'. Use the eyedropper tool to sample a grey colour from the moon's surface. Press Alt/Option+Delete to fill the selection on your new layer with the current foreground colour. Change the blending mode of the layer to Color in the Layers palette. Reduce the Opacity of the layer to 60% to lessen the effect slightly.

10 Create another new layer (call it 'shadow') and drag it below the 'man' layer in the Layers palette. Use the Lasso tool to draw the rough outline of a shadow on the ground. Sample a black foreground colour using the eyedropper and fill the shadow shape on the new layer with the sampled colour. Choose *Select > Deselect* (shortcut Ctrl/Cmd+D) to deselect the current selection.

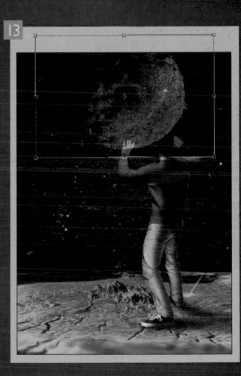

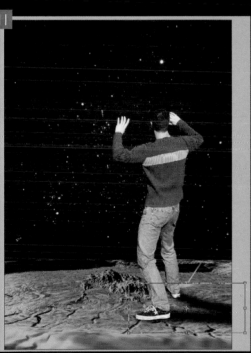

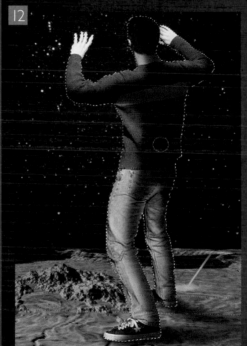

11 With the 'shadow' layer still selected, select *Filter > Blur > Gaussian Blur* and enter a radius large enough to substantially blur the edges of the shadow. Next, change the 'shadow' layer's blending mode to Multiply and reduce the Opacity to 50%. Select *Image > Resize > Scale* from the menu. Drag the midpoint on the right side of the bounding to the right, off the canvas area, to slightly increase the horizontal scale of the shadow. Press Enter or click the tick icon in the Options Bar to apply the scale adjustment. Select the Eraser tool, use a large soft brush tip and a very low Opacity setting to erase some of the shadow that falls off to the right.

12 Ctrl/Cmd-click the 'man' layer in the Layers palette to generate a selection from it. Create a new layer (called 'figure shadow') with a Multiply blending mode and an Opacity setting of 80%. Move the layer to the top of the palette and select the Brush tool (shortcut B). Use a soft brush tip and a black foreground colour to add some shadow to the figure inside the selection. Just because he's a giant doesn't mean that he shouldn't appear as if he belongs in the scene. Press Ctrl/Cmd+D to deselect the current selection.

13 Open up the asteroid image. Use the Move tool to drag the asteroid into the working file as a new layer (called 'asteroid'). Move the asteroid to the top of the layer hierarchy in the Layers palette and reduce the Opacity of the asteroid layer so that we can see the imagery underneath it. Click inside the bounding box and drag the asteroid up to the top of the image, then hold down Alt/Option+Shift. While holding these keys down, drag the corner point inwards to reduce the size of the asteroid. Press Enter to apply the scaling effect.

14 Return the layer to full Opacity and select the Eraser tool (shortcut E) with a hard, round brush tip and an Opacity setting of 100%. Begin to carefully erase all of the areas on the asteroid layer that do not belong to the actual asteroid itself. Take your time and decrease the size of your brush tip if need be to carefully isolate all of the details of the asteroid from the background.

15 When you have finished with the Eraser, move the 'asteroid' layer down in the Layers palette so that it is below the 'man' layer. Because the colour of the asteroid is less blue than the rest of the grays within the image, with the asteroid layer selected, select *Enhance > Adjust Lighting > Levels* (Ctrl/Cmd+L) from the menu. Select the Blue channel from the pull down menu and move the middle slider of the input levels slightly to the left.

16 Drag the "asteroid" layer onto the "Create a new layer" icon at the top of the Layers palette to duplicate it. Change the blending mode to Lighten and reduce the Opacity to 60%. Use the method we have used previously to reduce the size of the asteroid on the duplicated layer and move it up and to the left. Select the Eraser tool, and with a large, soft brush and low Opacity setting, gently erase areas of the layer that are too strong. Duplicate this layer, reduce it, move it up and to the left, erase it, and repeat. Repeat this process until you have created the illusion of movement toward the figure.

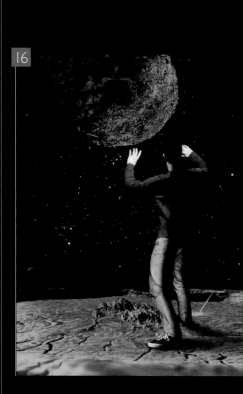

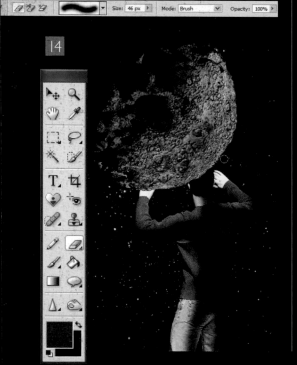

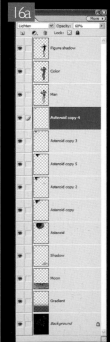

And here's the final asteroid attack image. The secret of this particular project was to emulate the muted colours and strong shadows that we would expect to see on the moon.

THE BIG CATCH

Naturally, there's a huge amount of fun to be had playing around with scale in Photoshop Elements, but there are times when to achieve a really specific effect, such as 'The Big Catch' by Todd Pierson, you need to do a lot of preparatory work to get the result you're after. Much of Todd's work is based around preplanned images, which are then carefully put together to create the final result. Here, Todd takes us through another of his highly effective and amusing visual jokes that have made his work hugely popular in both Europe and the United States.

1 We begin with photographing the children. For this project, the models were photographed separately because of the difficulty of giving instructions and getting the right expressions when shooting two kids at once.

2 Open the image of the boy. Now open the shot of the girl and make a rough selection of her and the dock and drag this over to the shot of the boy. Reduce the Opacity so you can line the piers up with each other. We can use a Levels adjustment to add some contrast to the boy image so it matches the shot of the girl.

3 Use the Eraser tool (shortcut E) with a large brush and erase the hard line that was made from putting the images together. With the Clone Stamp tool (shortcut S) clone out the bag at the end of the dock and the two white poles at the end of the girl's dock.

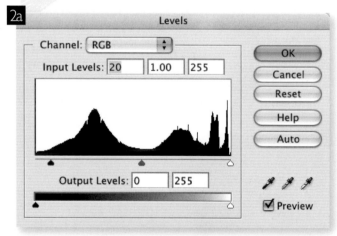

Levels

Channel: RGB

Input Levels: 20 1.00 255

OK
Cancel
Reset
Help
Auto

Output Levels: 0 255

☑ Preview

4 Now, if you notice, the little boy is holding a clamp on the end of his fishing line. The clamp was used so the boy could be holding something and to keep the line taut. We had a real fish, but it was too big, so we shrank it down in Photoshop. Open the image of the fish, select the white background using the Magic Wand tool (shortcut W) and feather the selection by 1 pixel. To select the fish instead of the background go to *Select > **Inverse*** (Ctrl/Cmd+Shift+I) and drag the fish onto the image of the boy and place it over the clamp.

5 Now the fun part begins. Open the large fish image which is on a layer by itself, follow the same moves as with the small fish, and place the big fish on the dock. This fish was shot on another day. As I held the fish, my wife fired the shutter. We ended up shooting maybe 30 different angles to make sure we had enough to choose from. The right angle and perspective is critical here.

6 Next we have to line the fish up on the dock. The gaps in the fish are already cut out to fit just right. You may have to clean up around the edges or on the dock pole.

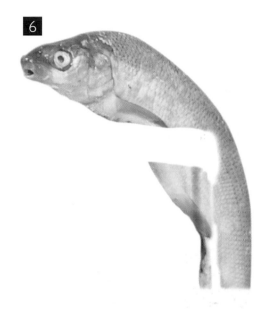

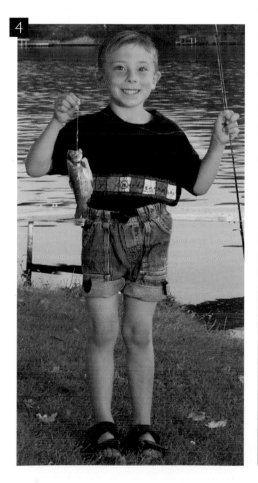

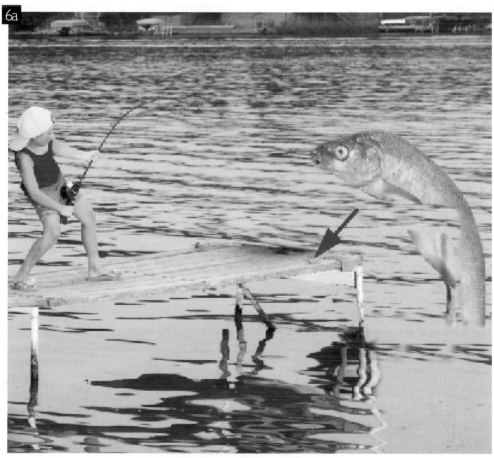

THE BIG CATCH

7 I left out two details when shooting this image. First is the fact that there would be water on the pier from the fish as it was being landed, and second, there would be a 'plume' of water with rings of water disturbance around the fish. So I shot these details in another lake and on a friend's deck.

8 Open the 'rings of water' image and place it around the fish. Next open the 'water on the pier' image and place it on the pier.

9 Now we need to open the fish reflection and place it in the water. Reduce the Opacity to about 50% then flatten the image and work on smoothing out the lake in the background where the two initial photos had slightly different water 'roughness' due to boat traffic. What I did here was use a very thin brush size and cloned in slivers of water from the light and dark areas. Then slightly blur that area so it blends into the surrounding water. Clone out the poles in the water and on the pier that look like they go nowhere. These are poles that boats are moored to, and they just cluttered up the image.

10 Finally, with a one-pixel brush, draw a white line from the end of the fishing pole to the large fish's mouth. There was a line there to bend the pole, but you can't see it.

We think the final result is a great image. The attention to detail has really paid off, helping us to focus on the boy's oblivious expression.

effects with colour

RESPRAYING A CAR

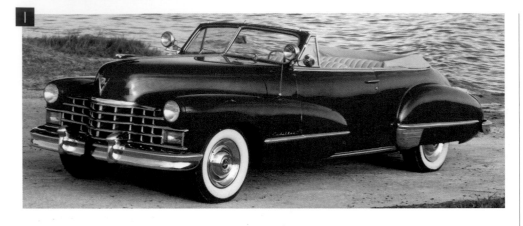

1

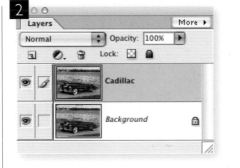

Respraying your car a different colour can be a costly business — especially if you don't know what colour you want. Here's an easy way to choose exactly the right shade before a trip to the body shop.

2

1 Here's our classic automobile, a vintage Cadillac in bright cherry red. Let's see how it would look in a different hue entirely.

2 Begin by duplicating the background layer: grab it in the Layers palette and drag it onto the 'Create a new layer' icon to make a copy, then rename it 'cadillac'. It's always worth working on a copy rather than the original when making sweeping changes to an image, just in case something goes wrong and you need to revert to it later.

3 We're going to change the colour of this car using *Enhance > Adjust Color > **Replace Color***. When this dialog pops up, click anywhere on the red body of the car: you'll see a white indication within the black preview of the range of colours selected.

4 The Fuzziness is the tolerance of the tool: the greater the Fuzziness level, the wider the range of similar colours that will be included. Although it might seem like a good idea to simply raise the fuzziness to capture the whole car, it makes more sense to keep this value low — around 40 works well — or you'll start selecting unwanted colours from the background as well.

5 Drag the Hue slider away from the centre — it doesn't really matter where you drag it to at this stage. The purpose is only to change the colour of the selected area of the car, so you can see what you're doing and which parts of the car are affected.

3

4

5

TIP

Experiment with the Fuzziness settings if you need to expand the range – for example, if there's a blurred element you need to alter within the picture. But beware of dragging it too far, or you'll lose control of the operation.

6 Here's the car with its changed colours so far. We can see that only a small part of its bodywork has been affected. To extend the range, hold the Shift key and click on an unchanged portion of the car – either on the preview within the Replace Color dialog box or on the car itself while the dialog is open.

7 The more times we click in different places with the Shift key, the more red on the car is changed to our new colour. Here's the situation after a couple of Shift-clicks: the car is now turning a lurid shade of green.

8 Here, we've clicked once too far. By clicking inadvertently on the reflection of the sky in the car's bonnet, we've added a shade of gray blue that appears throughout the image – in the sky, on the ground, even in the grass.

9 When we look at the dialog box, we can see the extent of the damage: the affected area, shown in white, covers a large part of the image. The solution is to hold the Alt/Option key and click (or click and drag) in an unwanted area, such as the ground beside the car. That will remove those colours from the selected area.

10 This is about as far as we can get with adding and subtracting colours. We haven't managed to change the entire car yet, but we can fine-tune it later. In the meantime, let's look at the colour itself. Time to lose that bright green and replace it with something more tasteful.

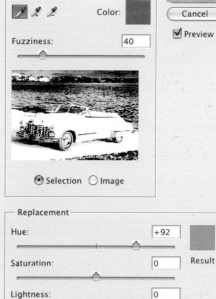

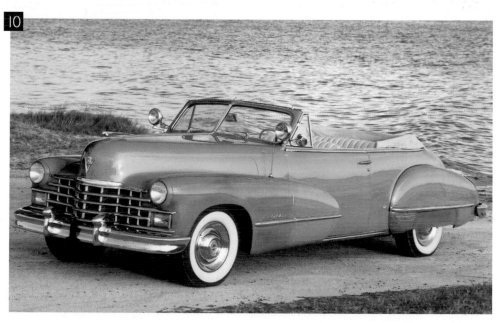

RESPRAYING A CAR

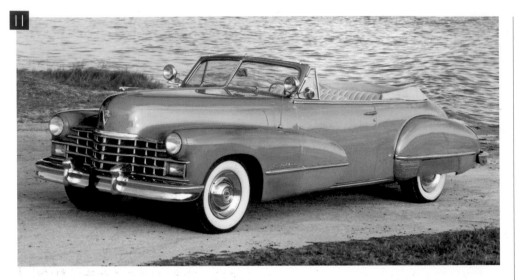

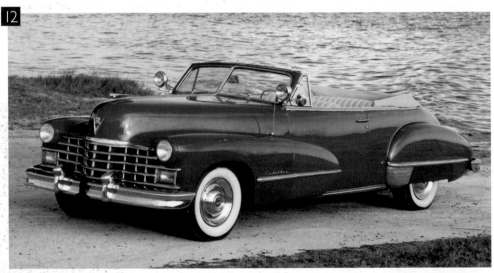

11 How about turquoise? Dragging the Hue slider all the way over to the right will change the colour to this authentic 1960s hue that suits the bodywork well. The trouble is, it's now rather at odds with the blue of the water behind it: let's drag the Hue slider some more.

12 Here's a good solution. Dragging the Hue slider to a value of -40 has produced this sophisticated deep pink, which looks really good against all that chrome and white upholstery. We're done with the Replace Color dialog for now, so click OK to return to the image.

13 Unfortunately, some parts of the car that we didn't want changed became recoloured – the upholstery and the white wheel trims, for example, now have a distinctly pinkish tint that wasn't there before. One option would be to reopen the Replace Color dialog, taking the trouble to omit those shades – but there is an easier way.

14 Remember we decided to work on a copy of the original rather than the original layer itself? Well, now we can see why. All we have to do is to erase those parts of this layer that we don't want to see – in other words the areas in which the colours were changed by mistake – and we'll be left with the original image (and therefore colours) showing through underneath.

15 There are still some parts of the car we didn't recolour fully, however – remember, we couldn't capture them with the Replace Color dialog because we picked up the sky as well. We can change the colour of small areas using the Brush tool (shortcut B): but first change its blending mode from Normal to Color in the pull-down Mode menu in the Options Bar.

16 Now sample a colour from within the car with the Eyedropper tool (shortcut I), and use the Brush tool with a small brush to paint the colour in where we want it. The smaller the brush, the more precise we can be: and because the brush is set to Color, it won't affect the luminosity of the image.

TIP If you untick the Preview button within the Replace Color dialog window, you'll see the image as it was before you started messing around with the colours. Useful for making before-and-after comparisons!

Here's our car, entirely recoloured. Once you're familiar with the process, it doesn't take very long to do – so it's easy to try several different variations and see which appeals to you most.

ORANGES AND LEMONS

As we've seen, one of Elements' most useful features is the ability to precisely control colour, and change it entirely if necessary. Of course, you can do this to achieve wild and wacky results if you wish, but perhaps what is even more impressive is being able to change colours subtly so that no one would ever know you've done it.

1 Begin by opening the lemon and orange images. Imagine we want to create an image of a lemon cut in half showing the ripe, juicy flesh, but we only have a photo of a whole lemon, and the cut end of an orange. For Elements this is not a problem, we can simply combine the two and correct the colours to make it look like a seamless whole.

2 First we go to the lemon file and make a copy of the background layer (call it 'lemon') by dragging it to the 'Create a new layer' icon at the top left of the Layers palette.

3 Use the Magic Wand (shortcut W) to select the white around the lemon and delete it by pressing the Delete key. Hide the background layer by clicking on the eye icon to see the result properly. Transparent pixels are shown as a light grey checkered pattern in Elements – you can imagine this being the pattern of the pasteboard on which you are working, and now that we have removed the white pixels, we can see right through to it.

1

1a

2

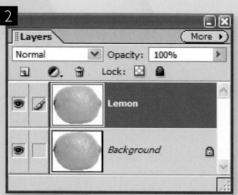

3

4 We can put the cut orange on the lemon now, but it will make it look twisted if we don't remove the stalk at the end. At the angle we're creating, this would be out of view. So first make a selection using the Elliptical Marquee tool (shortcut M), holding down the Option key to size the lemon to the marquee from its centre; this way we can create a smoothly rounded end for the lemon.

5 We can move the selection to position it more accurately by dragging inside it. Once that's done use the Clone Stamp tool (shortcut S) to remove the green stalk from inside the selection.

6 Go to *Select* > **Inverse** (or type Ctrl/Cmd+Shift+I) to invert the selection, then using the Eraser tool (shortcut E), with a medium-sized soft brush remove the stalk that's now outside the lemon. Press Ctrl/Cmd+H to hide the selection to make sure the result merges smoothly with the rest of the lemon.

7 Next we need to clean the lemon by removing the specks. Choose *Enhance* > *Adjust Color* > **Replace Color**, zoom into the image, and click inside one of the dark specks. Concentrate just on the left side of the lemon because we'll be deleting the right half. Once selected, use the control in the dialog panel to make the specks less visible. When you've finished, click OK.

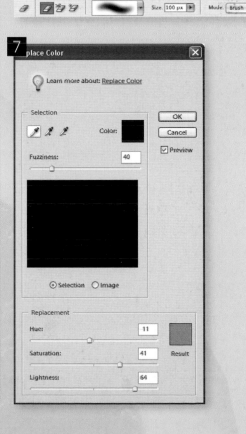

ORANGES AND LEMONS

8

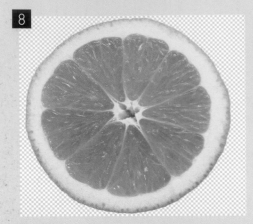

8a

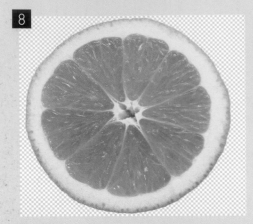

8b

8 Now we return to the image of the orange and select the white using the Magic Wand tool. Invert the selection as before (Ctrl/Cmd+Shift+I), and copy and paste the orange to a new layer (call it 'orange'). This does the same job as steps 2 and 3 earlier and shows there is always more than one way to accomplish something in Elements. Drag the new layer from the Layers palette into the lemon document's window and drop it there.

9

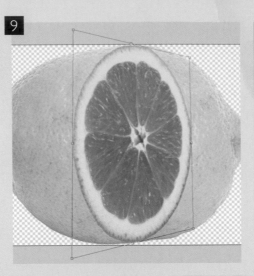

9a

9 Use the transform bounding box to resize the orange. Squashing it horizontally is not enough to make it look as if it is viewed on a slant, you need to add perspective distortion. To do this, hold the Ctrl/Cmd+Option+Shift keys down and drag the top or bottom right corners of the bounding box. To prevent the handles from snapping to the document edges go to *View* > *Snap to Grid* to untick this option. Finally, resize the orange so that the top and bottom edges are flush with those of the lemon. Accept the transformation by pressing Enter, or by clicking on the tick icon in the Options Bar.

10 Ctrl/Cmd-click the 'orange' layer to select the outline of the orange. Invert the selection as before, select the lemon layer, and delete the right half of the lemon with a large, soft Eraser tool.

TIP Even if you're only working with two or three layers, it's good practice to get into the habit of naming your layers. It doesn't take too many layers before you get confused about which is which. You can easily rename any layer by clicking in the layer thumbnail in the Layers palette and typing in the new name.

10

11 Choose Hue/Saturation from the 'Create adjustment layer' icon at the top of the Layers palette. Move the Master Hue to turn the orange yellow, and adjust the Saturation control until it matches the colour of the lemon skin. The image is still a bit orange, so we simply add another Hue/Saturation adjustment layer and move the Hue slider to the left slightly to make the overall colour resemble that of a fresh lemon.

11a

11b

11c

The finishing touch is to resize the canvas to give the hybrid fruit more space and add a drop shadow, tinting this brownish-yellow using another Hue/ Saturation adjustment layer.

CROSS-PROCESSED PORTRAIT

'Cross-processing' is a wet photography trick in which film is developed in the 'wrong' kind of chemical solution – for example, slide-processing fluid for colour negatives, or vice versa – so that colours are generated differently. The result is a photo with unexpected colours and often high contrast. Similar effects can be created by manipulating the red, green, and blue 'channels' that make up a digital colour image. But one of the few limitations of Photoshop Elements is that it doesn't support colour channel editing. Here's how to enhance your photos with cross-processing effects using layers instead.

1 Start with any ordinary, well-balanced colour photo, and rename the background layer 'blue'. Now we need to duplicate the entire image into two new layers. Go to *Layer > Duplicate Layer*, and name the new layer 'green', then repeat the process but naming the third layer 'red'. Check that you have three identical layers in the Layers palette. The top one is currently highlighted.

2 With the 'red' layer still selected, we then select *Enhance > Adjust Color > Color Variations*. Here we're shown how the picture will look with red, green, or blue added or subtracted. Click Midtones, so that our changes affect the central range of colour values in the image (as opposed to the darkest or lightest areas), and adjust the Color Intensity slider to maximum. Then click on Increase Red, and Click OK to confirm.

3 Now we need to select the 'green' layer in the Layers palette and go into Color Variations as before. This time we're going to click Increase Green.

4 Finally, select the 'blue' layer and this time use Color Variations to increase the blue component. We should now see the three thumbnails in the Layers palette tinted red, green, and blue respectively.

CROSS-PROCESSED PORTRAIT

5 The image itself will appear as a red tint, because the top layer is completely overwriting those below. To adjust this, change the blending modes of the top two layers in the Layers palette. For a high-contrast but natural-looking result, try Pin Light for the 'red' layer and Hard Light for the 'green'. Some other combinations are shown here.

TIP There are lots of blending modes to choose from, so you can experiment to create different effects. You can also swap around the layer order to alter the results.

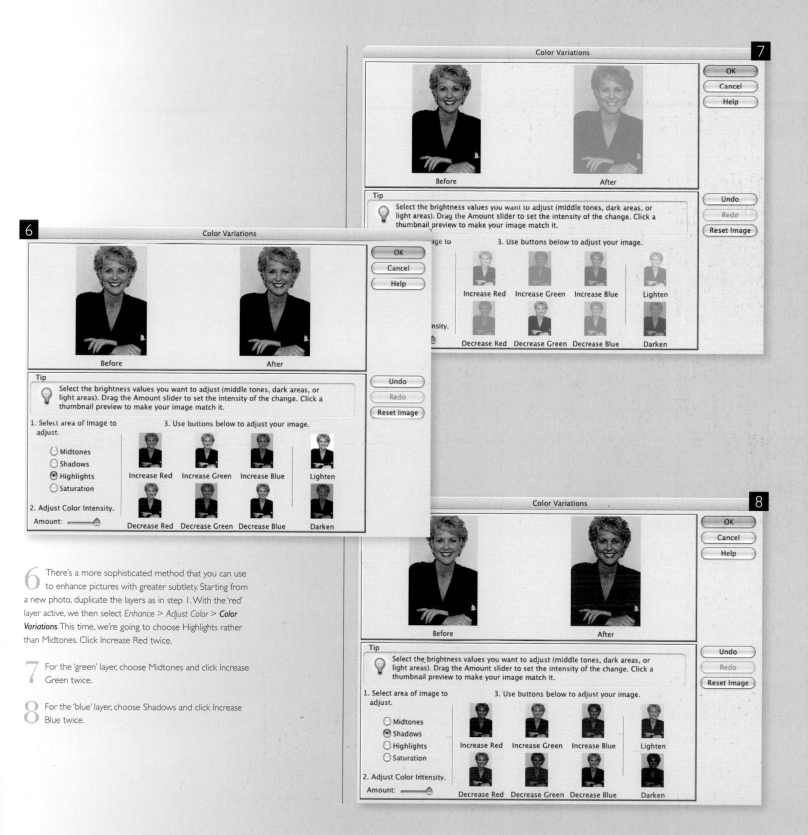

6 There's a more sophisticated method that you can use to enhance pictures with greater subtlety. Starting from a new photo, duplicate the layers as in step 1. With the 'red' layer active, we then select *Enhance > Adjust Color > Color Variations*. This time, we're going to choose Highlights rather than Midtones. Click Increase Red twice.

7 For the 'green' layer, choose Midtones and click Increase Green twice.

8 For the 'blue' layer, choose Shadows and click Increase Blue twice.

CROSS-PROCESSED PORTRAIT

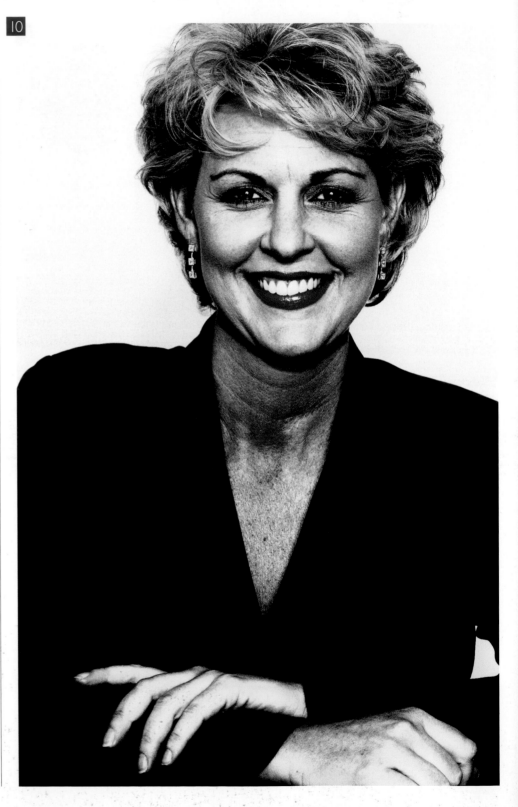

9 Setting both 'red' and 'green' layers' blending modes to
Soft Light gives a well-balanced effect that enhances the
original picture without introducing a strong colour bias.

10 For a more dramatic cross-processed look, change
the 'green' layer's blending mode to Overlay.

11 Even images that are more dramatically
coloured from the start can benefit from a
boost. Here's the same effect again.

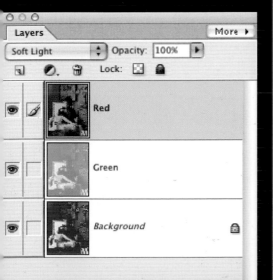

000

Layers More ▶

Soft Light ⬍ Opacity: 100% ▶

🔲 ⊘, 🗑 Lock: ⬚ 🔒

👁 ✎ Red

👁 Green

👁 Background 🔒

**In this final image notice how light areas
are 'blown out' to white by the addition
of light from layer to layer, giving a
brilliant, glowing feel. At the same time,
the colour relationships within the
photo are virtually unchanged.**

distortion effects

CREATING A LABEL

Placing labels on flat surfaces is an easy task – but wrapping a label around a bottle or jar is a different proposition entirely. It is possible in Elements – it just needs some cunning to make it work....

1 Here's our bottle – and we're looking down on it from above, which makes the job a little trickier. The label has been created next to it, in the same document, roughly at the size we're going to want to use it.

2 The label has been created in several parts – the buff-coloured label at the bottom, with all the text on separate layers. To work with it, we need to create a single layer from all these elements. We could simply merge all the layers together, but then we'd lose later editability; it's better to leave them intact, and create a separate new layer with all the label elements.

3 The easiest way to make our new layer is to hold Ctrl/Cmd and click on the 'label' layer in the Layers palette, to select it; then press Ctrl/Cmd+Shift+C to make a merged copy of all the visible layers, and then Paste (Ctrl/Cmd+V). This will give us an additional layer that holds all the label elements; we can now hide all the individual layers, so they don't get in the way.

4 To make the new label more realistic, let's apply some texture to it – using *Filter > Texture > **Texturizer***. The Canvas texture, applied with a low relief, is a good all-round paper texture as well, and it works well in this instance.

5 Here's the label with the texture applied. It's a subtle effect, but it's enough to prevent the label from looking too artificial and computer-generated. The next step is to wrap it around the bottle.

6 First, we need to rotate the label 90° so it's on its side – this is because the Shear filter, which we'll use in a moment, only works in this orientation. The quickest way to rotate it 90° is to select *Image > Transform > **Free Transform*** (Ctrl/Cmd+T) and then hold the Shift key as you rotate, which will constrain the rotation to 45° increments.

7 Now make a rectangular selection around the rotated label with the Marquee tool (shortcut M). Make the selection just a bit taller than the label, but a lot wider – this is to give it space to distort into. Then choose *Filter > Distort > **Shear*** to go on to the next step.

8 The trick with the Shear filter is that it creates curved distortions, but only horizontally – which is why we had to rotate the label. First, click near the top of the line down the middle of the Shear grid, and drag it a short distance: a new anchor point will be created when you click.

9 That looked a little artificial, so add another point at the bottom of the curve, and drag this by the same amount. This way, you should be able to create a symmetrical curve, even if it's a little too extreme for our purposes.

10 To smooth the curve out, now click on the extreme left-hand edge of the curve, and drag it back toward the right to make the entire curve less pronounced. It may take a while as you adjust the anchor points before you get exactly the shape you want, so have patience and keep looking at the preview so you can see what's going on.

CREATING A LABEL

11 Click OK to dismiss the Shear dialog, and you'll be left with your artwork distorted exactly as you saw in the preview. If it doesn't look right at this stage, don't deselect yet: Undo, then open the filter once more and adjust your curves to get a better fit.

12 Now rotate the label back to the correct orientation, using the same shortcut described earlier when we rotated it 90°. The shape should now approximate to that of the bottle – although, of course, the position and size are wrong.

13 Use *Image > Transform > Free Transform* (Ctrl/ Cmd+T) to move and scale the label so it fits the bottle. But don't dismiss the Free Transform state just yet: we can see that there's an element of perspective distortion on the bottle, which means that the label doesn't fit it perfectly. Because we're viewing the bottle from above, the label needs to flare out slightly toward the top.

14 Hold the Ctrl/Cmd key as you grab one of the bounding box corner handles, and drag it so that the label is distorted to fit the shape of the bottle more accurately. With a couple of attempts, it should be possible to get the combination of Shear and Free Transform just right so that it looks like the label really fits the bottle.

15 All that's needed now is a little shading to make the label look more realistic. Use the Burn tool (shortcut O) to darken up the edges, where they disappear around the side of the bottle, and your artwork will be finished.

Here's our finished bottle of Powdered Frog. Of course, the same technique can be used for designing your own wine labels.

FUNNY FACE

The Scale function in Photoshop Elements can be a powerful tool when it comes to facial alterations. The trick to seamless alterations is to understand how to not only use the Scale functions properly, but to combine them with layering, cloning, and selection techniques; and you'll be altering faces of friends and relatives in no time, although you may not be very popular....

1 Start by selecting the Lasso tool from the Toolbar (shortcut L). Use it to draw a rough and quick closed selection around one of the eyes. When we adjust the size of this selected area later, we don't want a hard edge. So we'll need to create a soft, graduated selection border by choosing *Select > Feather* from the menu. Specify a radius setting. Since we are working at 300dpi, we'll use a setting of 10. Click OK.

2 It is always a good idea to copy the selected portions of our image onto new layers before we perform any scaling adjustments. That way, if we do not like what we've done, we always have the original image untouched on the bottom layer. With the current selection active, choose *Layer > New > Layer Via Copy* from the menu. This creates a new layer (call it 'right eye') containing the selected area only, and deselects the current selection.

3 With the 'right eye' layer selected in the Layers palette, Choose *Image > Resize > Scale* from the menu. This will place a bounding box around the contents of the layer. The handles of the bounding box are what allow us to perform scaling functions. Hold down the Shift key, this makes sure that when we perform any scaling functions the width-to-height ratio remains the same, constraining the aspect ratio.

4 Drag the upper right hand corner handle away from the bounding box, outward and to the right, while still holding down the Shift key. This will increase the size of the bounding box contents. When you have succeeded in making the eye unnaturally large compared with the rest of the features, click inside of the bounding box and drag it back into its proper place on the face.

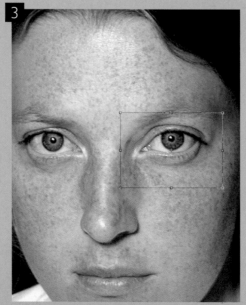

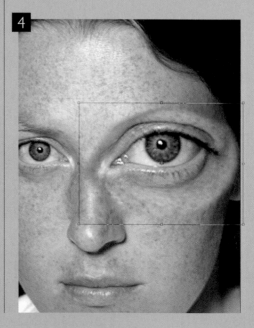

5 We can perform many different scaling functions within a single scaling operation before we apply it to our image. Grab one of the handles in the centre of either the left or the right-hand side of the bounding box. Drag the handle inward. Using this handle will only scale the contents of the box horizontally. Dragging inwards reduces the size.

6 Perform a mirror of that operation on the opposite side of the bounding box to drag the other side inward as well, decreasing the horizontal size of the contents of the bounding box. Now grab the central point of the top or bottom side of the bounding box and drag it outward to increase the vertical size of the box contents. Again, perform the same operation on the opposite side as well.

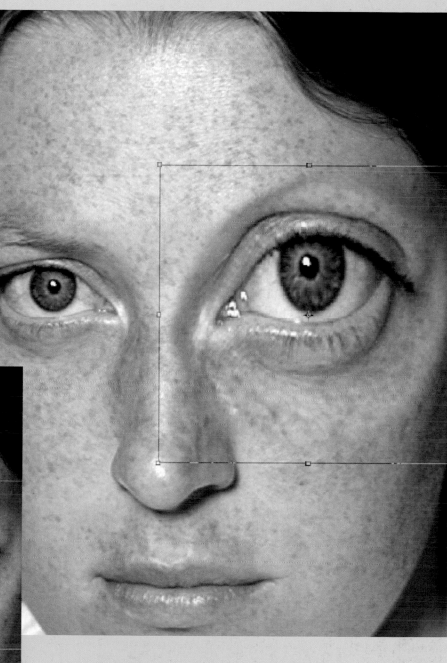

FUNNY FACE

TIP When you choose a brush tip from the preset picker in the tool Options Bar, it will have a default size. However, the brush size can be changed by using the size slider in the Options Bar. Also, to increase the brush size incrementally, type the [key on your keyboard, while decreasing the brush size incrementally is achieved by pressing the] button.

W: 162.6% H: 168.3% 0.0

7 When you are happy with what you've done, click on the tick icon in the tool Options Bar or hit Enter to apply the scaling operation. This applies all of the scaling functions to the actual pixels and, once applied, causes the bounding box to disappear. Select the background layer in the Layers palette and use the Lasso tool to draw a rough selection around the other eye this time.

8 Choose *Select > Feather* from the menu and feather the selection the same amount as we did previously. Then, with the selection still active. Choose *Layer > New > Layer Via Copy* from the menu as before, and call this layer 'left eye'. With the 'left eye' layer selected in the Layers palette, choose *Image > Resize > Scale* from the menu. This time, when you are holding down the Shift key, hold down the Alt/Option key at the same time.

9 Click on a corner point of the bounding box and drag it outward to increase the size of the contents. You now know that holding down the Shift key constrains the horizontal and vertical aspect ratio, preserving the proportion while scaling. Holding down the Alt/Option key scales the contents inward or outward, evenly on all sides, from the central origin point inside the bounding box. The central origin point is indicated by crosshairs in the middle of the box.

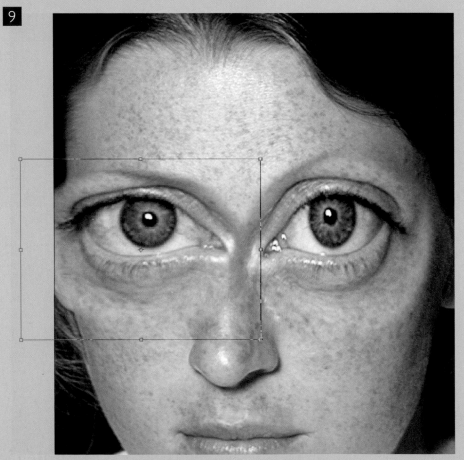

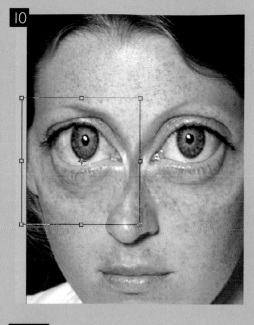

10 Continue to hold down the Alt/Option key and click on one of the central points on either the left or right-hand side. Drag it inward to scale down the contents, horizontally only, yet evenly on both sides of the origin point. Continue to hold down Alt/Option key and click on one of the central points on the top or bottom of the box. Drag outward to increase the vertical size evenly on either side of the origin point.

11 When you are satisfied with the result, apply the scale adjustment by clicking the tick icon in the Options Bar or press Enter on your keyboard. Select the Eraser tool (shortcut E) from the Toolbox. Select a soft round brush from the preset picker in the Options Bar, and specify a low Opacity setting of around 25%. Use the Eraser to gently erase edge areas, making it blend better with the layer underneath.

12 Select the 'right eye' layer in the Layers palette and use the Eraser on that layer as well to create a more natural blend effect. When you are satisfied with your erasing, select the Lasso tool from the Toolbox. Select the background layer in the Layers palette and draw a rough selection around the nose. Be certain that your selection contains a generous amount of cheek area on either side of the nose.

13 Again, choose *Select* > **Feather** from the menu and enter a radius value similar to your previous selections. Again choose *Layer* > *New* > **Layer Via Copy** from the menu to create a new layer from the feathered nose selection, and call it 'nose'. With your 'nose' layer selected in the Layers palette, choose *Layer* > *Resize* > **Scale** from the menu. Then, hold down the Alt/Option key and click on a central point of one of the sides. Drag the point inward to horizontally reduce the contents equally on either side of the origin point.

TIP When you are using the scale feature, try right-clicking inside of the bounding box (PC), or Control-clicking inside of the box (Mac). You will see a pop-up menu that allows you select other functions and change the behaviour of the bounding box. You can change the scale operation to that of free transform, free rotate, skew, distort, or perspective.

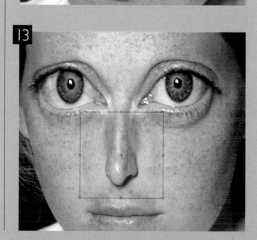

FUNNY FACE

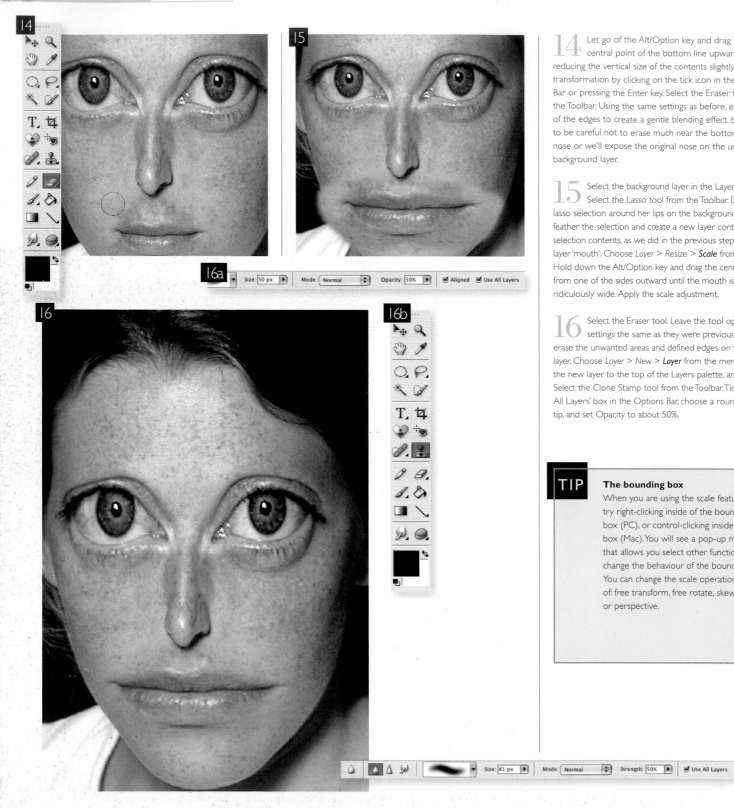

14 Let go of the Alt/Option key and drag the central point of the bottom line upward a little, reducing the vertical size of the contents slightly. Apply the transformation by clicking on the tick icon in the Options Bar or pressing the Enter key. Select the Eraser tool from the Toolbar. Using the same settings as before, erase some of the edges to create a gentle blending effect, but we need to be careful not to erase much near the bottom of the nose or we'll expose the original nose on the underlying background layer.

15 Select the background layer in the Layers palette. Select the Lasso tool from the Toolbar. Draw a rough lasso selection around her lips on the background layer. Again, feather the selection and create a new layer containing the selection contents, as we did in the previous steps. Call this layer 'mouth'. Choose *Layer > Resize > Scale* from the menu. Hold down the Alt/Option key and drag the centre point from one of the sides outward until the mouth is stretched ridiculously wide. Apply the scale adjustment.

16 Select the Eraser tool. Leave the tool options settings the same as they were previously. Gently erase the unwanted areas and defined edges on the "mouth" layer. Choose *Layer > New > Layer* from the menu and drag the new layer to the top of the Layers palette, and call it 'face'. Select the Clone Stamp tool from the Toolbar. Tick the 'Use All Layers' box in the Options Bar, choose a round, soft brush tip, and set Opacity to about 50%.

TIP

The bounding box
When you are using the scale feature, try right-clicking inside of the bounding box (PC), or control-clicking inside of the box (Mac). You will see a pop-up menu that allows you select other functions and change the behaviour of the bounding box. You can change the scale operation to that of: free transform, free rotate, skew, distort, or perspective.

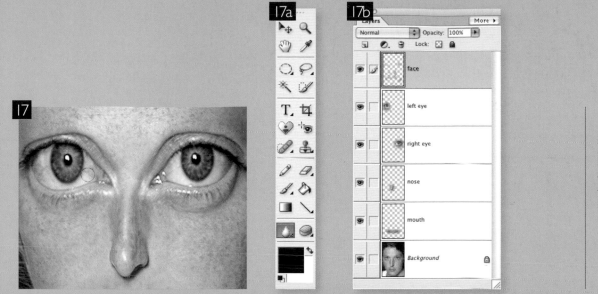

17a

17b

17 Use the Clone Stamp tool on the 'face' layer to patch together any areas that don't blend smoothly, or remove any unwanted leftover bits or blemishes. Hold down the Alt/Option key and click to define a source point, and then click to paint over the desired areas using the sampled source point.

To finish, we select the Blur tool (shortcut R), specify a round, soft brush tip and enable the 'Use All Layers' option. Set the strength to about 50% and use the Blur tool to paint over any areas that need additional smoothing.

PICKLED SHEEP

If you need a photo of an object sitting in a jar of liquid, the simplest answer is to get a jar of liquid, place the object inside and photograph it. The difficulty comes when you need something in the jar that you can't physically put in it, like a sheep's head. Think about the kind of jar that sits on a shelf in the mad scientist's lair in any movie involving a mad scientist.

1 We start by photographing a jar of water, filled to a couple of inches below the lid. The size of the jar won't matter as long as you don't include anything in the shot that gives a clue to scale. For a spooky effect, shoot from low down with a wide-angle lens (no zoom), and use flash to accentuate reflections and cast a looming shadow. Use the Lasso tool (shortcut L) to draw around the water in the jar, holding the Alt key temporarily to make straight lines. Then use the Hue/Saturation dialog (shortcut Ctrl/Cmd+U) with the Colorize option to colour the bottle green. Reduce the Saturation so that it doesn't look too fluorescent. Before continuing, go to Select > *Save Selection*, name the selection 'bottle' and click OK.

2 If you don't have a sheep handy, you'll easily find a photo of one in a clip-art collection. Open it and use the Lasso or Magic Wand (shortcut W) to select the sheep's head and neck.

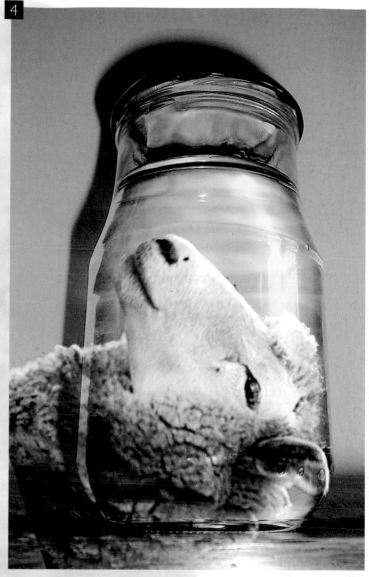

3 Using the Move tool (shortcut V), drag the selection into the jar photo's window. Drag the handles to scale and rotate it into position, then double-click to confirm.

4 The image you dragged in is contained in a new layer called 'sheep'. In the Layers palette (open this from the Window menu), you'll see this is highlighted to show it's the active layer; it should remain so for the rest of the task. Using the pop-up menu, change its blending mode from Normal to Hard Light. Now the colour, shadows, and highlights of the jar image show through, making the sheep look as if it's in the water.

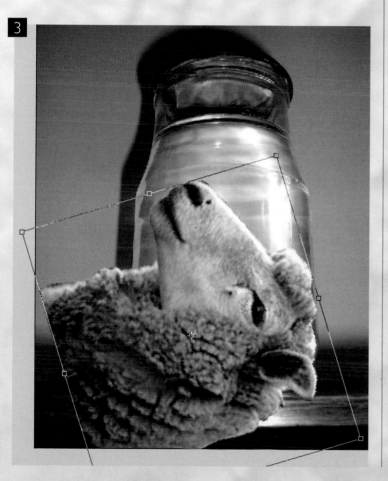

PICKLED SHEEP

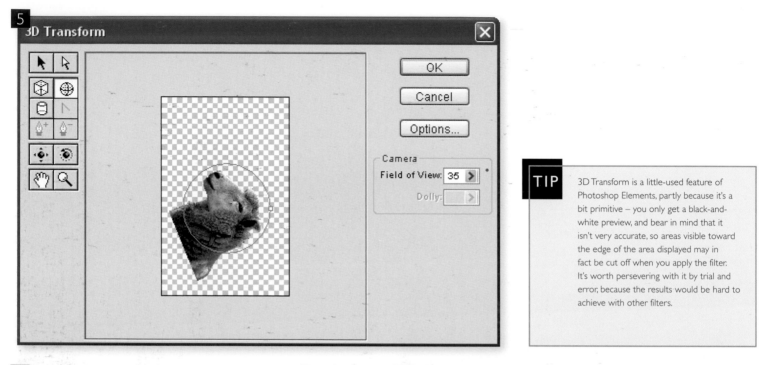

TIP 3D Transform is a little-used feature of Photoshop Elements, partly because it's a bit primitive – you only get a black-and-white preview, and bear in mind that it isn't very accurate, so areas visible toward the edge of the area displayed may in fact be cut off when you apply the filter. It's worth persevering with it by trial and error, because the results would be hard to achieve with other filters.

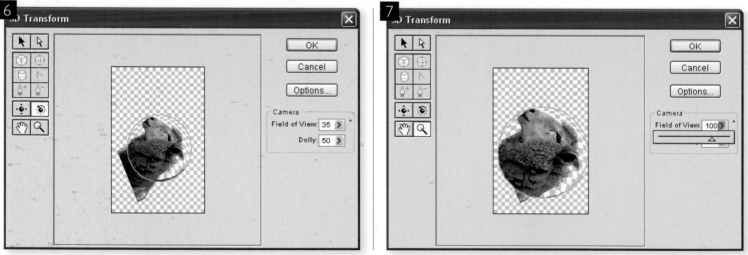

5 Next, we select *Filter > Render > 3D Transform*. With this single filter, we'll make the sheep appear as if viewed from below, like the jar, and also distorted by the glass and water. Start by choosing the Sphere tool (shortcut N) and dragging to draw a circle around the sheep's head. If you don't get it right the first time, drag one of its two side handles to adjust its size, move it using the Direct Selection tool (shortcut A), or delete it by pressing Delete.

6 With the Trackball tool (shortcut R), click in the circle and drag upward. The selected area is mapped onto the outside of a sphere, represented by the circle, which is then rotated according to your mouse movements.

7 To exaggerate the effect, bring the sheep closer to the viewer by reducing the Dolly setting. Although strangely appropriate to a pickled sheep, this actually refers to the trolley on which a movie camera would be mounted. As you move it closer, the image will get too big for the frame. To correct this, increase the Field of View setting.

8 Click OK to apply the Transform. Next, we need to select the Move tool (shortcut V) to rescale the head as necessary to fit the jar.

9 The bottom part of the head should look squashed where the jar curves under. To simulate this, we use the Rectangular Marquee tool (shortcut M) to select an area at least as wide as the jar, starting a little way up from the bottom and going down to include some of the sheep's neck. Switch back to the Move tool and drag the bottom centre handle up to the base of the jar.

PICKLED SHEEP

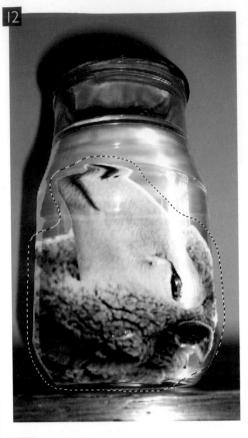

10 The shoulder of the jar should also cause distortion. We use the Rectangular Marquee tool to select a narrow band around this, then go to *Filter > Distort > Shear*. In the dialog box, click the line on the graph to add a new control point on each of the three gridlines, then drag the middle point to one side to make a wave. Click OK.

11 Now we need to reload the inverse of the 'bottle' selection we saved earlier: go to *Select > Load Selection*, tick Invert, and click OK. This selects everything except the jar. Press Delete to clear this area, and so remove the extraneous parts of the sheep.

12 Holding the Ctrl/Cmd key click the 'sheep' layer in the Layers palette to select the shape of the sheep. Invert this selection (shortcut Ctrl/Cmd+Shift+I), then go to *Select > Modify > Expand*. Enter a large enough value to make a reasonable border around the edge of the sheep, in this case 32 pixels, and click OK. Feather the selection by the same amount using *Select > Feather*. Our selection should end up as seen here.

13 Press Delete to clear the selected area. This fades off the edges of the sheep's head so that it appears to recede into the water.

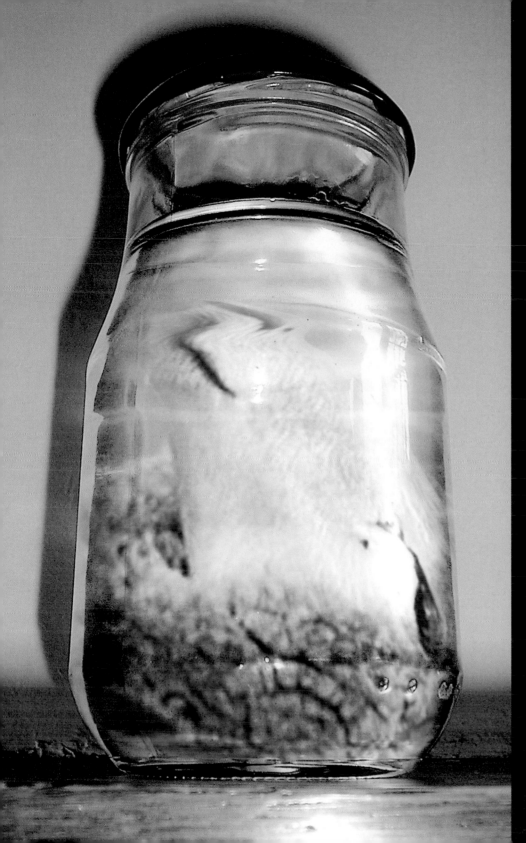

The final result is pretty gruesome and worthy of a place on any mad professor's shelf. It would be easy enough to add some wisps of smoke leaking from the top of the jar to really take it to the realms of 1960s horror movies.

MELTED CAN

Elements' various distortion filters offer a huge range of options when it comes to warping and distorting images. One of the most powerful of these filters is Liquify. You can use Liquify to create bizarre characters out of photos of friends and family, but it can also be used more creatively too.

1 In this example we'll use the Liquify tool to make it look as though the oil can is melting in extreme heat.

2 Because working on the entire image with the Liquify tool can be slow we'll break it down into sections and work on these individually. We'll start with the base which is the easiest to do. Select the Rectangular Marquee tool (shortcut M) and draw a rectangular box over the bottom of the can.

3 Choose *Filter > Distort > Liquify* to launch the Liquify interface. Select the Warp tool (shortcut W) – the top icon of the short list of tools at the left of the window with the brush size set to about 150 and pressure to 50%. We'll begin by gently pulling out the bottom edge of the can to make it look as if the metal is slowly spreading out over the floor.

4 Carry on doing this along the edge trying to get an uneven spread of the melting effect. We can even begin working on a row around the base of the can to make it look like the metal is beginning to flow over itself.

5 To do the spout we'll first make a copy of the tip to protect it. Draw a rectangular marquee selection around the tip of the spout and then copy (Ctrl/Cmd+C) and paste (Ctrl/Cmd+V) it to a new layer (call it 'tip') . We can put this undistorted tip back on after liquifying the spout.

6 Ensuring we've returned to the main image, select the spout with a marquee selection and open the Liquify filter again. Use the same brush to carefully bend the spout. In order to do this successfully you will need to stretch one side of the spout…

7 … and then push the opposite side to maintain the thickness of the spout and to avoid too much fuzziness in the pixels. Click OK to apply the filter.

8 Our saved tip, which will appear on the main image floating above the rest of the spout, can now be repositioned and rotated. Select *Image > Transform > **Free Transform*** (Ctrl/Cmd+T) or the Move tool (shortcut V) and reposition the tip at the end of the drooping spout.

TIP
Holding down the Ctrl/Cmd key will turn any tool that's been selected into the Move tool. When you release the Ctrl/Cmd key the original tool will return. This helps enormously when you're navigating elements around an image.

MELTED CAN

9 Next, we can work on the handle. Again, make a selection and run Liquify. This time use a large brush radius and both the Twirl tools (shortcut R and L) to produce an over-all distortion of the handle. The longer you click with these tools the greater the 'twirl' effect.

10 Using a much smaller radius brush tip and the Warp brush we can add some drips to the handle. Unlike the spout, we want to smear out the pixels so make it look like just edges of the metal are melting.

11 Continue on with the rest of the can using the Liquify tool, making selections and applying the melt effect, and leaving no edge straight.

12 The blue colour doesn't really go with the melting can theme so we apply a Hue/Saturation adjustment layer and move the Hue slider to create a red background.

With the blue background replaced by a
red one, the sense of heat is much more
evident. It would be fun to use Elements'
sophisticated text capabilities to add some
melted lettering to the can.

montage

GIRL IN A BOTTLE

Photomontage is all about combining elements – which means not just placing them next to each other, but making them blend together. Here, we'll look at how to blend just two elements, by placing a girl inside a bottle.

TIP If, when making a selection, it goes wrong or you have to leave it unfinished, you don't have to throw away the time spent making the selection. To pick up and add to a selection, either hold down the Shift key or click the 'Add to selection' icon in the Options Bar.

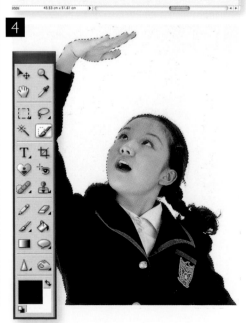

1 We begin by lifting the girl off her background. Since the background here is white, this is easily done by clicking on it with the Magic Wand tool (shortcut W) which selects all contiguous (that is, connected) areas of the same colour. With the first click, almost all the perimeter is selected.

2 When we zoom in, we can see that there are missing regions – such as between her calves. To add them to the selection, hold Shift and click in the area. Holding Shift before you make a new selection will add it to the existing selection. We can then do the same for the missed areas around the feet.

3 There are frequently some odd bits of dirt that refuse to be picked up in this way: we can add these using the Lasso tool, once again holding Shift before starting to trace with it. Once again, these areas are added to our selection.

4 There are some areas we can't pick up with the Magic Wand – all the holes in the hair, for example, are just too fiddly to be selected. The easiest way of adding them is to switch to the Selection Brush tool (shortcut A) which will give us more control over the process.

5 When we change tools in this way, the selected area is shown as a red overlay. Using a small, soft-edged brush, we can paint in all the white that's missing from our selection. A soft brush works best with hair, helping to avoid hard edges.

6 It doesn't matter if you go over the edges slightly when using this method – it's better to select more of the background than you need, than to leave parts of it showing. When you're done, click on the Move tool (shortcut V), and the red overlay will return to the familiar 'marching ants' selection.

7 So far, everything outside the girl has been selected – so we need to inverse the selection by going to *Select > Inverse* (Ctrl/Cmd+Shift+I) to select the girl herself. Then, using the Move tool, drag her from the original document into the document containing the bottle, and call her layer 'girl'.

8 First, we need to scale her so that she fits the bottle. Use *Image > Transform > Free Transform* (Ctrl/Cmd+T) for this, making sure that all her extremities are contained within the bottle's outline – it doesn't do to leave any hands poking out of the side!

9 Now switch to the background layer – the one containing the bottle itself. Select the white around it using the Magic Wand, then inverse the selection so that the bottle is selected. Use *Layer > New > Layer via Copy* to duplicate the bottle to its own layer, and call it 'bottle'.

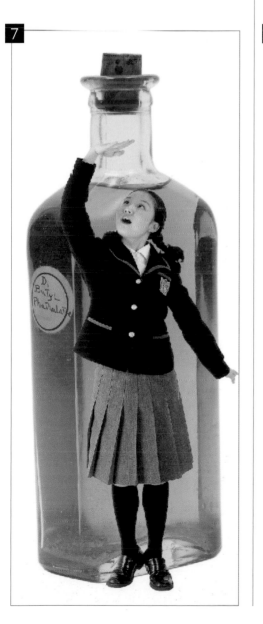

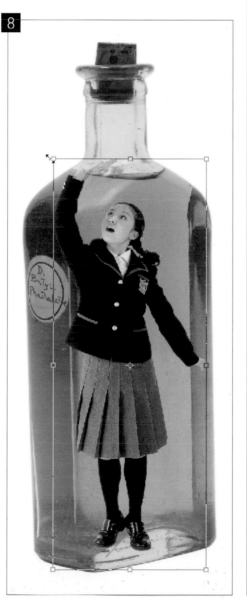

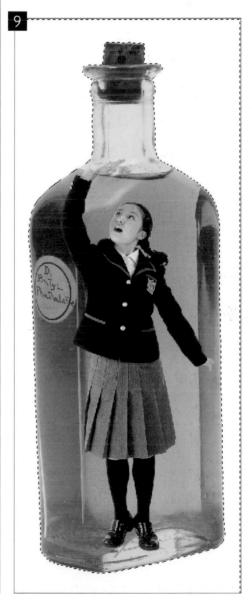

GIRL IN A BOTTLE

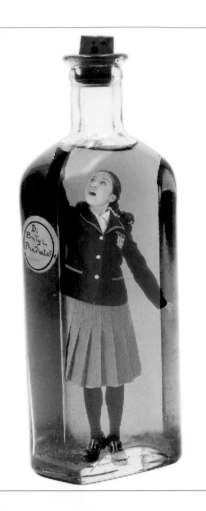

10 Now drag the new 'bottle' layer so it appears above the 'girl' layer. The result, not surprisingly, is that the girl disappears: sandwiched between the two layers, we can't see her at all. Yet.

11 The answer is to change the mode of the 'bottle' layer from Normal to Hard Light, using the drop-down menu at the top of the Layers palette. This special mode allows the shadows and highlights from a layer to show through, while concealing the mid-tones.

12 Right away, the girl looks far more like she's in the bottle. Except that the new Hard Light layer has affected the bottle, as well as the girl, making the whole thing darker: we only want to change the way the girl looks.

13 Press Ctrl/Cmd+G to group the Hard Light 'bottle' layer with the 'girl' layer. You can also hold Alt/Option and click on the dividing line between the two layers in the Layers palette if you wish.

14 The result is that the Hard Light layer will only be seen where it overlaps the layer beneath it, so it only affects the girl: the original bottle, behind her, remains as it was when we started. All that's left to do is to make the girl look more contained within the bottle.

15 The problem is that the girl is too highly contrasted – the bottle and liquid within should make her harder to see. We could just change her contrast directly, but it's better to do this with an adjustment layer. Click on the 'girl' layer and from the top of the Layers palette, click on the 'Create adjustment layer' icon and select Brightness/Contrast from the pull-down menu.

16 It only takes a small amount of change to bring about the effect we want: here, we've increased the brightness slightly, while lowering the contrast by a small amount at the same time. The result is a somewhat murkier view of the girl, who now looks far more like she's pickled in our bottle.

TIP Instead of making a new adjustment layer (step 15), we could just change the brightness and contrast directly on the layer. But this would be an irrevocable step: using adjustment layers allows us to make changes and then edit them later – or remove them entirely simply by making the layer inactive.

14

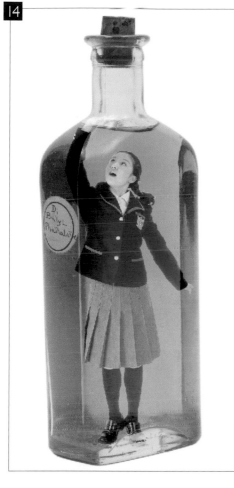

16a

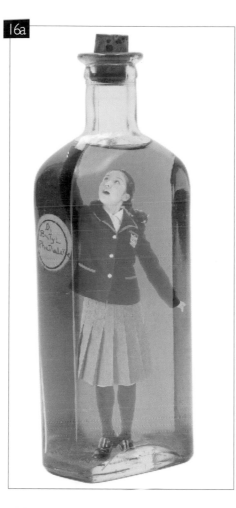

15

| Layers | | | More ▶ |

Hard Light ▼ Opacity: 100% ▶

Lock: 🔒

Solid Color...
Gradient...
Pattern...

Levels...
Brightness/Contrast...

Hue/Saturation...
Gradient Map...
Photo Filter...

Invert
Threshold...
Posterize...

16b

Brightness/Contrast

Brightness: 28

Contrast: -19

OK
Cancel
Help

☑ Preview

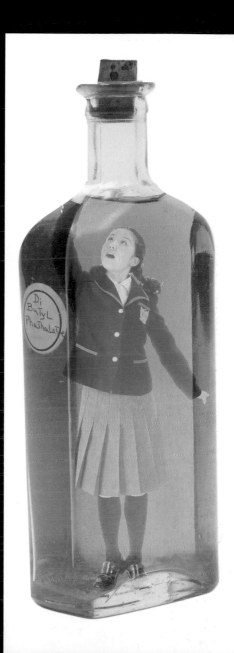

Our final image looks pretty convincing, and is reminiscent of a scene from *Alice in Wonderland*.

It is important to look beyond the obvious when choosing images for compositing purposes. Photoshop Elements provides all of the necessary tools to create unique and compelling compositions. But it is up to you to spot the potential uses of individual images and photographic elements. When Derek Lea picked up this old worn booklet from a local junk shop, he knew it had a story to tell. The wondrous aged texture provided an excellent starting point. After looking at it for a while, the other images fell into place.

1 The scanned image of the book (called 'book') will be the basis for our working layered file. Now open up the image of the woman's face. Use the Move tool (shortcut V) to click on the image of the face, and while holding down the Shift key, drag it over to the book image. The image of the woman will be added to the file as a new layer; we'll call it 'face'.

2 In the Layers palette, change the blending mode of the 'face' layer to Overlay and reduce the Opacity to about 56%. Now, duplicate the face layer (call it 'face2') by clicking and dragging the layer icon onto the 'Create new layer' icon in the Layers palette. Change the blending mode of the duplicate layer to Lighten and increase the Opacity to around 77%.

3 Choose the Selection Brush tool (shortcut A) from the Toolbar. In the Options Bar, select a large soft round brush from the list of presets. Use the slider in the Options Bar to increase the size of the brush until its pixel radius is large enough to cover one of her eyes. Select Mask from the Mode pull-down menu.

4 We are using the mask brush to define which areas of the layer we are going to preserve. Use the brush to paint over her face and the lower right hand corner, have a look at the Layers palette to be certain that you are working on the 'face2' layer and not the original 'face' layer. A red mask will appear on the areas that you paint over.

5 Switch the mode back to Selection in the Options Bar. The mask will disappear and all of the areas that fall outside of your painted mask are selected. Press the Delete key on your keyboard to delete the contents of the selection from your current layer. Choose *Select > **Deselect*** (Ctrl/Cmd+D) from the menu to deactivate the selection. Switch the Selection Brush tool Mode back to Mask and use your current brush to paint over some of the lighter areas of her face.

UNLOCKING HIDDEN POTENTIAL

6 If you have masked an area that you wish to remain unmasked, don't worry, there's an easy way to remedy this. Hold down the Alt/Option key and paint over the area y want to 'unmask', when you paint with the Alt/Option key held down it removes masking from that area. Let go of the Alt/Option key and the brush reverts to its default masking setting. Be certain that you haven't painted a mask over her eyelashes, if so, now is the time to try out the Alt/Option method to remove it.

7 Change the Selection Brush Mode to Selection in the Options Bar. When the selection is generated from the mask, direct your attention to the top of the Layers palette. Click on the 'Create adjustment layer' icon button and select Levels from the list. This creates an adjustment layer with an adjoining mask. The mask uses your current active selection to define what part of the adjustment layer is masked and what part is visible.

> **TIP** Holding down the Shift key while dragging images from file to file will preserve the positioning of layer content as you move it. For total accuracy images should be the exact same pixel dimensions, however, if your images are approximately the same size, the results will be much better than if you hadn't used the Shift key.

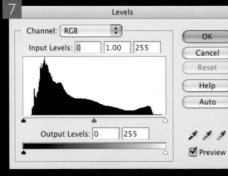

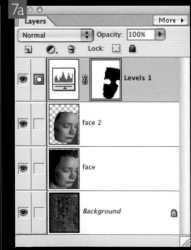

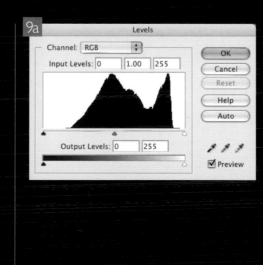

8 In the Levels dialog, grab the left slider of the Input Levels and drag it to the right. This will increase the darkness and shadows. Be certain that you are adjusting the RGB composite channel and that you haven't chosen any individual channels from the Channel pull down menu. When you have darkened the highlights, click OK. Hold down the Ctrl/Cmd key and click on the adjustment layer's mask icon in the Layers palette. This will generate a selection based on the mask content.

9 Choose *Select > **Inverse*** (Ctrl/Cmd+Shift+I) from the menu to invert the selection. With this selection active, create another Levels adjustment layer in the Layers palette. Grab the right-hand slider and drag it to the left to increase the highlights. Also drag the centre slider to the left to lighten the midtones. This should lighten up the skin in her face nicely. Click OK when you are satisfied.

10 The contrast of the image is nearing perfect, but the colours are a little too saturated. At the top of the Layers palette, click on the 'Create adjustment layer' icon and select Hue/Saturation from the list. Adjust the Hue to +2 to change the colour cast from pink to yellow and reduce the Saturation by 22 to remove some of the colour. Click OK to apply the adjustment.

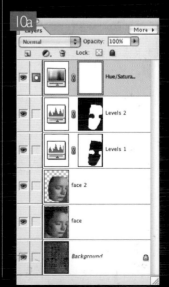

UNLOCKING HIDDEN POTENTIAL

11 The image is looking good but it still lacks contrast. Use the same method to create a Brightness/ Contrast adjustment layer. Increase the contrast by 7 and increase the Brightness by 3. It is often easier to adjust the Contrast first even though it is the second slider in the adjustment layer dialog box. When we have applied the adjustment, select the 'book' layer in the Layers palette and duplicate it by dragging it onto the 'Create new layer' icon at the top of the Layers palette.

12 Drag the 'book copy' layer to the top of the stack in the Layers palette. Change the blending mode to Screen and reduce the Opacity to 51%. Now duplicate the 'book copy' layer ('book copy 2'). Change the blending mode of the new layer to Hard Light and reduce the Opacity to 19%. This method of duplicating layers and altering modes and Opacity settings really helps to make the face and book seamlessly blend together.

13 Now open the tree image and use the Move tool, while holding down the Shift key, to drag it into your working file as a new layer (call it 'tree'). The picture of the tree will add some atmosphere to the image; the fact that it is already slightly worn can only help things. Reduce the Opacity of the 'tree layer' to 10% and change the blending mode to Hard Light. Duplicate this layer ('tree copy'), change the mode to Overlay, and increase the Opacity to 41%.

14 With the 'tree copy' layer still active, choose Solid Color from the adjustment layer pull-down menu at the top of the Layers palette. This will open the Color Picker dialog box. In the picker, specify a desaturated green and click OK. In the Layers palette, change the blending mode of the 'tree copy' layer to Color and reduce the Opacity to 80%. The monochromatic effect of using the Solid Color layer really makes the composition as it stands look like a textured background.

TIP You can edit your adjustment layers at any point by accessing the options relative to each specific adjustment. In order to access the options for an adjustment layer, simply double-click the adjustment layer icon in the Layers palette. To access the options correctly you must be certain that you are double-clicking the layer icon and not the mask icon or layer name.

11

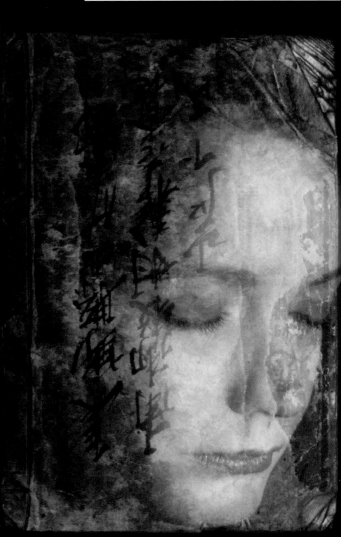

11a

Brightness/Contrast

Brightness: +3 OK
Cancel

Contrast: +7 Help

☑ Preview

12

12a

Normal
Dissolve

Darken
Multiply
Color Burn
Linear Burn

Lighten
Screen
Color Dodge
Linear Dodge

Overlay
Soft Light
✓ Hard Light
Vivid Light
Linear Light
Pin Light
Hard Mix

Difference
Exclusion

Hue
Saturation
Color
Luminosity

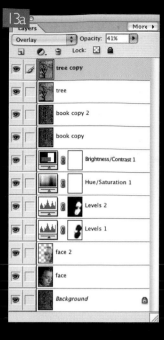

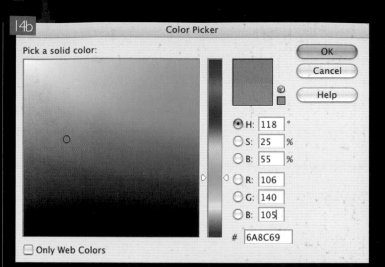

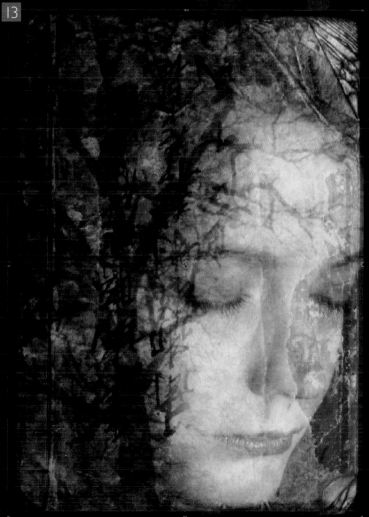

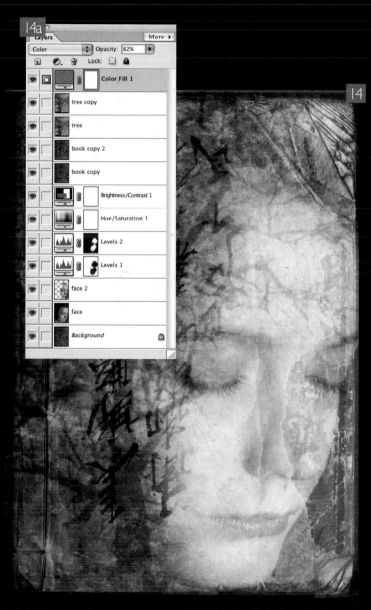

15 Now we need to open the file that contains the picture frame. Use the Move tool (shortcut V) to drag it into the file as a new layer and call it 'frame'. Position it, using the Move tool, over the eye closest to the centre of the image. Reduce the Opacity of the layer to 50%. Duplicate the layer ('frame copy'), change the blending mode to Luminosity and increase the Opacity of the 'frame copy' layer to 100%. Select the Eraser tool (shortcut E). Choose a large soft brush preset in the Options Bar and reduce the Opacity to 25%. Make certain that the Eraser is set to Brush mode in the Options Bar.

16 Render invisible the 'frame copy' layer in the Layers palette by clicking the eye icon, and then select the 'frame' layer. Use the Eraser tool to gently erase the bottom right of the picture frame on this layer. Slowly move across to the left and feel free to decrease the Opacity to create a subtle blending effect. Also increase or decrease the size of the brush tip as required. Select the 'frame copy' layer and enable its visibility. Use the same method to gradually erase areas of the frame on this layer. Zoom out for a moment and look at the image so far.

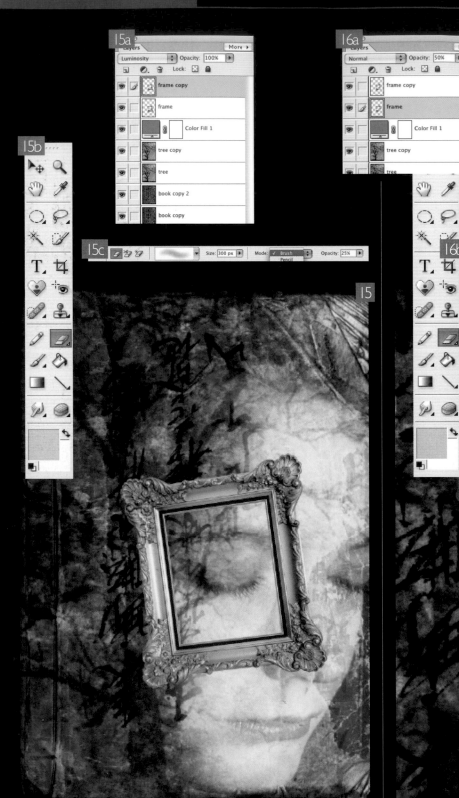

17 The beauty of working with layers means that we can change our minds at any point in the composition, improvising along the way. This sort of flexibility is essential for creating successful montages. The tree isn't visible enough. Duplicate the 'tree copy' layer ('tree copy 2') and change the blending mode to Lighten. Reduce the Opacity to 31% and use the Eraser to erase the contents of this layer all around the edges. Duplicate the layer ('tree copy 3') and change the blending mode to Hard Light.

18 Choose the 'frame copy' layer in the Layers palette and select the Magic Wand tool from the Toolbar. Click once in the empty area inside the frame to select this area. With the selection active, select the 'face' layer in the Layers palette and go to *Layer > New > Layer Via Copy*. This will create a new layer (call it 'frame eye') that contains the contents of your selection. Drag the 'frame eye' layer to the top of the stack in the Layers palette. Change the blending mode to Normal and increase the Opacity to 77%.

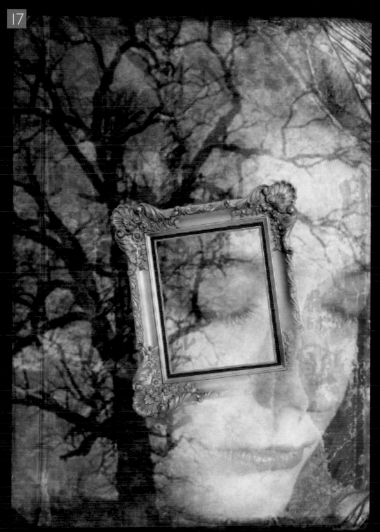

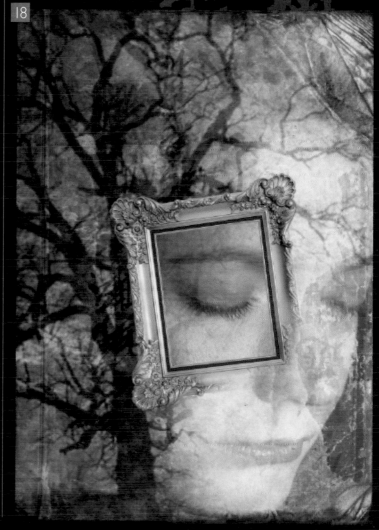

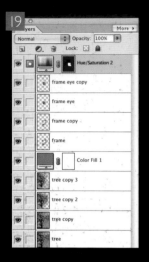

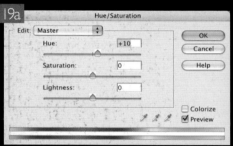

19 Duplicate the 'frame eye' layer ('frame eye copy') and change the blending mode to Screen. Ctrl/Cmd-click the layer icon to generate a selection from it. With the selection active, create a new Hue/Saturation adjustment layer and change the Hue setting to +10 to change the skin to a more yellow hue, removing the pink cast. The montage is really starting to shape up, now all we need are some floating fish for that added touch of surrealism.

20 Open up the fish image and drag the fish layer into your working file as a new layer ('fish'). Position the fish wherever you like on the background. Use the Eraser tool with a soft brush tip and low Opacity setting to erase his tail and underside so that he gradually blends in with the underlying imagery. Select the Move tool; drag one of the corners outwards while holding down the Shift key to scale the fish proportionately, making him a little bigger. Click the Enter key on your keyboard to apply the transformation.

21 Hold down the Alt/Option key and click and drag the fish to duplicate the fish layer. Move it to another area of the layer, and adjust the size like you did on the previous fish layer. Reduce the size a little this time. Use this method to create a number of duplicate fish layers with different size fish across the background. Disable the visibility of all of the layers except for the fish layers. Then choose *Layer > Merge Visible* from the menu to merge all of the fish layers into a single layer.

22 Enable the visibility of all of the layers again. Select the 'fish' layer if it isn't already and change the blending mode to Luminosity. Duplicate the 'fish' layer ('fish copy') and change the blending mode to Overlay. Reduce the Opacity of the layer slightly and use the Eraser to erase sections of fish that are too bright. Use a large soft brush and low Opacity settings like you have been doing so far for a gradual blending effect. Also erase areas on the first 'fish' layer that appear too strong.

23 And to finish off, create another Levels adjustment layer. Select Blue from the channel menu and move the centre input level slider a little to the right to warm up the image a little overall. Then, select the RGB composite channel from the channel menu and drag the left input level slider to the right a little to increase the shadows slightly.

The final result is a
moving and mysterious
montage; the sort
of image one might
expect to see on the
cover of a ghostly
whodunnit.

BRAIN STORM

Layers are a formidable part of the tool set used for digital image creation in Elements. Layers allow you to do amazing things with images such as combine them in new and creative ways. Creating a montage of images, where layers interact to produce a seamless, detailed whole is quite easy once you know how.

1 Let's begin by opening the earth and plasma images. These will serve as the initial palette from which we'll work to assemble a composite digital artwork.

2 We're going to work in portrait mode, so create a new document by selecting *File* > **New** (shortcut Ctrl/Cmd+N) and choosing the A4 format from the preset menu in the New file dialog window.

3 Switch to the earth image and drag its layer from the Layers palette into the blank document you created, and call the new layer 'earth'. Select *Image* > *Transform* > **Free Transform** (Ctrl/Cmd+T) to access the Transform tool, then centre the earth and rotate it so that the part in shadow is at the bottom. You'll find it easier to do this if you hold the Shift key while rotating the image, as this constrains the rotation to 45° increments.

2 pboard

Default Photoshop Elements Size
Letter
Legal
Tabloid
2 x 3
4 x 6
5 x 7
8 x 10
640 x 480
800 x 600
1024 x 768
NTSC D1 Square Pix, 720 x 540
PAL D1/DV Square Pix, 768 x 576
HDTV, 1280 x 720
HDTV, 1920 x 1080
A4
A3
B5

3a

Layers

Normal	Opacity: 50%

Lock:

plasma

earth

Background

4 Now drag the plasma layer into the new file too (call it 'plasma'). Again using the Transform tool to scale the 'plasma' layer up so that it fits more or less over the earth image. To help find the fit, reduce the 'plasma' layer's Opacity to around 50%, that way you can see the earth image underneath. Once you've achieved the desired fit, return the Opacity to 100%.

5 Fill the background layer with black (the easy way to do this is to simply invert the layer's colour by typing Ctrl/Cmd+I) then set the 'plasma' layer to Screen blending mode. This makes black pixels transparent so that we can see the earth through the plasma.

6 Now we'll open the brain image. With the Elliptical Marquee tool (shortcut M) draw an elliptical selection (hold down Option-Shift as you drag to get a perfect circle) of the brain and box then choose *Select > Feather* and set the value to 60. Press Ctrl/Cmd+C to copy the selection, swtich to the composite document and type Ctrl/Cmd+V to paste it in. Call the new layer 'brain'.

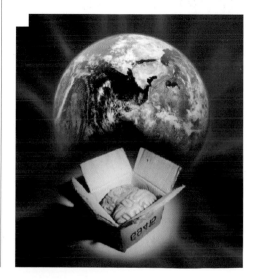

BRAIN STORM

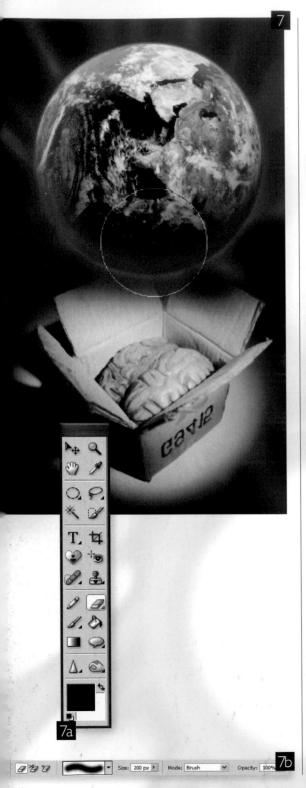

7

7a

7b
Size: 200 px Mode: Brush Opacity: 100%

7 Scale up the brain layer using the Transform tool again, then with a large soft Eraser (shortcut E) erase the top of the box where it overlaps the earth.

8 The key to tying in the different images is to use a colour wash layer. Create a new layer (called 'solid blue') and change its blending mode to Color, then fill it with a mid-blue colour with the Paint Bucket tool (shortcut K). This unifies the image and makes it more integrated.

8

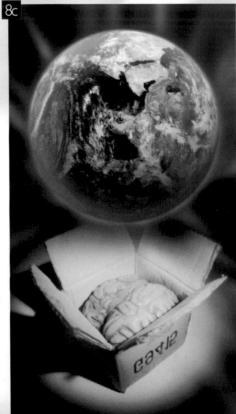

8c

9 Now we're going to open the clouds file and drag it into the composite, calling its layer 'clouds'. Scale it up to fit the document as we did before, and position it below the 'earth' layer then set the mode to Hard Light. You'll see the 'earth' layer's black background, so to fix this change the 'earth' layer's blending mode to Screen. Duplicate the 'clouds' layer and flip it horizontally using *Image > Rotate > Flip Layer Horizontally*. Reduce both cloud layers' Opacity to taste.

9a

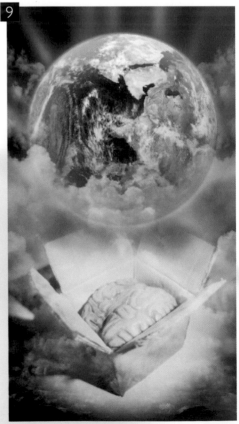

9

10 Finally introduce a little colour to the image by duplicating the 'plasma' layer and moving it to the top of the layer stack. Set its blending mode to Overlay then apply a Hue/Saturation adjustment layer to it, adjusting the Hue, Saturation, and Lightness to get a pale green glow effect.

The final image is the kind of illustration you'd expect to see on the cover of *Newsweek* or *Time* magazine.

JUST HELPING

Todd Pierson's work involves putting kids into impossible situations that appear real but didn't really happen. This image would have been too costly to do for real. So the idea was to make it look like the young boy had painted the car, but in fact he was only painting a board.

1 We'll start with the shot of dad washing the car. Because skies have a tendency to lose colour when the shot is exposed for the foreground, we need to fix this. Make a selection of the sky as shown and via *Select > Feather* give it a 10 pixels feather. Now open the Color Picker by clicking on the Foreground Color box at the bottom of the Toolbar and choose a nice sky blue. With the Brush tool (shortcut B) set at 700 pixels and Multiply mode, lightly brush over the sky to darken it.

2 Open the picture of the boy painting the white board and select *Image > Adjust > Hue/Saturation*. Give the image about +10 Saturation to pump up the colour slightly. Some digital captures will need a little bump in saturation, but this depends on the camera and the lighting of the shot. Toward midday, colours lose some of their intensity and by the time I shot the boy, the day was 20 minutes later than the car image.

3 With the Polygonal Lasso tool (shortcut L) carefully draw around the boy, the paint can, and also include most of the pavement he's standing on. Drag this selection to the car shot and place it in front of the driver's door. A new layer will be created automatically, call it 'boy'.

Now, using the Eraser tool (shortcut E) with a medium soft brush, we need to brush out most of the pavement the boy is standing on. However, be very careful not to brush out his reflections.

We now need to make careful selections of the remaining parts of the board the boy is painting on; the areas between his legs and feet and between his arm and the paint bucket. Even though we'll check all the selection edges later, you could at this point soften them slightly with a 1 or 2 pixel feather.

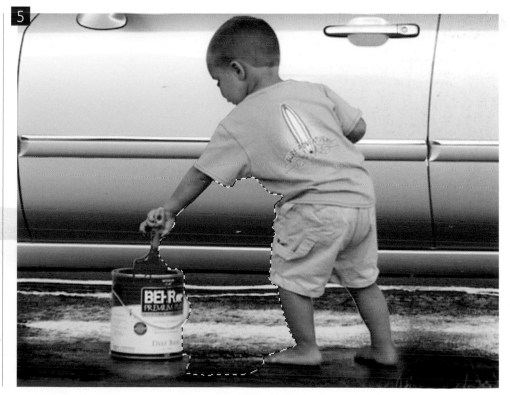

JUST HELPING

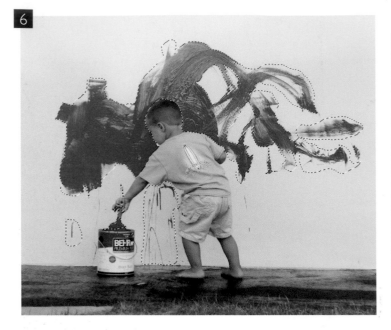

6 We now need to go back to the original picture of the boy and paint image. This time we need to make a selection around the paint.

7 Now drag the selection into the car image and call it 'paint'. Place the 'paint' layer beneath the 'boy' layer and looking at the composite image, line the paint up around the boy's head.

8 With the 'paint' layer still selected Ctrl/Cmd-click the 'paint' layer icon in the Layers palette. This will bring up our paint selection. Choose the Selection Brush tool (shortcut B) and in the Options Bar choose Mask as the Mode. From the brushes palette in the Options Bar select one that has an irregular shape and begin going around the paint to mask the white board that shows. This won't look exactly like the finished image, but that's OK. There is a lot of room for personal interpretation on how much paint to show. You will have to pay special attention to the window and chrome trim because paint does not go over those slick surfaces like it would on the painted surfaces of the car. Once you've masked out the board, choose *Select > **Inverse*** (Ctrl/Cmd+I) and then *Edit > **Cut*** (Ctrl/Cmd+X) to delete it.

9 As one of the finishing touches, we're going to add some drips that I photographed separately earlier. Open the layered 'drips' file and drag the drips to the car shot. Don't worry about placement just yet. First get the layers on top of the other layers and be sure to drag all of them over to the main image.

10 Now put the drips in place. Some are tilted where they should go, but you may have to move them around until they look just right. The last step will be to increase the magnification and check all the edges. You may have to soften some of the edges where you deleted the background. Once you view and finish the edges, you can flatten the image and see if you need to do any other 'edge' work.

And there you have it. A mischievous boy helping out his dad; and you don't have to worry about getting the paint off the new car.

REACHING OUT

Often the temptation when creating a montage in Photoshop Elements is to introduce a large number of elements to the image. However, there are many instances where simplicity works best. Meticulously blending together a few carefully chosen images and textures can create a wonderful, simplistic, and thought-provoking montage. This antique cedar wardrobe cabinet was an ideal prop for a spooky image.

1 First we'll start with the original photo of the arm reaching out of the cabinet. In the Layers palette change 'Background' to 'cabinet'. Also open up the mannequin hand image, and you'll notice that the positions of the fingers differ considerably. We are going to place the mannequin hand on top of the other image on a separate layer and we don't want the fingers to be visible underneath.

2 Select the Clone Stamp tool (shortcut S) from the Toolbox. Hold down the Alt/Option key and click on a section of wood just outside the fingers of the hand to define an origin point for cloning. Make sure to select a soft round brush tip in the Options Bar. Then click and drag to paint with the Clone Stamp tool over the top of the fingers. Continue cloning until you have covered the thumb, fingers, and knuckles.

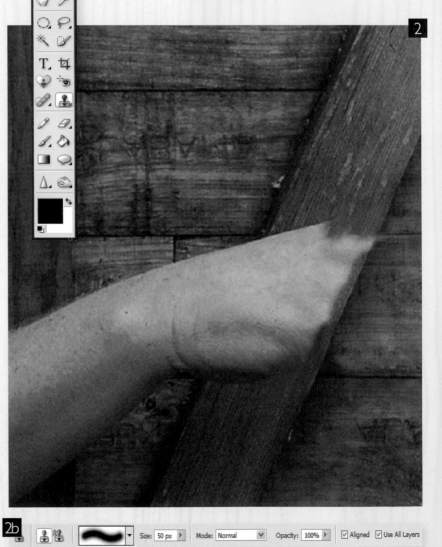

3 Open the unbleached paper image and use the Move tool (shortcut V) to drag and drop it into the working file as a new layer (call it 'paper'). Hold down the Shift key while dragging to preserve the original positioning. Reduce the Opacity of the new layer in the Layers palette to 34% and select the Eraser tool (shortcut E) from the Toolbox. Set the Eraser Opacity to 50%, set the mode to Brush and choose a large soft brush tip in the Options Bar. Click and drag to gently erase the paper in the area that overlaps the arm on the underlying layer.

4 Duplicate the layer by dragging the layer icon onto the 'Create new layer' icon in the Layers palette. Change the blending mode of the duplicate layer to Hard Light. Duplicate this layer and change the layer blending mode to Luminosity. Use the Eraser tool on this layer to remove more of the paper in the centre. Create a new Solid Color layer from the pull-down menu at the top of the Layers palette. When the Color Picker opens, select a brown colour.

REACHING OUT

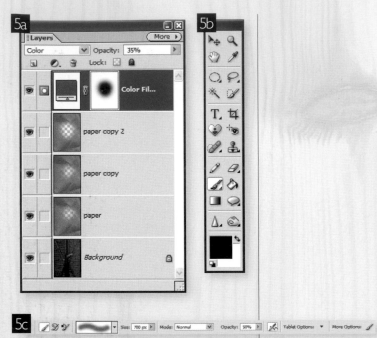

5a

5b

5c

6a
- rmal
- Dissolve

- Darken
- **Multiply**
- Color Burn
- Linear Burn

- Lighten
- Screen
- Color Dodge
- Linear Dodge

- Overlay
- Soft Light
- Hard Light
- Vivid Light
- Linear Light
- Pin Light
- Hard Mix

- Difference
- Exclusion

- Hue
- Saturation
- Color

5 Reduce the Opacity of the Solid Color layer to 35% and change the blending mode to Color in the Layers palette. Select the Solid Color layer's mask by clicking on it in the Layers palette. Select the Brush tool (shortcut B) from the Toolbox and specify a large soft brush tip in the Options Bar and set the Opacity to around 50%. Select a black foreground colour and paint within the centre of the image within the Solid Color layer mask.

6 Create a new Hue/Saturation adjustment layer via the pull-down menu at the top of the Layers palette. Reduce the Saturation by about 10 and click OK to desaturate the image a little overall. Open the first desktop scan of coffee on paper. Use the Move tool (shortcut V) to drag it into the working file as a new layer (call it 'first coffee') and position it lower down in the image area. Change the Opacity of the layer to 60% and the blending mode to Multiply.

5

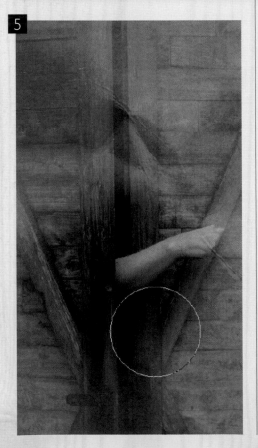

6

TIP Like many functions in Photoshop Elements, there is more than one way to duplicate a layer. In addition to dragging it onto the 'Create new layer' button in the Layers palette there is also a Duplicate Layer option under the Layer menu in the Menu Bar. And, if you right-click (PC)/Ctrl-click (Mac) on your layer content while using the Marquee or Lasso selection tool, a pop-up menu will appear giving you the option to duplicate your current layer.

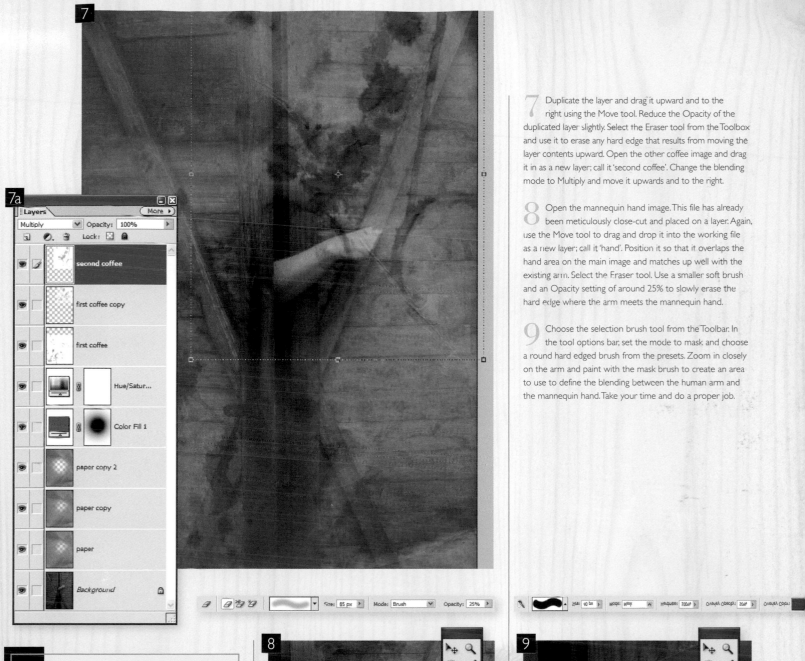

7

7 Duplicate the layer and drag it upward and to the right using the Move tool. Reduce the Opacity of the duplicated layer slightly. Select the Eraser tool from the Toolbox and use it to erase any hard edge that results from moving the layer contents upward. Open the other coffee image and drag it in as a new layer; call it 'second coffee'. Change the blending mode to Multiply and move it upwards and to the right.

8 Open the mannequin hand image. This file has already been meticulously close-cut and placed on a layer. Again, use the Move tool to drag and drop it into the working file as a new layer; call it 'hand'. Position it so that it overlaps the hand area on the main image and matches up well with the existing arm. Select the Eraser tool. Use a smaller soft brush and an Opacity setting of around 25% to slowly erase the hard edge where the arm meets the mannequin hand.

9 Choose the selection brush tool from the Toolbar. In the tool options bar, set the mode to mask and choose a round hard edged brush from the presets. Zoom in closely on the arm and paint with the mask brush to create an area to use to define the blending between the human arm and the mannequin hand. Take your time and do a proper job.

7a

Layers More ▶

Multiply Opacity: 100%

Lock:

👁 ✏️ second coffee

👁 first coffee copy

👁 first coffee

👁 Hue/Satur...

👁 Color Fill 1

👁 paper copy 2

👁 paper copy

👁 paper

👁 *Background*

Size: 85 px Mode: Brush Opacity: 25%

TIP When you wish to zoom in or out while working in Photoshop Elements you don't always have to reach for the magnifying glass in the Toolbar. Simply hold down the Ctrl (PC)/Cmd (Mac) key and press the – key on your keyboard to zoom out, or press the + key on your keyboard to zoom in. You can zoom out to .03% and zoom in to a maximum of 1600%.

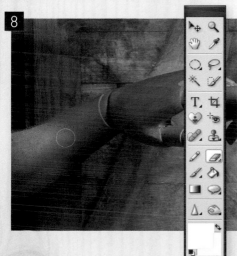

8

9

REACHING OUT

10 Choose the Clone Stamp tool (shortcut S) from the Toolbar. Set the Opacity to 100%, choose a soft brush preset and enable the 'Use All Layers' function in the Options Bar. Create a new layer ('woodskin') in the Layers palette and choose *Select > **Inverse*** (Ctrl/Cmd+I) from the Menu Bar. Alt/Option+click on an area of the wooden arm to define an origin point, then click and drag within the selection border on the 'woodskin' layer to start adding wood over the top of the skin.

11 Reduce the Opacity to 50% and use the Alt/Option key frequently to define origin points as you go along. Continue clicking and dragging until you have created a smooth blend between skin and wood within the selection border on the new layer. When you are happy with the result, create a new layer in the Layers palette ('second woodskin'). Keep the current selection active and select the Brush tool (shortcut B) from the Toolbar.

12 Select a soft round brush tip preset and reduce the Opacity to 25% in the Options Bar. Using a black foreground colour, paint inside the selection on the 'second woodskin' layer to define shaded areas of the arm, concentrate on the underside and where a shadow would be caused at the left by the cabinet door. Hold down the Alt/Option key and click on one of the lightest areas of the fingers to sample this colour as the current foreground colour using the Eyedropper (shortcut I) tool.

13 Reduce the size of the brush and reduce the Opacity to 10% in the Options Bar. Then paint a little highlight on the upper part of the arm within the selection. When you are satisfied, choose *Select > **Deselect*** from the menu to deactivate the selection. Create a new Levels adjustment layer from the pull-down menu at the top of the Layers palette. Quickly darken the shadows and brighten the highlights a little by moving the input levels sliders.

14 Now open up the swirling black and white image file. This file is the result of using the KPT FraxFlame filter on a black background previously and saving it as an image file. Use the Move tool to drag and drop this image into your working file as a new layer; call it 'bw effect'). Hold down the Shift key and drag one of the corners outwards to increase the size of the image within the bounding box until it fills the image area. Click inside the bounding box to position the layer so that it's centred.

15 Choose *Enhance > Adjust Lighting > **Brightness/ Contrast*** from the Menu Bar. Reduce the Brightness setting a little and increase the Contrast so that there are few intermediate grey tones and mostly what remains is black and white. Select the Magic Wand tool (shortcut W), leave the Tolerance set to its default value of 32, enable Anti-alias and disable the Contiguous option in the Options Bar. Click on an area of light grey or white with the wand to generate a selection from that colour.

TIP Use the [and] keys to the right of the P key on your keyboard to scroll up and down the brush sizes. This saves you continually having to go to the Options Bar to change brush sizes.

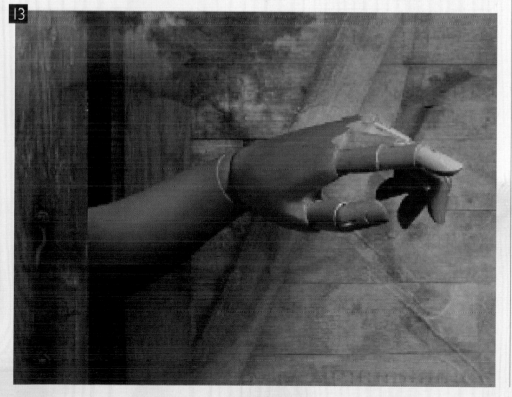

REACHING OUT

16 With the current selection active, disable the visibility of the 'bw effect' layer in the Layers palette and create a new layer ('bw effect 2'). With the new layer selected in the Layers palette, Choose *Edit > Fill* from the Menu Bar. Choose White from the Use menu and leave the blending mode set to Normal and the Opacity set to 100% in the Fill dialog box. Click OK and choose *Select > Deselect* from the Menu Bar (Ctrl/Cmd+D).

17 Choose *Filter > Blur > Gaussian Blur* from the Menu. Enter a pixel radius setting large enough to soften the white fill on the layer and click OK. In the Layers palette, change the blending mode of the 'bw effect 2' layer to Overlay and reduce the Opacity to 26%. Select the Move tool and move the mouse pointer to an area just outside of a corner point on the bounding box. The mouse pointer will change to indicate rotation. Click and drag to rotate the contents of the bounding box. Feel free to grab corner points and resize the contents as well.

18 When you are satisfied with the size and rotation, select the Eraser tool from the Toolbar. Use a large soft brush tip and a low Opacity setting. Begin to erase areas of the layer that overlap key details like the hand. Erase any areas that interfere with the focal point of the image or that are high enough in contrast that they distract from the hand area.

TIP A good way to evaluate many of the tools in Elements is to enter your first choices into the options and click the Preview checkbox on and off. Jumping between the before and after examples makes it far easier to adjust the settings and get the best results for the image.

16a

Select	Filter	View	Window

All	Ctrl+A
Deselect	**Ctrl+D**
Reselect	Shift+Ctrl+D
Inverse	Shift+Ctrl+I
Feather...	Alt+Ctrl+D
Modify	▸
Grow	
Similar	
Load Selection...	
Save Selection...	
Delete Selection...	

18a

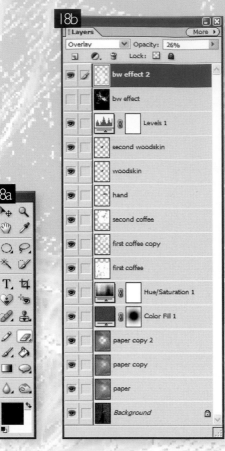

16

17

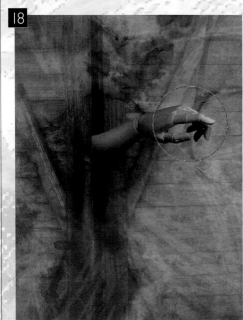

18

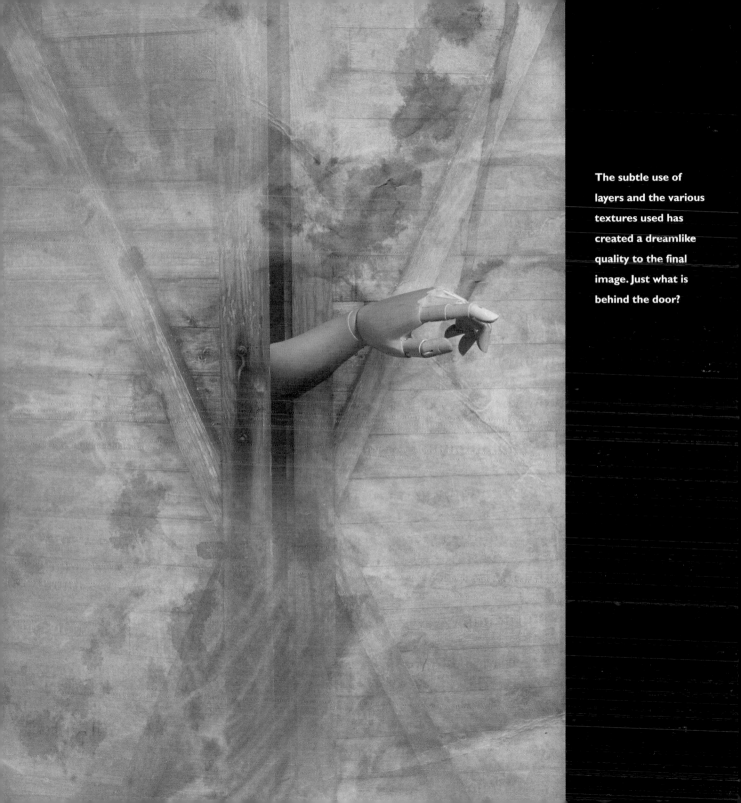

The subtle use of layers and the various textures used has created a dreamlike quality to the final image. Just what is behind the door?

OVERFLOWING BATHTUB

This is a fun image combining photos shot in two different locations. One image was shot in a bathroom and the other was photographed in a basement using a set built to replicate the bottom half of the shot.

1 We'll begin by opening the shot of the boy and bathtub. Then open the shot of the water flowing over the edge of the bath and place this image in the bathtub shot with the boy. You will have to reduce the Opacity so you can move it around and line it up with the first image. Now take the eraser tool and erase everything but the water coming over the edge and the water in front of the first two rows of tile.

2 The tough part to this image was flooding the floor with water without actually destroying the house. The answer was to build a set in the basement that was an exact replica of the bathroom floor. An expensive and time-consuming job, but necessary to get the final image I was after.

3 The camera angle had to be exactly the same as the bathroom shot. Otherwise the shots and tile wouldn't line up. As it turned out, they were not lined up as close as I hoped, so the images had to be adjusted to fit using *Image > Transform > **Free Transform*** (Ctrl/Cmd+T).

4 Now open the image of the flooded floor and drag this layer of water onto the floor in the main shot. Reduce the Opacity in the Layers palette and line it up with the other bath. Here is where you may have to use the Transform tool to make the image fit. Once you're happy with the position of the layer of water, use the Eraser tool (shortcut E) to erase everything but the water on the floor. Zoom in to make sure that you erased the parts that shouldn't show.

5 When shooting this image, it became apparent that I couldn't actually fill the bath to the brim because of the danger of splash over. So I imaged in the water. Open the image of the brim of the bath and lay it over the bath. Line it up so the imported image is in register with the main shot. This image also serves the purpose of showing details of water flowing over the front.

OVERFLOWING BATHTUB

sailboat_68.psd @ 100% (Layer 3, RGB*)

6 Using the Clone Stamp tool (shortcut S) with a soft brush, finish the job by cloning the water right up to the edge all of the way around the tub.

7 Next open the image of the boat and drag it into the main photo. You can place it where you want, but leave room for the 'floating rug' image, which we're also going to place. Reduce the Opacity on the rug just slightly to give it a less harsh appearance. Place the rug over the shadow which I have already completed for you.

8 Because I wanted the room to appear partially illuminated by the window I had to use a relatively long exposure, causing the window to overexpose (as you can see in step 1). I took a separate correctly exposed shot of the window, which we need to place over the window in the main shot. Using the Eraser tool (shortcut E) remove the wall around the second window up to the shade.

9 Now for some room decorating. It's always better to do it in camera if you can, but sometimes, I'll look at a shot and notice something is missing. In this case it was a border above the bathtub to give it a nice finishing touch. Open the separate image of the border and drag it into the shot. Line it up and you should be ready to crop the finished photo. Use the Crop tool (shortcut C) to get rid of the rough working edges. Increase the contrast a little and there you have it.

And here's the final image. An overflowing bathtub with no house damage or insurance claims to worry about.

effects with light

THE POOL ROOM

All photographers know that light and shade are essential to good photography. But with Elements, all that shading can be added after the photograph has been taken.

1 This photograph of a pool room is not a bad picture in itself – but there's so much going on here it's difficult to focus on any one object in the scene. We're going to add shading to draw the eye down to the table, to make sense of all that clutter.

2 We'll begin by drawing some visible light from one of those lamps. Click the 'Create new layer' icon in the Layers palette, and use the Lasso tool (shortcut L) to draw a trapezoidal shape, starting at the lamp and widening as it touches the table. Now use *Select > Feather* to soften the edges of the selection: we've used a 20 pixel feather, but the amount depends on the size of your image.

3 Now open up the Color Picker and choose a bright yellow. Switch to the Gradient tool (shortcut G), and click the Edit button in the Options Bar. Choose the Foreground to Transparent gradient type; this will create a yellow gradient that gradually fades away to nothing.

4 Starting at the top, by the lamp, drag the Gradient tool straight down, finishing just above the table surface. Hold the Shift key as you drag to make it exactly vertical: the result will be a soft-edged light beam.

5 Now we need to draw an extra glow around the bulb itself. Select the Brush tool (shortcut B) with a soft edge and loaded with white, and paint a blob at the top of the selection area. Because the selection has been feathered, the painted light will spill over the edge of the shade in a convincing manner.

6 Let's miss out the middle light – three lamps in a row can look like too much – and go for a more moody shot by just lighting the end lamp. No need to go through the process again: duplicate the 'light' layer, and scale it slightly so it matches the perspective of the new position.

7 We're now going to make a shadow to cover the background. Rather than painting on the background directly, start by making a new layer called 'shadow'. Set the mode of this layer to Multiply, so it only darkens the background image. Move this layer below the 'light' layers, directly above the background layer.

8 Select the Brush tool with a large, soft edge and choose a dark blue colour. Lower the Opacity of the brush considerably – around 30% is a good value – and begin painting in the shadows. With a low Opacity such as this, it's easier to build up the shading bit by bit.

TIP If you have trouble drawing the shape in Step 2, remember you can hold Alt/Option while drawing with the Lasso tool to constrain it to drawing straight lines between click points.

New Layer

Name: Shadow

☐ Group With Previous Layer

Mode: Normal Opacity: 100 ▸ %

Normal
Dissolve

Darken
Multiply
Color Burn
Linear Burn

Lighten
Screen
Color Dodge
Linear Dodge

Overlay
Soft Light
Hard Light
Vivid Light
Linear Light
Pin Light
Hard Mix

Difference
Exclusion

Hue
Saturation
Color
Luminosity

OK

Cancel

xists for Normal mode.)

THE POOL ROOM

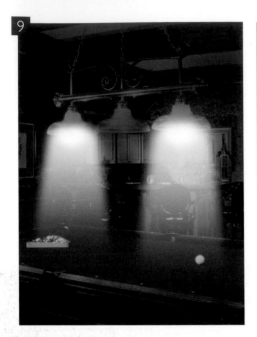

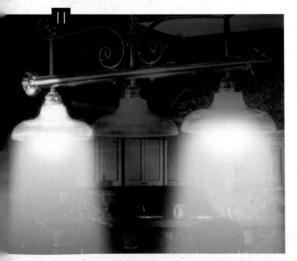

9 Continue all around the room, even adding some shadow to the top of the table. Also, remember to darken that unlit lamp! The room should look really dark so that the lights stand out well.

10 Now we're going to erase the shadow from areas that should be fully lit. Switch to the Eraser tool (shortcut E), and choose a smallish, soft-edged brush. You may have to change to an even smaller brush for fiddly areas.

11 Begin by erasing the shadow over the lamps themselves. Here, the left lamp has been fixed: it looks far more lit than the right lamp, which is still filled with shadow. It's worth changing to a smaller eraser, and losing the shadow on the reflective brasswork above the lights as well.

12 Continue until both lamps, and most of the underside of the brass fitting, have been cleared of their shadows. This can be quite fiddly work at times, and the finer parts of the structure will require a small brush.

13 To add some life to the background of this picture, let's also erase the shadow over the doorway – as if the room beyond is brightly lit. This will help to break up the large expanse of shadow at the back of this room, and create additional visual interest.

14 Now to complete the table scene. Using the Elliptical Marquee tool, (shortcut M), make an elliptical selection on the surface of the table, at the point where the light beam strikes it. Use the Feather command to soften the edge once again: the same amount of feathering we used previously will do well.

15 Now simply press the Delete key to remove that region from the shadow. This easy task creates the light spot on the table that will add focus to the entire scene. Repeat the procedure for the other lamp.

16 Finally, we need to tone the lights down slightly – the brash yellow we started with now looks too strong against our muted background. Use a Hue/Saturation adjustment layer on the 'light' layer to reduce the saturation until it looks right; then repeat the process once more, for the copy of the 'light' layer.

TIP In steps 11 to 13, it's necessary to change between different Eraser brush sizes. No need to keep going back to the palette: use the square bracket keys to make the brush larger and smaller.

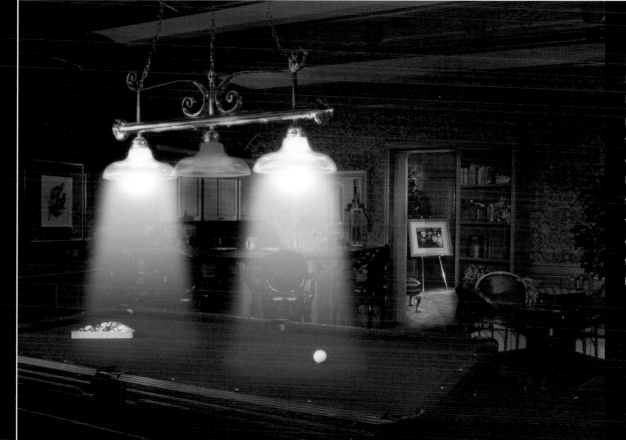

Here's our final image, with all the light and shade in place. Compared with the cluttered original, we now have a striking, focused image with real points of interest in the foreground and background.

FAKING A MULTI-LIGHT SETUP

In any professional photographer's studio, the first thing you'll trip over, after the assistant, is the lights. No matter who or what's being shot, at least three powerful light sources will usually be directed at it, and the time spent shifting them around, twiddling with their tripods, and disentangling the assistant from their cables will account for most of the session.

TIP If you're not fortunate enough to have your own studio, things may not look quite the same. Beginner or expert, enthusiast or pro, we've all found ourselves once in a while trying to snap a decent picture equipped with nothing more than a kitchen table, a small sheet of cardboard that used to be white, and a single floor lamp, ominously marked 'Max 60W'. There's no easy way to get the perfect shot in these circumstances, but a good head start is to use Photoshop Elements to turn one lamp into three or more.

1 Set up your still life and position the camera to frame your shot. Unless you have blackout blinds or thick curtains, wait until evening to do this, so that your tricks won't be foiled by natural light. A room with central lighting on a dimmer switch is most convenient. If you're using a digital camera, you'll need a medium light level to see the LCD clearly.

Make sure your camera is steady. If it's resting on something, rather than screwed firmly to a tripod, get some tape and stick it down, taking care not to get the tape over the lens, any of the sensors on the front of the camera, or the LCD screen (which it could damage). You're going to take the same picture three times, and the three shots need to match, so nothing must move in between. Before you continue, check that you've got plenty of battery life, and put your camera in self-timer mode (if available).

2 Fit your floor lamp with the largest bulb you can find that doesn't exceed its rating. A reflector bulb is best, silvered on the back to direct the light forward. Now imagine you have three lamps, and plan where you'd put them. If in doubt, just pick three different positions around the scene and, if your lamp is easily adjustable, three different heights. Remember shadows are a part of the composition, so make them fall appropriately.

Place your lamp in position one, turn it on and any other lights off, and set the camera not to flash. Check that the camera is happy by half-pressing the shutter button. If you get a low light warning, turn the central lighting up a bit as a boost. Now you're ready to take a shot. Using self-timer will mean it doesn't happen until a few seconds after you stop touching the camera, the idea being that if you wobble it slightly it'll have settled back into place. Take a couple of shots just in case. Now move the lamp to your second position and shoot again. Repeat for position three.

3 Download the pics to your PC and open them all in Photoshop Elements. You should be able to spot which ones have come out best, and which were wobbly or poorly exposed. Pick one from each lamp position, and in turn choose one of these as your starting point—it doesn't really matter which. With the Move tool (shortcut V) click on one of the other images you've chosen and drag it onto this one. Give each layer the name of a lamp, such as 'lamp one' and 'lamp two'.

4 Move it around and it'll snap into place. Repeat for the third image, so that they're all stacked up, as you can see in the Layers palette. Use the pop-up menu at the top left of the palette to change the top two layers' blending modes to Overlay. (The Background layer doesn't have a blending mode.)

TIP

Don't forget to check that your pictures line up. However careful you were to keep the camera and subject still, there'll be tiny discrepancies between the shots. These can usually be fixed by nudging a layer (with the Move tool active, use the cursor keys), but you may sometimes need to rotate it slightly. Click the eye icons in the Layers palette to turn layers on and off so you can see which one is the furthest out and try tweaking it first. When everything's aligned as best you can, use the Crop tool (shortcut C) to cut off any overlap at the edges.

FAKING A MULTI-LIGHT SETUP

5 To combine the images successfully into a well-lit picture, you'll need to experiment with their blending modes. Experiment to find combinations of modes that give a good picture. You're looking for lots of contrast without bleached highlights or gloomy shadows. For example, try leaving the second layer in Overlay mode while changing the first to Lighten.

6 A good rule is to use a darkening mode on the second layer and a lightening one on the first. For a more saturated, glowing picture, try Linear Burn and Linear Dodge respectively.

7 Because you're basically adding light, the picture looks better and better. But you may be missing out on some cool shadows, like the one at the left of the 'lamp one' image in this example, which fills a space in the arrangement. To bring these out, try a combination such as Hard Light and Pin Light.

8 Notice the red colour cast that emerges quite strongly in some layer combinations. This is the result of shooting under ordinary tungsten lighting. You may like the effect, but if not, correct it by applying Auto Levels to each layer (shortcut Ctrl/Cmd+Shift+L). You can then get a very natural effect by setting both upper layers to Lighten.

9 Don't overlook the more exotic blending modes. This dramatic version uses Exclusion, which creates a kind of solarized negative, for the second layer, and Linear Light for the first.

10 You can also experiment with the layer order, as this will also provide an entirely new range of possibilities.

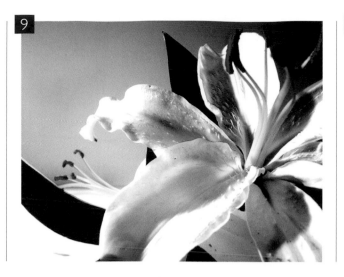

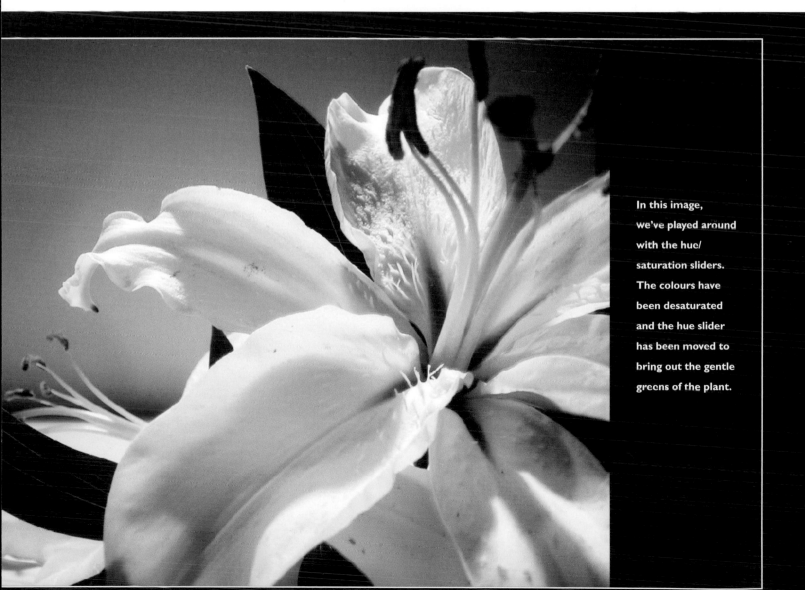

In this image, we've played around with the hue/ saturation sliders. The colours have been desaturated and the hue slider has been moved to bring out the gentle greens of the plant.

LOVELY LIGHTNING

Photoshop Elements offers a variety of ways to add drama to a scene by taking control of the weather. We can create a dramatic stormy scene without the risk of being soaked to the skin or electrocuted by a bolt of lightning. Indeed, natural phenomena such as lightning are virtually impossible to catch on camera, so we'll look at a Photoshop Elements' technique that will enable us to create a bolt from the blue from the comfort of our desktop. Using the Cloud Filter, the Magic Wand, and a sprinkling of other Menu commands, we can make sure that creative lightning does strike twice (or as many times as we need!).

1 The first thing to do to add drama to any scene is to replace a boring-looking sky with a more exciting cloudscape. In our example, we selected the Magic Wand tool (shortcut W) to select the unwanted sky. Hold down the Shift key and click to add unwanted clouds to the selection. The default Tolerance setting of 32 should enable you to select all the unwanted blue-sky pixels.

2 Double-click on the background layer's thumbnail to unlock it. With the Magic Wand selection still active hit the Backspace key to delete the sky. *Edit* > **Copy** (Ctrl/Cmd+C) a more dramatic sky from a different image and then *Edit* > **Paste** (Ctrl/Cmd+V) it into the scene on a new layer. Place the 'new sky' layer behind the 'building' layer.

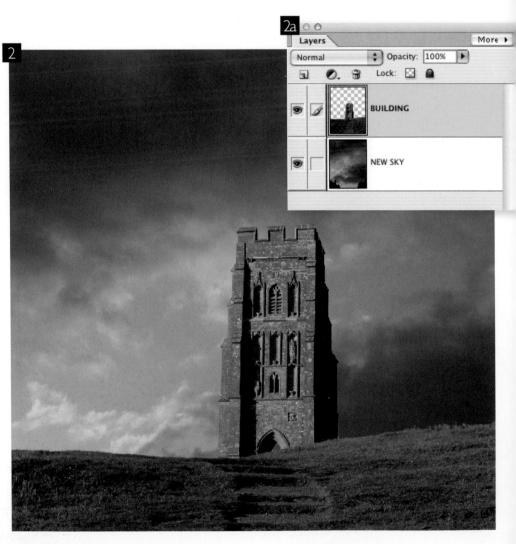

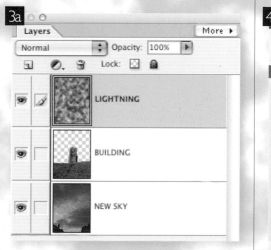

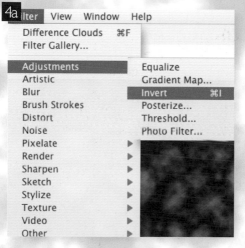

3 Click the 'Create a new layer' icon in the Layers palette and call it 'lightning'. Go to the Menu Bar and select *Filter > Render > Clouds*. This will fill the layer with a fractal-generated cloud. Now go back to the main menu and choose *Filter > Render > **Difference Clouds***. This will create a layer of clouds with black, zigzag veins running through it. These will form the basis for our lightning bolts.

4 To turn the black zigzags to white go to the main menu and choose *Filter > Adjustments > **Invert*** (Ctrl/Cmd+I). Then increase the contrast of the image by choosing *Filter > Adjustments > **Equalize***. You'll now see more dramatic white, zigzag shapes in the clouds.

5 Go to the Layers palette and set the 'lightning' layer's blending mode to Lighten. This will hide all the unwanted black cloud sections, leaving the more dramatic fractal-generated zigzags visible.

LOVELY LIGHTNING

6 Select a particularly good lightning-shaped section using the Rectangular Marquee tool (shortcut M). *Select > Inverse* (Ctrl/Cmd+Shift+I) the selection to get rid of the majority of the 'lightning' layer. Use the Free Transform tool (Ctrl/Cmd+ T) to rotate the selection to get a long line of lightning striking the top of the building.

7 Use the Eraser tool (shortcut E) to remove some of the 'lightning' layer to isolate a particularly spectacular bolt of lightning. Use a soft-edged brush when using the Eraser tool to hide any telltale traces that show the tool has been used. Change the size of the Erase brush interactively by pressing [to shrink it and] to enlarge it.

8 Place the 'lightning' layer behind the 'building' layer but on top of the 'new sky' layer. With the 'lightning' layer selected in the Layers palette choose *Enhance > Adjust Color > Adjust Hue/Saturation* from the main menu. Click on the Colorize button and drag the Hue slider to give the lightning bolt a more dramatic colour glow around the edges.

9 Once you've chosen a dramatic colour for your lightning bolt, duplicate the 'lightning' layer, place the new layer above the original, and set the blending mode to Vivid Light. This will add a striking glowing intensity to the centre of the bolt.

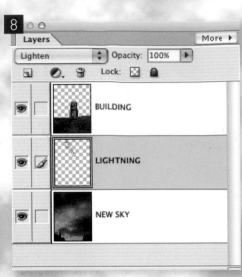

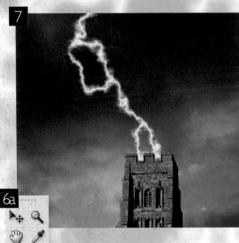

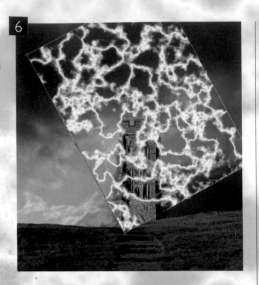

TIP Add emphasis to your lightning strike by creating a glow where it hits the building. Set the Foreground Color to white. Select the Gradient tool (shortcut G) and set it to Radial. Go to the Gradient Editor and choose the Foreground to Transparent option. You can now draw a fading glow on the area where the lightning hits the building.

10 Turn on the taps by filling a new layer with the Clouds filter. Go to *Filter > Noise > Add Noise*. Set the Noise value to 200% and make it Monochromatic. Then turn the Noise to streaks of rain by using *Filter > Blur > Motion Blur*. Then choose *Image > Adjustments > Equalize* and set the 'rain' layer's blending mode to Screen.

Our final image is a dramatic transformation from the first sunny shot; and all the equipment stayed safe and dry.

SUNSET STRIP

A field of hay bales is an image you'll probably find in most landscape photographers' collections, after all, they don't move and are particularly photogenic. Our picture was taken on a sunny afternoon, it's OK, but lacks mood. Here, we're going to merge the original photograph with a photograph of a sunset to create a single, more ambient image.

1 Let's begin by opening both the picture of the bales and the sunset photo.

2 Always make a copy of the original image, that way, if you do make a mistake, it's a lot easier to fix. To do this, you can either drag the layer thumbnail to the 'Create a new layer' icon in the Layers palette or by selecting *Layer > Duplicate Layer*. Click the layer visibility icon (the eye) on the background layer to hide it.

3 Make sure you are working on the copy (it will be highlighted and will have the paintbrush icon showing). It's good practice to give meaningful names to your layers, in this case, 'bales'.

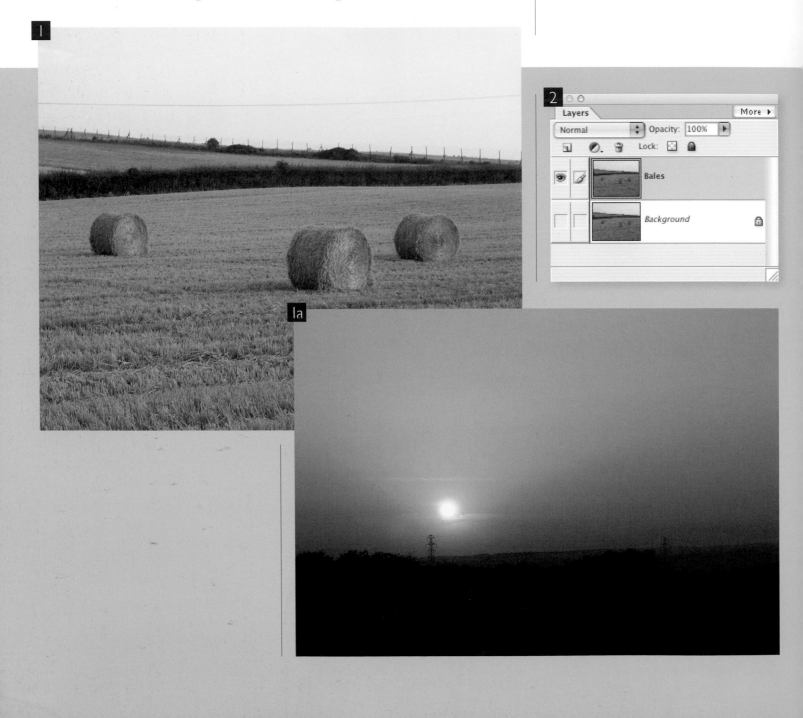

4 As nice as it is, that blue sky needs to go! Select the Magic Wand (shortcut W) from the Toolbar and use the settings shown. Click the Magic Wand tool anywhere in the sky, the entire area should now be selected. If there are any obvious parts that have been missed, hold down the Shift key and click that area to add it to the selection.

5 The horizon will need a soft edge if it's going to blend in with the new background. From the Select menu; choose *Modify* > **Expand**, enter a value of 3 pixels, and click OK. Again, from the Select menu, choose Feather (Ctrl/Cmd+Alt/Option+D) and enter a value of 2 pixels and click OK. Now press the Delete key or from the Menu Bar *Edit* > **Clear**. Choose *Select* > **Deselect** (Ctrl/Cmd+D) to deactivate the selection.

6 Now that we've prepared the image, it's time to add the background. Click on the 'sunset' layer to make it active. Choose *Select* > **All** (Ctrl/Cmd+A) from the Menu. The entire image should now be selected, choose *Edit* > **Copy** (Ctrl/Cmd+C) from the Menu.

7 Bring the 'bales' image back to the foreground and select *Edit* > **Paste** (Ctrl/Cmd+V) to place the sunset on a new layer. The sun sets in the west, so our image needs to be mirrored; *Image* > *Rotate* > **Flip Layer Horizontal**.

8 The position of the sun still isn't quite right; Select the Move tool (shortcut V) and drag the layer horizontally with the mouse, so that the right-hand edge of the sun is at the far right of the image.

9 There's an obvious problem now, our sky has a hole in it! With the Move tool still selected, click and drag the middle-left handle of the bounding box to the far left of the image. Press Enter or click the tick icon on the Options Bar to set the resize.

10 Go to *Layer* > *Arrange* > **Send Backward** (Ctrl/Cmd+[) to place the sunset behind the field. Position the sun vertically so it's about half way behind the landscape.

11 Because we've changed the time of day, we need to move the shadows. Select the Clone Stamp tool (shortcut S) with a medium-edged brush, around 70–80 pixels in diameter. Hold down Alt/Option and click in the area just below the central bale's shadow. Now, carefully paint out the shadow. The Clone Stamp can be a difficult tool to master; sometimes it's best to sample and dab the brush, rather than use one continuous stroke. Repeat the process for the other shadows.

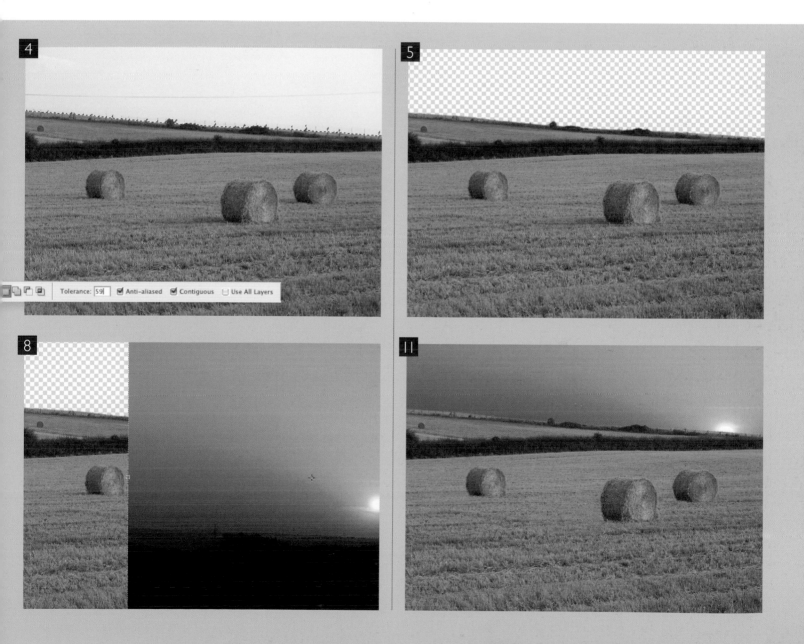

Tolerance: 59 ☑ Anti-aliased ☑ Contiguous ☐ Use All Layers

SUNSET STRIP

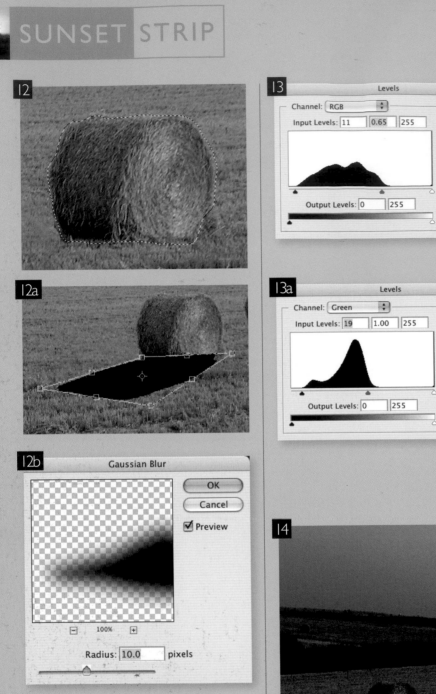

12 Now that we've removed the original shadows, we need to make our own. Create a new layer above the 'bales' layer and label it 'shadow 1'. Select the Lasso tool (shortcut L) and draw a rough outline around one of the bales. Select *Edit > Fill* and choose black for the contents. Deselect (Ctrl/Cmd+D) and choose *Image > Transform > Free Transform* (Ctrl/Cmd+T). While holding the Ctrl/Cmd key, drag each of the corners to distort the shadow so it appears to lie flat on the ground. Once you are content with the angle, press Enter or click on the tick icon in the Options Bar to accept the transformation. Now select *Filter > Blur > Gaussian Blur* and set the radius to around 10 pixels.

You'll notice that the shadow overlaps the bale. Choose the Eraser tool (shortcut E) and choose the softest brush (repeat Shift+[) and an Opacity around 30%. Carefully paint out the overlapping areas. Repeat the whole process for the remaining bales, renaming the new layers accordingly. We should now have three rather harsh looking shadows.

13 We now need to give our scene the effect of waning sunlight. Reselect the 'bales' layer and select *Enhance > Adjust Lighting > Levels* (Ctrl/Cmd+L). Move the sliders to the positions shown.

A sunset throws a strong red/orange cast, so we need to take out some of the green from the field. Click the Channel drop-down menu and select Green. Adjust the left-hand slider so it meets the edge of the histogram.

14 Select each of the shadow layers one by one and lower their overall Opacity to around 50%.

15 There's one final adjustment. We need to darken the faces of the bales. Go back to the 'bales' layer again and select the Burn tool (shortcut O). Set the Range to Midtones and using a soft-edged brush, with a low Exposure (around 20–25%), paint out the lighter areas.

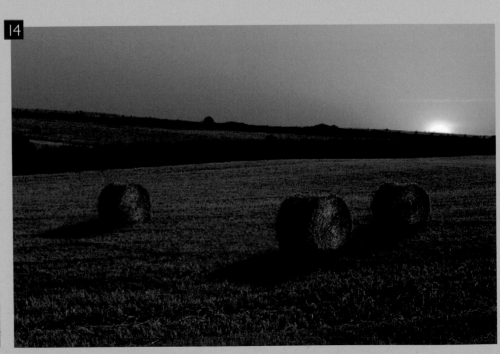

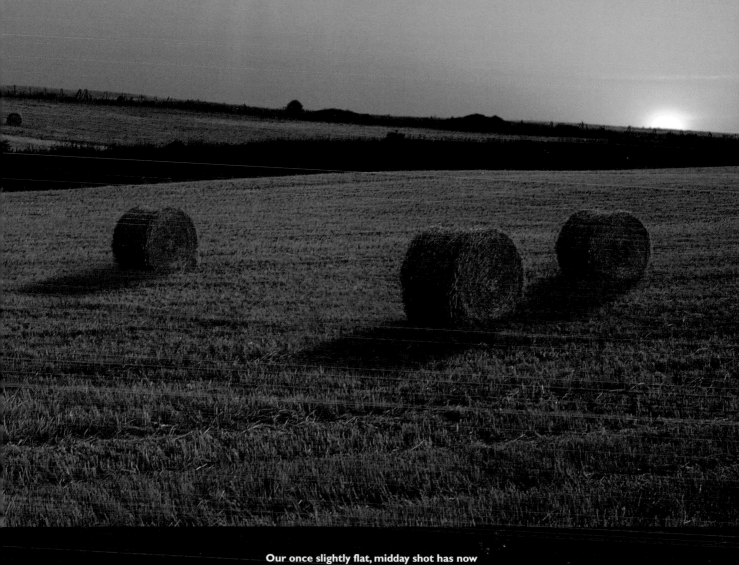

Our once slightly flat, midday shot has now
been imbued with a soft evening light, that
creates a much more pleasing image.

RAY OF SUNLIGHT

You can add an ethereal feeling to your imagery by introducing rays of light. Here, we'll show you how to create the illusion of the sun shining through a window, complete with the cloudy effect caused by swirling dust particles.

1 We'll begin by opening the image of the room and naming it 'room'. The next thing we need to do is define the overall area and shape of our light beam. Select the Polygonal Lasso tool (shortcut L) and click to add the first point, then move the mouse and click again to add the second point. We'll continue in this manner until we've created a selection that frames the top and left of the window and indicates the direction of the light beam to the lower right. Close the selection by either returning to our first point or pressing the Enter key.

2 Click the 'Create a new layer' icon in the Layers palette and call it 'beam'. Click on the Foreground Color swatch in the Toolbar to open the Color Picker. Select a very light yellow from the picker to use as the current Foreground Color. Press Alt/Option+Delete to fill the active selection on the 'beam' layer with the light yellow colour.

3 Choose *Select* > **Deselect** (Ctrl/Cmd+D) from the Menu to deactivate the selection. Reduce the Opacity of the layer to 20% in the Layers palette. Choose *Filter* > *Blur* > *Gaussian Blur* from the Menu. Specify a large-enough radius setting to soften the edges of the yellow area considerably. Select the Eraser tool (shortcut E) and choose a large, soft round brush tip from the preset picker in the Options Bar. Reduce the Opacity of the Eraser to 15%.

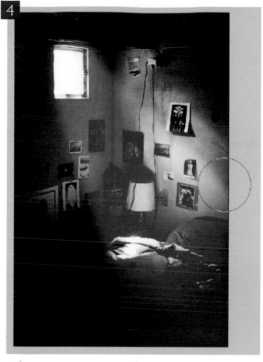

4 Use the Eraser to erase the bottom right of the yellow shape. Click and drag, going over some areas more than once, to gently erase the edges and create a softer blending effect in this portion of the image. Drag the 'beam' layer icon onto the 'Create a new layer' icon in the Layers palette to duplicate it. Change the blending mode of the 'beam copy' layer to Overlay and use the Eraser to soften the bottom right corner of this layer even further.

5 Create another new layer in the Layers palette and call it 'clouds'. Press the 'D' key on your keyboard to set the foreground and background colours in the Toolbar to their defaults. The default settings are a foreground colour of black and a background colour of white. From the Menu, select *Filter* > *Render* > **Clouds** to create a random cloud pattern in the 'clouds' layer using the current foreground and background colours.

RAY OF SUNLIGHT

7 Turn off the visibility of the "clouds" layer in the Layers palette and create a new layer called "gradient." Select the Gradient tool (shortcut G) and choose the Radial option and the Foreground to Transparent preset option from the Options Bar. Specify a light yellow foreground color from the Color Picker once again. Now we set the Opacity of the Gradient tool to 50% and click and drag within the active selection. Start from the center of the window and drag outwards to create a gradient on the new layer.

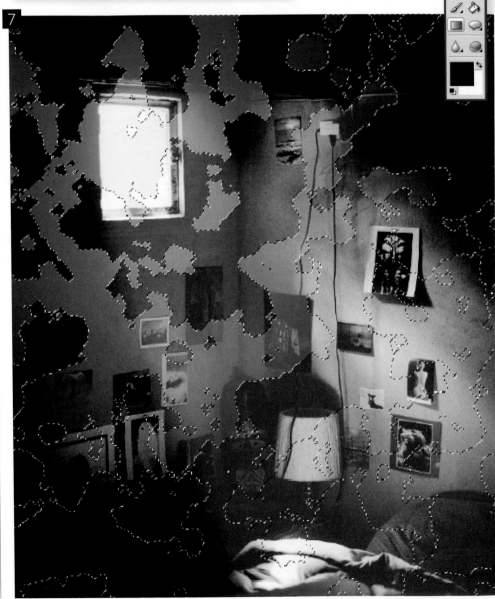

6 Choose *Enhance > Adjust Lighting > **Brightness/ Contrast*** from the Menu. Increase the contrast of the 'clouds' layer by about 30. Select the Magic Wand tool (shortcut W) and in the Options Bar set the Tolerance to 50, enable Anti-aliasing, and be certain that the Contiguous option is deactivated. Click on a light grey area of the 'clouds' layer with the Magic Wand to generate a selection based upon that range of colour and the limits specified by the Tolerance setting.

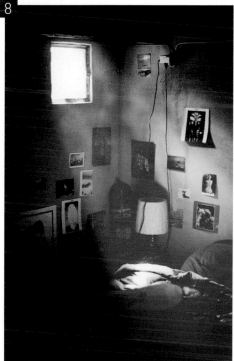

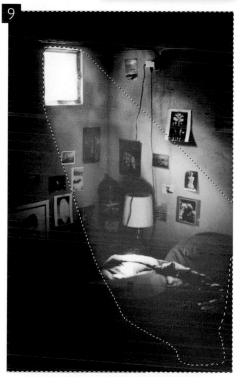

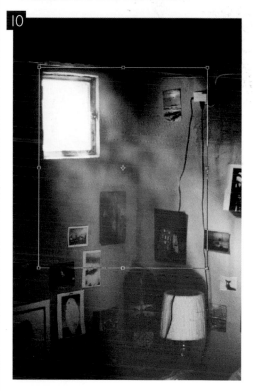

8 Deselect (Ctrl/Cmd+D) and choose *Image > Transform > Free Transform* (Ctrl/Cmd+T) from the menu. Hold down the Ctrl/Cmd key and drag the corners around to reshape the contents of the bounding box so that it roughly matches the beam of light. Press Enter to apply the transformation. Change the layer blending mode to Overlay and then choose *Filter > Blur > Gaussian Blur* from the Menu. Choose a radius setting that is about half of what we used previously for the edges of the beam.

9 Now hold down the Ctrl/Cmd key and click on the original 'beam' layer thumbnail in the Layers palette. This generates a selection from the contents of the layer. Choose *Select > Inverse* (Ctrl/Cmd+Shift+I) from the menu to invert the selection. Be certain that your top layer is selected in the layers palette and then press the Delete key to delete any content that falls outside of the beam area. Choose *Select > Deselect* (Ctrl/Cmd+D) from the menu.

10 Drag the 'gradient' layer thumbnail onto the 'Create a new layer' icon at the top of the Layers palette to duplicate it. Change the blending mode to Screen to create a brighter effect when the blurred clouds blend with the underlying layers. Use the Free Transform (Ctrl/Cmd+T) function to resize and reduce the contents of this layer. Make these clouds a little smaller and position them a little closer to the window. Click Enter to apply the transformation again.

RAY OF SUNLIGHT

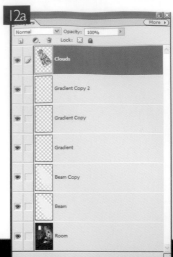

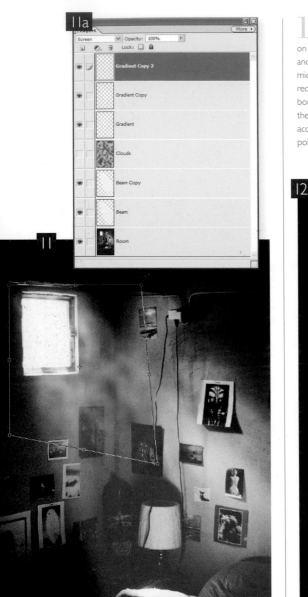

12 Bring the original 'clouds' layer to the top of the Layers palette and enable its visibility by clicking on the eye icon. Select Free Transform (Ctrl/Cmd+T) again and this time drag the midpoints of the sides inward and the midpoints of the top and bottom outward to create a more rectangular shape. Move the mouse pointer outside of the bounding box until it changes to indicate rotation. Rotate the box so it matches the angle of the light beam more accurately. Hold down the Ctrl/Cmd key and drag the corner points to adjust the shape of the box, too.

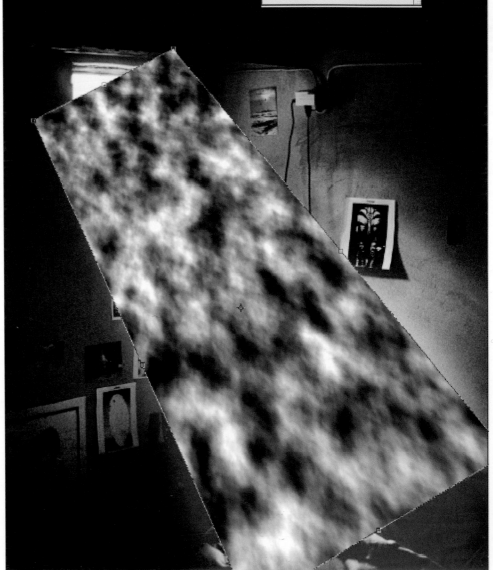

11 Duplicate the 'gradient' layer using the same technique and again, choose Free Transform from the *Enhance* > *Transform* menu. Reduce the contents of the bounding box even more, but do not let them extend beyond the top or the left of the window in the image on the 'room' layer. Hold down the Ctrl/Cmd key and drag the bottom right point outward. Move it around and watch the contents of the bounding box. When the box contents cover more of the dark areas between clouds on previous layers, hit Enter to apply the transformation.

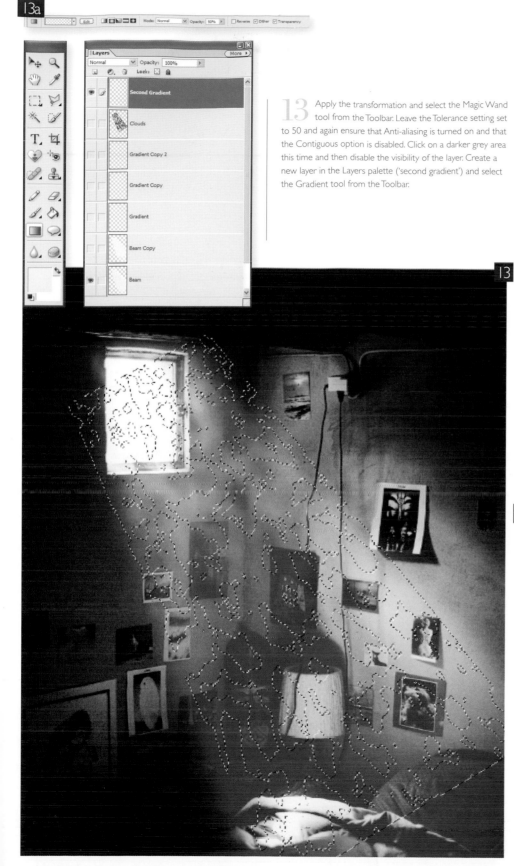

13 Apply the transformation and select the Magic Wand tool from the Toolbar. Leave the Tolerance setting set to 50 and again ensure that Anti-aliasing is turned on and that the Contiguous option is disabled. Click on a darker grey area this time and then disable the visibility of the layer. Create a new layer in the Layers palette ('second gradient') and select the Gradient tool from the Toolbar.

TIP The Magic Wand's Tolerance setting allows you to specify whether to include a broad or narrow range of colour in your selection. The default Tolerance setting of the Magic Wand tool is 32. However, you can increase the range to as much as 255 or decrease the range to as little as 0.

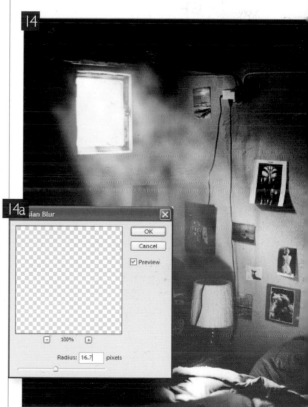

14 Select the Radial gradient that we used previously, with a Foreground to Transparent preset, 50% Opacity, and a soft yellow foreground colour. Click and drag within the active selection, creating a radial gradient from the window frame outward. Choose *Select > Deselect* (Ctrl/Cmd+D) from the Menu to deactivate the current selection and then choose *Filter > Blur > Gaussian Blur* from the Menu. Leave the Radius setting set the same as it was previously and click OK.

RAY OF SUNLIGHT

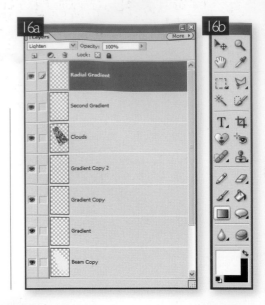

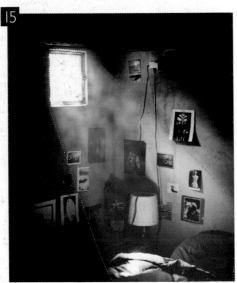

16 Choose *Select* > **Inverse** (Ctrl/Cmd+Shift+I) from the Menu to invert the selection back again to its original form. Create a new layer ('radial gradient') in the Layers palette and specify a white foreground colour by resetting the Foreground/Background colours to their default settings and then inverting them by typing the 'X' key on the keyboard. Click and drag within the selection on the 'radial gradient' layer to create a small, white radial gradient near the window. Change the layer blending mode to Lighten and deselect (Ctrl/Cmd+D) the current selection.

15 Change the 'second gradient' layer's blending mode to Screen and reduce the Opacity of the layer to 70% in the Layers palette. Hold down the Ctrl/Cmd key and click on the layer thumbnail of the 'beam' layer in the Layers palette to generate a selection from the contents of that layer. Choose *Select* > **Inverse** (Ctrl/Cmd+Shift+I) from the Menu to invert the selection. Choose the 'second gradient' layer in the Layers palette and press the Delete key to delete the unwanted portions of your gradient-filled clouds on this layer.

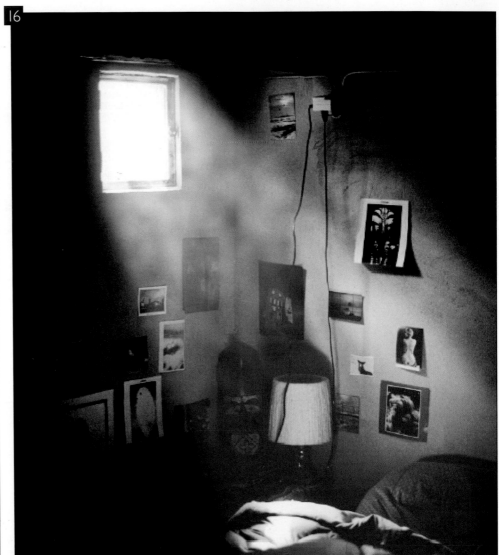

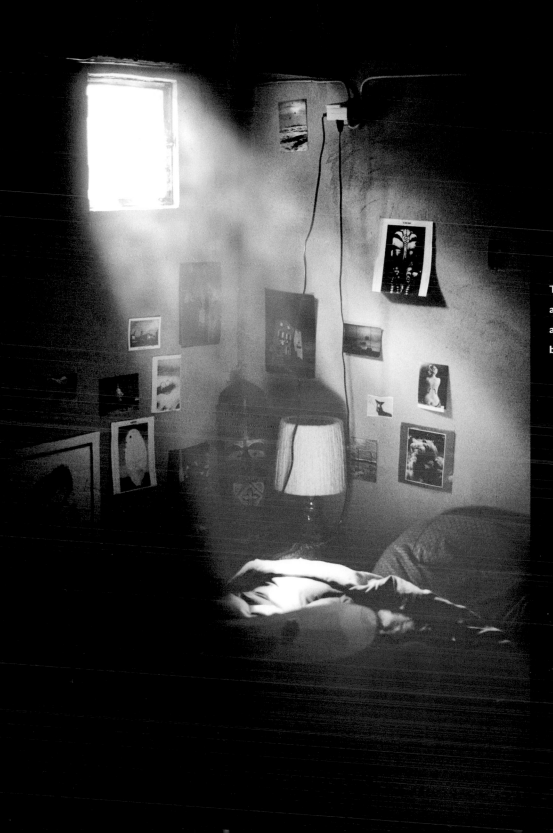

The final image creates
a much more evocative
atmosphere, somehow
bringing the picture to life.

AWESOME AUROROS

There's something magical about the colourful cosmic lightshow of the *Aurora Borealis*. The Inuit people believed that these shimmering curtains of colour were lights from the afterlife guiding the souls of the dead through holes in the sky. We now know that the lights are caused by particles from the sun reacting with the Earth's magnetic field. Knowing the science behind the phenomenon doesn't detract from its beauty. The ephemeral colours of the Northern Lights can be seen if you're willing to make the trip to Norway or Sweden (or if you're really lucky, you can catch them from the Highlands of Scotland). Thanks to Photoshop Elements' Gradient tool, we can create Auroras to magically enhance our own landscape photos.

1 We'll begin with a suitable source photo. The best type of shot for this effect will have a cloud-free sky with plenty of space for the Aurora. As the lights are seen in the evening, we'll need to turn the foreground elements into a dramatic silhouette. Take the Magic Wand tool (shortcut W) and click to select the sky. You might need to choose *Select > Similar* to catch all the sky-coloured pixels hiding in tree branches and other such areas.

2 When you've selected all the pixels making up the sky, choose *Select* > *Inverse* (Ctrl/Cmd+Shift+I). This will select all the trees and buildings. Click on the 'Create a new layer' icon in the Layers palette. Label this layer 'silhouette'. Go to the main Menu Bar and choose *Edit* > *Fill*. Fill the new layer with black to create a striking silhouette effect.

3 Hit Ctrl/Cmd+D to deselect the selection. Create a new layer for the Northern Lights to inhabit called 'aurora'. Place the 'aurora' layer between the 'silhouette' layer and the original background layer. Select the Gradient tool (shortcut G) from the Toolbar. Click on the Edit button in the Options Bar to bring up the Gradient Editor.

4 The Gradient Editor lets you choose a variety of different gradient styles and colours from its Presets menu. You can leave the tool set to a default Black to White gradient or select the Spectrum Gradient to create rainbow type effects. To create your Aurora leave the Gradient Preset as it is and change the Gradient Type setting to Noise. This gives you vertical bands of colour in your gradient.

5 Auroras can be made up of a variety of colours. Click on the Randomize button until you get a colour scheme that takes your fancy. We went for a mystical mix of blues and pinks. When you're happy with your cosmic colour scheme click OK.

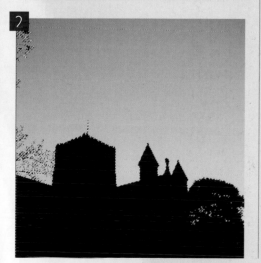

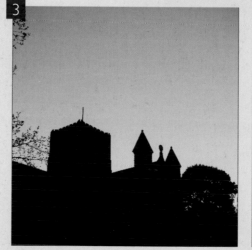

AWESOME AURORAS

TIP

Once you've created an Aurora-styled Gradient that you're happy with, using the Gradient Editor, save the settings for access at a later date. Click on Save in the Gradient Editor window and label the Gradient Aurora.grd. You can load this edited gradient back in from Photoshop Element's Gradient Folder or even share your edited gradient with friends.

6 Select the 'aurora' layer from the Layers palette. Make sure the Gradient tool is set to a Linear Gradient by clicking on the Linear Gradient button in the Options Bar. Click and drag the mouse across the screen from left to right to draw your custom-made Aurora-style gradient.

7 To give the bands of colour a more ephemeral billowing look, go to the main menu and select *Filter > Distort > Shear*. Click on the vertical line in the Shear window to add control points. Drag these points left or right to distort the gradient's vertical lines and make them curve. Select the Repeat Edge Pixels option.

8 When you're happy with the look of the distorted 'aurora' layer click OK to apply the Shear effect. This will cause the Aurora to ripple in a more realistic way. At this stage the colours are still too bright and cartoony, so you'll need to make the effect more subtle if it's going to look believable.

TIP

Experiment with different layer blending modes to create different styles of aurora. A quick way of cycling through blending modes is to select the Blending Mode option in the layers palette, then use the up and down arrows to change and apply different blending techniques. This tip only works on the PC version of Elements.

9 The trick to achieving a realistic-looking Aurora is to use layer blends to reduce the intensity of the Aurora's colours and allow some of the natural blue sky from the layer below to show through the gradient. Set the 'aurora' layer's blending mode to Lighten to achieve a more realistic effect.

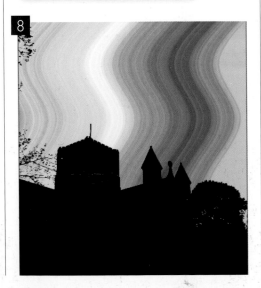

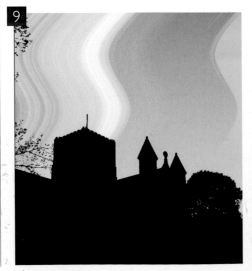

And here's our final Aurora image. The dark silhouette of the church has worked particularly well with this lighting effect.

NEON GLOW

Neon signs evoke dark nights in big cities, cigarettes and alcohol, high life and low life. In graphics and illustrations, they're shorthand for clubs and casinos, motels and bars. Adding a neon effect to text, or any kind of line art, is fairly straightforward, but if you're starting with a photo, you'll first need to turn it into lines. Here's a quick way to do it without taxing your drawing skills.

1 Crop your photo to the part you want to turn into a neon sign, leaving some white space around as many sides as possible. It doesn't matter whether the picture is in colour or black and white, but make sure the image's colour mode (*Image > Mode*) is RGB. Change the layer's name to 'neon'.

2 Go to *Filter > Blur > **Gaussian Blur***, and apply a fairly small Radius. With this image, about 1,500 pixels square, a suitable amount is 4 pixels. The reason for blurring the image is to smooth out a certain amount of detail in preparation for the next step.

3 The command we'll use to turn the continuous-tone photo into hard lines is Trace Contour; this is found in the Stylize section of the Filter menu. Experiment with the Level setting to produce multicoloured lines that give a reasonably clear impression of the subject. Having clicked OK, you'll see what may appear to be broken lines, but if you zoom into 100% image size (Ctrl/Cmd+Alt+0), you'll see the lines are continuous, and exactly one pixel wide.

4 To give the lines some width, use Gaussian Blur again. This time, the Radius setting determines how wide your neon tubes will be, so if you later find they look too chunky or too spindly, use Undo as far as this step and try a different amount.

5 This is how our image should look now. Because of the blurring, the lines have become very faint. This can be corrected with a single command: *Image > Adjustments > Equalize*. The result of this is to bring all the coloured pixels within the blurred lines up to full saturation and brightness, creating solid, thick lines.

6 One of the lines will always be black, which isn't a good colour for glowing neon. To change it, use the Paint Bucket tool (shortcut K). In the Options Bar at the top, set Tolerance to 128 and deselect Contiguous. Hold the Alt/Option key – the cursor shows an Eyedropper – and click in one of the other colours that overlaps the black line. Let go of Alt/Option and click on the black line to fill it with the chosen colour.

7 This would be a good time to check over the lines we've produced. If there are any extraneous blobs, select around them using the Marquee (shortcut M) or Lasso (shortcut L) tools and press Delete (Windows) or Backspace (Mac) to clear.

8 For extra realism, bear in mind that neon tubes always have a beginning and an end, so that they can be connected to an electrical circuit. Simulate this by making at least one gap in each line using the Eraser tool (shortcut E). In the Options Bar, choose Pencil mode and set a fairly small size, then click and drag to paint over small sections of the lines, leaving rounded ends.

NEON GLOW

9 Because the Trace Contour command used in step 3 has no option to 'anti-alias' its results, the lines will have stepped or 'jagged' edges when viewed close-up. Smooth these out now by applying a two-pixel Gaussian Blur.

10 Copy the artwork into a second layer using *Layer > Duplicate Layer*, or drag the layer over to the 'Create a new layer' icon in the Layers palette. Click OK to confirm. Open the Layers palette and you'll see the new layer, we've called it 'new neon'. Using the pop-up menu at the top left of the palette, change its blending mode from Normal to Exclusion.

Click on the original 'neon' layer at the foot of the Layers palette and invert the image (Ctrl/Cmd+I). Then choose *Filter > Blur > Gaussian Blur* and set a Radius about three times as large as we originally used to broaden the lines, in this case 12 pixels. We now have quite a good neon tube effect, but on a white background.

11 With the 'neon' layer still active, use *Layer > Duplicate Layer* (or drag the layer over to the 'Create a new layer' icon in the Layers palette) to copy it into a third layer, called 'third neon'. Drag this to the top of the Layers palette and set its blending mode to Hard Light. Your artwork is now complete.

9

9

10a

10b

10

TIP It's much easier to apply final tone corrections to your artwork if you first flatten the image into a single layer. Before doing so, don't forget to save a copy of the image in Photoshop (.PSD) format with the layers intact: if you need to make changes later, you can still load this and edit the layers individually.

11a

11

To make the sign glow as brightly as possible,
combine all the layers together
(*Layer > Flatten Image*), then use Auto Levels
(Ctrl/Cmd+Shift+L).

FORBIDDING SKY

Lighting is a crucial ingredient to any image's mood. Sunny skies can create an uplifting feeling, while heavy, dark skies can engender a sense of forboding. With Elements, you can control the lighting of an image to a certain degree, and in no time at all change the overall mood of the scene. This can be drastic or subtle.

1 We'll begin by opening the image of a farmhouse set within a field of corn on a beautiful summer's day. This is a very bright, happy, and serene image, lots of uniform primary colours and even lighting.

2 Skyscapes are an ideal subject for lighting adjustment because we are well aware of the weather and what kind of mood the weather is in, just by glancing out of the window. We'll turn this image into a darker and more brooding scene. To begin with we'll tone down the sky. First check that the Foreground colour is set to black, its default colour. Press the 'D' key to reset it if otherwise. Create a new layer (call it 'gradient') and select the Gradient tool (shortcut G). Set the Gradient type to Linear in the Options Bar then click the Edit button.

3 There are two main options we'll consider when using the Gradient tool for this technique, and they are using a Foreground to Background gradient or a Foreground to Transparent gradient. Which one we use is important because it will change the choice of blending modes that we can use. Select the Foreground to Transparent option for this particular gradient.

4 Drag the Gradient cursor from the top of the image to about halfway to draw the gradient. Hold down the Shift key to keep the gradient line perfectly straight.

5 Set the 'gradient' layer's blending mode to Overlay then Ctrl/Cmd-click on the 'gradient' layer to load its transparency as a selection. Click on the 'Create adjustment layer' icon in the Layers palette and select Hue/Saturation. Shift the Hue to about +158 and reduce the Saturation to about –44. This gives a dark, slightly brownish tint to the sky, making it look moody.

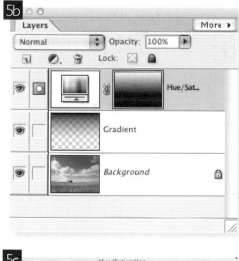

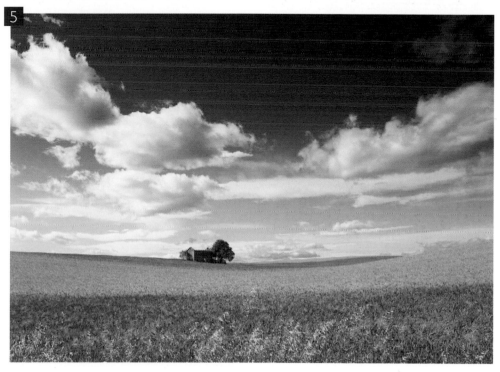

FORBIDDING SKY

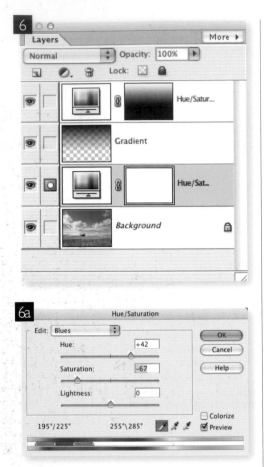

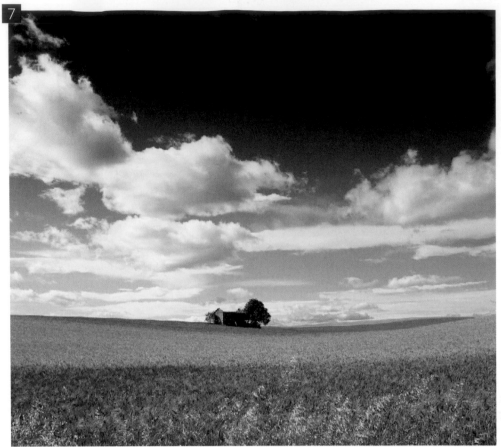

6 Click on the 'background' layer and create another Hue/
Saturation adjustment layer, which will appear below the
'gradient' layer. Select the Blues channel from the drop-down
menu. We can apply separate control to just these colours.
Adjust the Hue to about +42 and the Saturation to –67.

7 Switch back to the Master channel and reduce the
overall Saturation to about –46. This dampens down all
the colours as you would expect if the lighting had changed
in the scene.

8 Finally, we're going to add some fading to the edges
of the frame. In a new layer (called 'edges') use
the Gradient tool to draw a circular gradient using the
Foreground to Background gradient type. Drag from the
centre out past the edges of the image. Set the blending
mode to Multiply. Create a Levels adjustment layer and pull
in the White Point slider to restrict the darkening to just the
very edges of the image.

Even with relatively few straightforward
adjustments, the whole image has taken on a
much more atmospheric feel.

effects with filters

SPILLED PAINT

If you thought the Plastic Wrap filter was just for making polythene, think again: it can be used to create liquids of all kinds in seconds.

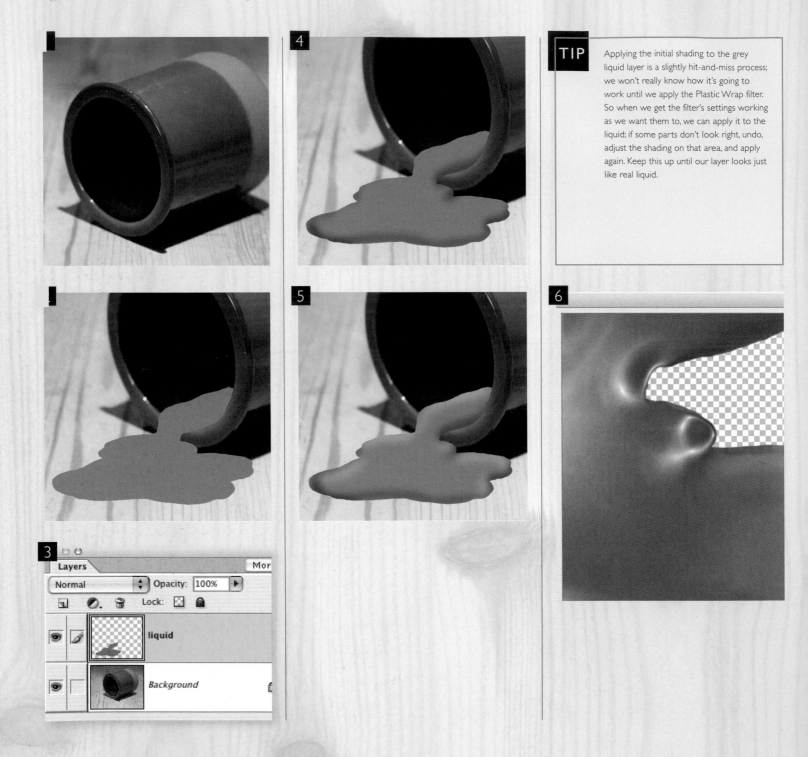

TIP Applying the initial shading to the grey liquid layer is a slightly hit-and-miss process; we won't really know how it's going to work until we apply the Plastic Wrap filter. So when we get the filter's settings working as we want them to, we can apply it to the liquid; if some parts don't look right, undo, adjust the shading on that area, and apply again. Keep this up until our layer looks just like real liquid.

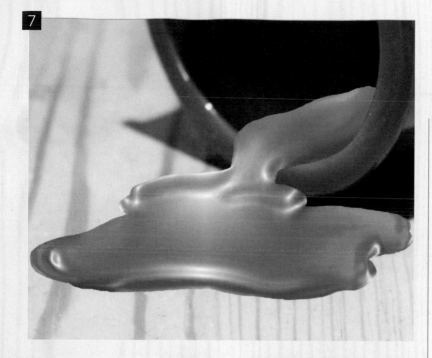

3 Making a new layer for the liquid is essential, since we'll need to treat that layer independently of the background. Always check the Layers palette to make sure you're painting on the right layer!

4 Now use the Burn tool (shortcut O) to darken the edges of the liquid layer slightly. You should aim to darken those edges closest to us: don't overdo it, we need to aim for quite a subtle effect to make this trick work.

5 Next, switch to the Dodge tool (shortcut O) and paint some highlights on the opposite side of the liquid from the shadows we just drew. Again, keep the effect subtle, and don't make either the shadows too dark or the highlights too bright.

6 Now it's time for the Plastic Wrap filter. Open *Filter > Artistic > Plastic Wrap* and a dialog will appear: set the Highlight Strength to maximum, and the Detail and Smoothness settings to about three-quarters of the way along (although feel free to experiment with different settings). One of the odd things about this filter is that the Preview looks almost nothing like the finished result; you'll need to keep applying it and keep changing the settings to get the effect exactly right.

7 Here's the result of the Plastic Wrap filter – and, as you can see, it looks nothing like the preview. Instead, it's turned that soft shading into a shiny, almost reflective surface that, as it stands, looks more like liquid metal than anything else. But we're not finished yet!

8 The key to turning the metal into liquid lies in changing the 'liquid' layer's blending mode, using the pop-up menu at the top of the Layers palette. Experiment with the different blending modes to see the effect they produce: here, we'll begin by changing the layer's blending mode to Screen.

9 In Screen mode, the layer will only brighten what's beneath it, which is why all the dark parts of the layer have disappeared. The result is a watery-looking milky liquid: it's not quite what we want here, though, so let's look at experimenting with other blending modes.

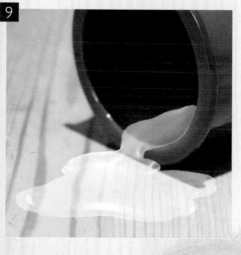

1 Here's our starting image – a stone jar lying on its side on a wooden table. We're going to use a few short steps to make some liquid pour out of this jar – the process is easier than you might think.

2 First, make a new layer on which to paint the liquid, and call it 'liquid'. Pick a mid-tone grey, and use a hard-edged brush to paint the area the liquid will take up. Remember that we're looking from a low angle, so the liquid will appear to spread out more to the sides than up and down.

TIP Because the Plastic Wrap preview doesn't show the end result, you may need to keep on trying the filter, then pressing Ctrl/Cmd+Z to undo, and then reapplying the filter with different settings. There's a useful shortcut here: while Ctrl/Cmd+F will reapply the filter exactly as before, if we hold the Alt/Option key as well, we'll bring up the filter's dialog with the previous settings already set, making it easy to make adjustments and then to apply it again.

SPILLED PAINT

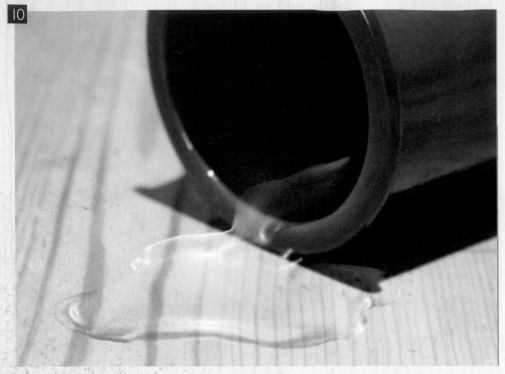

10

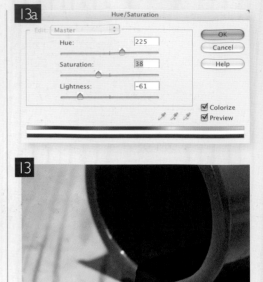

13a Hue/Saturation

Edit: Master

Hue: 225
Saturation: 38
Lightness: −61

OK
Cancel
Help

☑ Colorize
☑ Preview

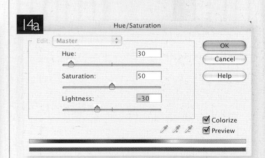

13

11a Hue/Saturation

Edit: Master

Hue: 0
Saturation: 25
Lightness: 0

OK
Cancel
Help

☑ Colorize
☑ Preview

12a Hue/Saturation

Edit: Master

Hue: 0
Saturation: 41
Lightness: −45

OK
Cancel
Help

☑ Colorize
☑ Preview

14a Hue/Saturation

Edit: Master

Hue: 30
Saturation: 50
Lightness: −30

OK
Cancel
Help

☑ Colorize
☑ Preview

11

12

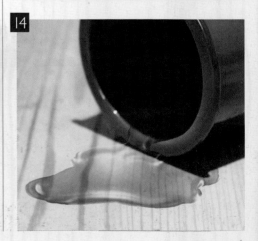

14

10 Changing the mode from Screen to Hard Light gives us an interesting result. In this mode, all the midtones disappear and we're left with just the shadows and the highlights. Although it's sometimes a little hard to see, this is now clearly a puddle of water leaking out of the jar.

11 We can have some fun with this liquid using the Hue/Saturation dialog. When you open it for the first time, make sure you click on the Colorize tickbox to get these default settings. The result is a little insipid, so let's see if we can liven it up somewhat.

12 Moving the Hue slider down to 0 gives us a strong red shade: by raising the saturation a little and lowering the lightness, we can give that liquid a strong apperance of blood. We don't need to say OK to the dialog in order to see the results, of course – it's a live update as we drag the slider.

13 A few tweaks on the settings and we can turn that blood into a spill of dark blue ink. The shadows and highlights remain, however, which add greatly to the realism of the image.

14 By setting an orange hue and raising the saturation, we can change that ink for a reflective, shiny treacle appearance. The kind of liquid you choose is entirely up to you: experiment with the Hue, Saturation, and Lightness settings until you get exactly the liquid you're aiming for.

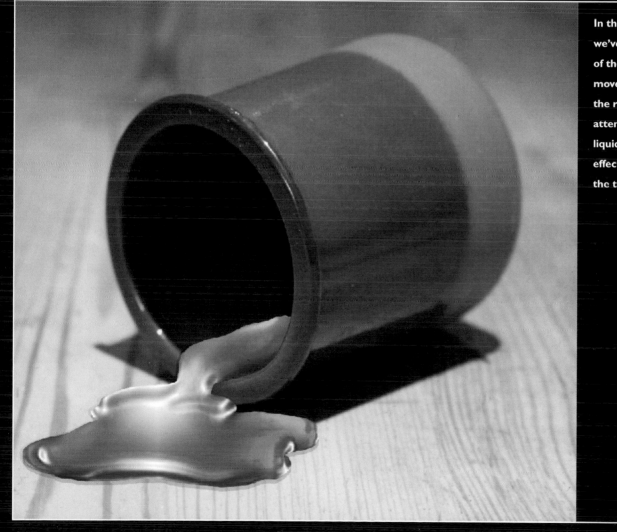

In this final image, we've duplicated one of the liquid layers and moved it down and to the right slightly in an attempt to give the liquid a shadowlike effect where it touches the table top.

FILTERS FOR PHOTOGRAPHERS

Elements is famous for its filters, but applying them without care or attention can make your photos look extremely cheap and nasty. It would be great if filters could be applied to actually improve an image, and save you time and effort, rather than subtract from it. Well, there are some ways of doing this.

1 One of the best filters for photographers is the humble Gaussian Blur. We'll show you some ways you can incorporate this filter into your everyday image retouching workflow using this picture as an example.

2 Duplicate the background layer by dragging it to the 'Create a new layer' icon in the Layers palette and call it "blur." Go to *Filters > Blur > **Gaussian Blur*** and set the radius to about 10 and click OK to apply the blur to the 'blur' layer.

3 Set the layer blending mode of the 'blur' layer to Screen and adjust the Opacity to control the effect. You get a nice inner glow/background bleed effect like a soft focus but without the lack of sharpness. It's a useful style to apply to certain images. For a different look, switch the 'blur' layer's blending mode to Multiply. This darkens the image significantly but gives an interesting dark glow effect that smoothes detail in the image.

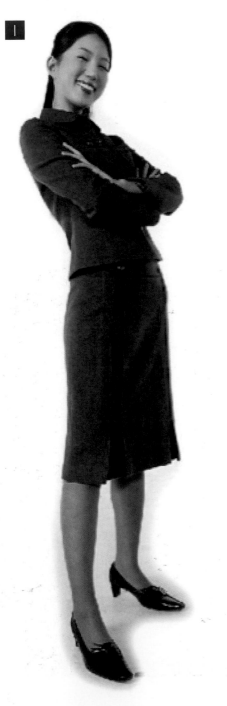

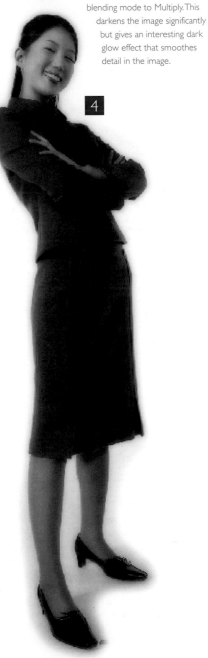

4 To compensate for the darkening we're going to click on the 'Create adjustment layer' icon in the Layers palette and create a Levels adjustment layer. In the Levels dialog window, move the Gamma (or midpoint) slider to the right to lighten the midrange.

5 Another option is to desaturate the blurred layer by typing Ctrl/Cmd+Shift+U. The result gives a really subtle, soft quality to the image yet maintains sharpness, since the original is not blurred at all. It also tends to desaturate the colours slightly, which results in a cooler, more restrained feel to the image. The model seems to be lit more evenly, too.

6 You can of course add a Hue/Saturation adjustment layer to the top of the layer stack to add back the lost saturation. The difference between the original and blur-adjusted image is subtle but very worthwhile. Here are the images sitting side by side so that you can see what we mean. The original is on the right, the blur-adjusted image on the left.

7 If you zoom up close, you can see that the blur-adjusted image looks much less noisy and has a better quality all round, yet we haven't really attempted to do this. You can also pump up the saturation without increasing the jpeg compression artifacts in the image. The original looks a little grainy and dirty by comparison.

FILTERS

8

9

10

9a

dows/Highlights [X]

💡 Learn more about: Shadows/Highlights [OK]
 [Cancel]

Lighten Shadows: [100] % ☑ Preview

Darken Highlights: [0] %

Midtone Contrast: [0] %

10a

| Layers | More ▸ |
| Overlay ∨ | Opacity: 70% ▸ |

🔲 ⊘ 🗑 Lock: 🔲 🔒

👁 🖊 [Shadows]

👁 [Background] 🔒

1 Here's another example of a similar effect. Begin with the image of the girl smiling. Before we apply the blur we'll 'pre-filter' the image using Element's Image Enhance controls. Duplicate the background as before (call it 'shadows' then choose *Enhance > Adjust Lighting > **Shadows/Highlights***.

2 Set the Lighten Shadows slider to 100% and apply the e The result is a very washed out, yet oversaturated image; not what we want as a final result, but great for what we will be doing.

3 Set the blending mode of the 'shadows' layer to Overlay and reduce the Opacity to about 70%. As you can see, the image looks pretty good already. Very bright, even, and saturated.

5 If the skin tone is too vibrant, you can simply apply a Hue/Saturation adjustment layer to the blurred 'shadows' layer and reduce the Saturation of the Red and Yellow channels.

6 If you want an extreme effect, then duplicate the 'shadows' layer to get a bleached skin tone with few distinctive features. Notice that you can still see the finest of hairs on the girl's head despite the blurring that has been applied.

4 Now we're going to remove the odd blemish. Rather than spend ages with the Clone Stamp tool removing every blemish by hand, to even up the skin tone just apply the Gaussian Blur filter to the 'shadows' layer and dial in the amount of blurring required. The more blur applied the smoother the skin appears, yet the image (especially the eyes) remains sharp; here we've set Gaussian Blur to 50. It's the digital equivalent of foundation for your model.

FILTERS FOR PHOTOGRAPHERS

1 Another useful effect for portrait photographers is combining the Noise with the Blur filter to simulate fast film grain. Let's open the image of the man. If we zoom into the image, we can see there's a bit of grain already, but we want to create a really lo-fi grainy look. Here's how.

2 Duplicate the background layer (call it 'noise') and apply Noise to the image using *Filter > Noise > **Add Noise***. Set the mode to Gaussian and enable the Monochromatic option. Set the level of noise you think you'll need. You'll need to add more than you think.

3 Set the 'noise' layer's blending mode to Overlay then apply Gaussian Blur to create the 'film grain' effect we're after. Adjust the layer's Opacity to set the amount of the effect you desire.

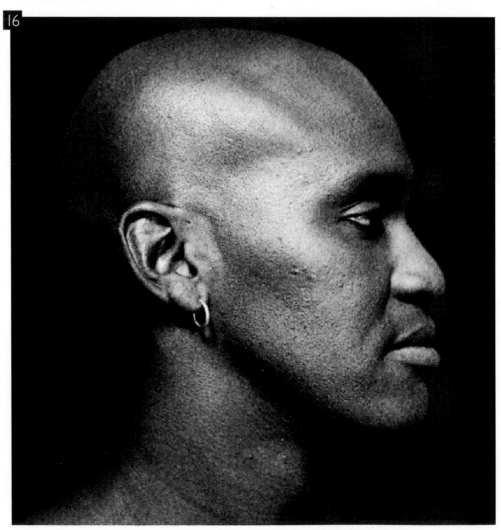

4 If you want a coarser grain effect, then first duplicate the image and resize it to 50%. This will make the grains appear twice as big; to make them four times as big, resize the image to 25% of the original size.

5 Apply the Noise filter to the smaller image as before, then drag this layer into the original image. Type Ctrl/ Cmd+T to enter Free Transform mode and ensure the *View > Snap To Grid* option is checked. Drag the corner handles to snap the images to the document bounds making it the right size once more.

6 Alternatively, you can enter 200% in both the W and H scale boxes in the Option Bar to scale the image up to the original size again; then using the *View > Snap To Grid* option, move the layer back to the centre.

7 Apply an Overlay blending mode once more and adjust the Opacity to taste. You can see that the noise grains are much bigger and coarser than before. It's important to remember that when you're working with very high-resolution images, the effects that the various filters have on the image are much less than with low-resolution files.

LIQUID EFFECTS WITH STONE

Even one of nature's hardest substances isn't impervious to the effects of the Liquify filter in Elements. Stone buildings and statues can be molded like putty, allowing you to create surreal and hallucinatory scenes by clever usage of this powerful tool.

3 For this project, we'll start with the Twirl Clockwise tool from the left. At the right, set the brush size to 75 and set the pressure to 100. Click and hold the brush over the top of an area where a section of the building or roof meets the sky to the right. Like the Airbrush tool, holding down the mouse button keeps applying the tool even if you don't move it. Watch as the spiral creates itself. When you are happy with the result, release the mouse button. Use this method to create a few spiral areas.

TIP For those of you who are using pressure-sensitive drawing tablets, worry not, pressure sensitivity is supported within the Liquify filter. If you enable the stylus pressure tickbox, the pen pressure of your drawing tablet will affect the pen pressure settings within the Liquify filter as you draw. This option is only available when you are using a pressure-sensitive tablet.

1 Let's start off with the abbey image. This will be our background image. Right now it is looking a little too average. To start manipulating the pixels, choose *Filter > Distort > Liquify*.

2 You'll notice that the Liquify interface is familiar enough. There are a selection of distortion, navigation, and reconstruction tools at the left and the tool options for your selected tool are at the right. All of the distortion tools are brush based. So, like the Eraser, Clone Stamp, and Exposure tools in Elements, you can use a variety of different brush tip sizes, from 1 to 600. You can also specify the pressure or strength of any given brush by entering a value of 1 to 100, or using the slider.

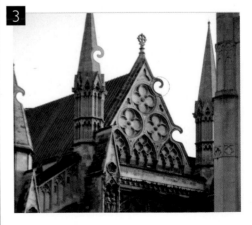

4 Now select the Twirl Counterclockwise tool and use the same size and pressure settings to create a few spirals on the opposite of the steeples and rooftops. When you have finished, greatly increase the size of the brush. Click and hold on some different areas to create much larger twirl effects. Don't be afraid to create these large spiral effects in areas that overlap or include some of the smaller spiral effects.

5 Select the Turbulence tool from the left. This tool will create wave or fire effects by smoothly scrambling the pixels in these patterns. You'll notice that the Turbulence Jitter slider becomes available when you choose the Turbulence tool. The higher you set this value, the more pronounced the effect. For starters, set the value to about 40. Reduce the brush size considerably and paint a few strokes across the right hand side of the image.

6 The effect of the Turbulence tool becomes immediately evident. For a more subtle effect, reduce the Turbulence Jitter to about 10. Increase the size of your brush but reduce the pressure setting to about 50. Paint over the same area as well as other areas within the image. You'll notice the strange hallucinatory effect really starts to happen at this stage.

4a

OK
Cancel
Revert
Help

Tool Options
Brush Size: 255
Brush Pressure: 100
Turbulent Jitter: 70
☐ Stylus Pressure

5a

OK
Cancel
Revert
Help

Tool Options
Brush Size: 145
Brush Pressure: 100
Turbulent Jitter: 40
☐ Stylus Pressure

6a

OK
Cancel
Revert
Help

Tool Options
Brush Size: 236
Brush Pressure: 50
Turbulent Jitter: 10
☐ Stylus Pressure

4

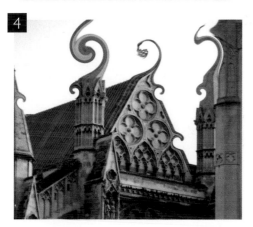

5

6

LIQUID EFFECTS WITH STONE

7 Now, select the Shift Pixels tool. This tool m pixels perpendicular to your stroke. It can be a little tricky to control to begin with, so we're just going to employ it in one small area. Click and drag a counterclockwise circle, using the current size and pressure settings, over top of the abbey's large, round window. You'll notice an interesting effect occur as pixels are pulled inward.

8 Select the Warp tool. This tool will push the pixels in the direction of your brush stroke. Have some fun with the current brush size and pressure settings. Push pixels around and alter the shape of the building. Try using some smaller brush sizes and less aggressive pressure settings to create a series of smaller warp effects throughout the image.

9 Now, the Liquify effects are looking good; however, we are starting to lose a sense of what the image actually is. Often the temptation is, when using Liquify options, to overdo it a little. This is precisely the reason that the Liquify interface contains a Reconstruct tool. Select the Reconstruct tool from the left. Use the current size and pressure settings to click and drag over areas of the image with the Reconstruct tool, returning them to their original state.

7a

OK

Cancel

Revert

Help

Tool Options

Brush Size: 236

Brush Pressure: 50

Turbulent Jitter: 10

☐ Stylus Pressure

8a

OK

Cancel

Revert

Help

Tool Options

Brush Size: 85

Brush Pressure: 22

Turbulent Jitter: 10

☐ Stylus Pressure

9a

OK

Cancel

Revert

Help

Tool Options

Brush Size: 85

Brush Pressure: 22

Turbulent Jitter: 10

☐ Stylus Pressure

10 Increase the size and pressure settings of the Reconstruct tool and paint over areas that need clearer definition. When you are finished, and happy with your Liquify tool result, press the OK button. This will apply the Liquify effect to your actual image and return you to the familiar Photoshop Elements' workspace. The next step is to open up the image of the statue head. Use the Move tool (shortcut V) to drag it into your file as a new layer (call it 'head') and position it to the lower right of the main image.

11 With the 'head' layer selected, choose *Filter > Distort > Liquify* from the menu once again. Zoom in on the face and select the Bloat tool from the left. Use a large brush size and a pressure setting of around 74. Paint over his cheeks with the bloat tool to make them look more bulbous; the same goes for the end of his nose and jowls. The Bloat tool moves pixels away from the brush centre, creating an extruded swelling effect.

12 Select the Pucker tool. The Pucker tool pulls pixels inward toward the centre of your brush. Use the current size and pressure settings. Click and hold on the corner area of an eye, the tear duct corner. Watch as the Pucker tool pulls pixels inward, sinking the area. Do this to the other eye. Then click on the outside corner of each eye and do the same thing.

LIQUID EFFECTS WITH STONE

13 Now, with the Pucker tool still selected, pan down to the lip area. Click and drag on each side of his lips, where they meet the cheek, to pucker this area and give the illusion that it is sunken. Select the Warp tool and leave the size setting the same. Reduce the Brush Pressure setting to 34. Click in the corner at the left of his lips and pull upward and to the right. Let go and click and drag a little more. Continue to do this until a sinister grin starts to present itself on the left side of the image.

14 Use the exact same procedure and tool settings to create an identical effect on the other side of his mouth. Then reduce the Brush Size considerably. Click and drag in small movements at the bottom of his lower lip. Create a bit of a pouting effect. Then continue clicking and dragging in the area above his lip to bring the dark area downward so that it looks as if his mouth has opened.

15 Zoom out a little so that you can see his entire face. Use the Warp tool with the current settings to first click and drag to move the outer edges of his eyebrows upward and out towards the sides of his head. Then push the brow areas closest to his nose downward toward his eyes. When you are finished with the brows, drag the lower areas of his eye bags down a little.

13a

| OK |
| Cancel |
| Revert |
| Help |

Tool Options

Brush Size: 273 >

Brush Pressure: 34 >

Turbulent Jitter: 10 >

☐ Stylus Pressure

14a

| OK |
| Cancel |
| Revert |
| Help |

Tool Options

Brush Size: 121 >

Brush Pressure: 34 >

Turbulent Jitter: 10 >

☐ Stylus Pressure

15a

| OK |
| Cancel |
| Revert |
| Help |

Tool Options

Brush Size: 121 >

Brush Pressure: 34 >

Turbulent Jitter: 10 >

☐ Stylus Pressure

13

14

15

16 Increase the Brush Size of the Warp tool and begin to pull areas of his head outward to create horns. Do the same thing with the tops of his ears to make them pointy. When you have finished that, push the sides of his head, above his ears, inward to make the top of his head slimmer than it was. Click OK to apply the Liquify filter and have a look at your new strange and distorted scene.

16a

OK

Cancel

Revert

Help

Tool Options

Brush Size: 224

Brush Pressure: 34

Turbulent Jitter: 10

Stylus Pressure

16

The final Liquified image is scary enough, but imagine all the extra fun that could be had with various lighting, colour, and other filter effects.

CREATIVE BLURRING WITH THE MEDIAN FILTER

Often the first thing you'll do to improve a digital image is to apply some sharpening. Other times, exactly the opposite is what's needed. Blurring a photo smoothes its lines, glosses over blemishes, and can give a softer and more relaxed feel to help set the mood of your artwork. While Gaussian Blur can be used to do this, this time we're going to use the Median filter.

TIP Dust & Scratches, also on the Noise submenu, is a refinement of Median intended for removing blemishes from scanned photos. Try applying it in the same way as Median, adjusting the Radius with the Threshold level set to 0. Then increase the Threshold to bring back detail selectively, generating fuzzy patterns. Balance the settings carefully, then try sharpening for unusual results.

1 Start with a photo that has the right basic elements for your task but needs an extra touch. This technique is quick to apply and will give similar results with almost any image, so it's ideal for adding consistency to a series of pictures that may not have been shot in the same way.

2 Gaussian Blur is very effective when you want something to look out of focus, but that's exactly the impression it gives. Rather than creating an intriguing special effect, it makes your subject recede, and if not used with care can remove the sharp contrasts that draw the eye.

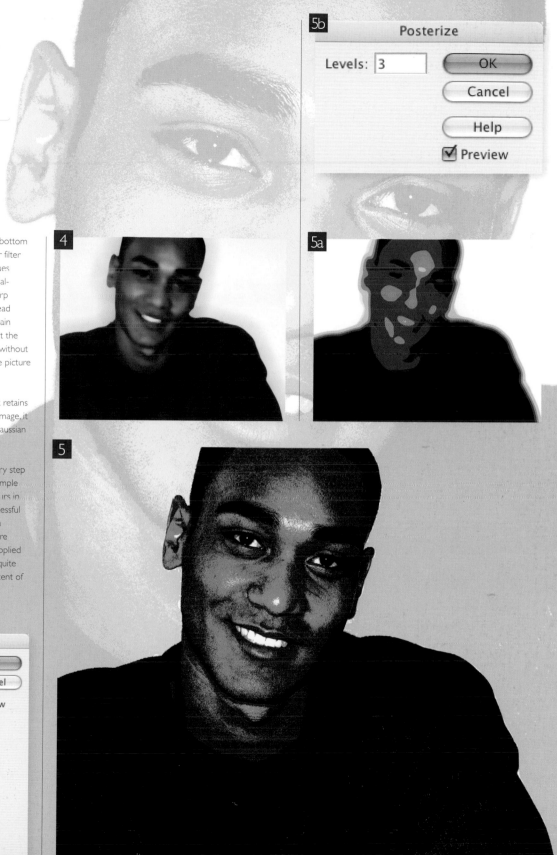

3 Instead, go to Noise on the Filter menu. At the bottom of the submenu, choose Median. This is a cruder filter than Gaussian Blur. Rather than smoothing colour values evenly, it tends to produce a 'lumpy' image with artificial-looking regions of flat colour. Notice, though, how sharp contrasts are preserved. Here, the model's teeth, instead of fading away as they did with the Gaussian Blur, remain as a hard-edged shape, despite losing fine detail. Adjust the Radius setting to give as strong an effect as you want without making the picture unrecognizable. (Or try making the picture unrecognizable – that's fun too.)

4 The result is a stylized version of the photo that retains its tonal contrasts. As you move back from the image, it looks increasingly similar to the original – unlike the Gaussian Blurred version, which always appears milky.

5 The Median filter is also a very useful preparatory step for other effects. Take the Posterize filter, for example (found under *Image > Adjustments*). This reduces colours in an image to a fixed number of levels. It's not very successful when applied directly to a photo (right), as it creates a speckled quality that doesn't reproduce well. Results are more interesting on an image that you've previously applied Gaussian Blur to (5a), but unless you make the effect quite weak, the overall impression is often not very reminiscent of the original subject.

CREATIVE BLURRING WITH THE MEDIAN FILTER

6a Posterize dialog:
Levels: 8
OK
Cancel
Help
☑ Preview

6 Use Posterize on an image you've previously treated with Median, and it's a different story. High-contrast features in the photo have already been picked out, and remain clear even when the colour palette is reduced.

7 Try taking the number of levels right down. With an easily recognizable subject such as a face, you can remove all detail from the image and yet leave something of the original impression intact.

8 Now that you've seen what the Median filter can do, keep it in mind for any purpose where you'd normally use a blur. For example, when background activity distracts from the main subject of a photo, it's often very effective to blur the background so that it recedes more. Use the Lasso tool to select the subject – here, the car and its owner – then invert the selection (Ctrl/Cmd+Shift+I).

9 Apply the Median filter with just enough radius to have an effect on the background figures. Because they're smaller, people in the background of the photo will need a much less heavy setting than if you were applying it to a main subject, as before.

10 The car and driver stand out, while the street scene now appears more distant and less 'real', serving a similar purpose to a painted backdrop.

7a Posterize dialog:
Levels: 3
OK
Cancel
Help
☑ Preview

10 Median dialog:
OK
Cancel
☑ Preview
100%
Radius: 4 pixels

The effect is very different than when
Gaussian Blur is applied. Using blur tends to
replicate a short depth of field effect (which
is fine if that's what you want), but using
Median Blur has created a different type of
effect altogether.

BEACH BOARDER

Like graffiti and other street art forms, skateboard graphics currently influence many designers' work. You can 'sk8ify' any photo by aping their techniques. Skateboard artists often use 'found' images, reproduced at low quality on scruffy materials, and they also love stickers, printed in bright colours and die-cut around the outline of the artwork. It's easy to imitate these styles using Photoshop Elements' filters.

1 We start by taking a suitable motif from a colour photo. Crop in to something distinctive and easily recognizable – faces are ideal. Don't worry too much about ending up with a low resolution file, because the effects we're going to apply will conceal this. Using Elements' Crop tool (shortcut C), select the area you want and double-click.

2 Choose *Select > **All*** (Ctrl/Cmd+A) and then *Edit > **Cut*** (Ctrl/Cmd+X). This will save us having to reselect the artwork later.

3 Set the background colour to white (shortcut D). Go to *Image > Resize > **Canvas Size***, and enter the width and height you want your finished artwork to be, then click OK.

4 Switch to the Move tool (shortcut V), then hit the shortcut key sequence Ctrl/Cmd+V, Ctrl/Cmd+E, Ctrl/Cmd+V. This pastes the motif as a new layer (call it 'motif'), merges this back onto the background, then pastes it again. As seen in the Layers palette, we are left with one copy of the motif in the 'motif' layer on a transparent background (chequerboard), and another in the background layer. The 'motif' layer is currently active.

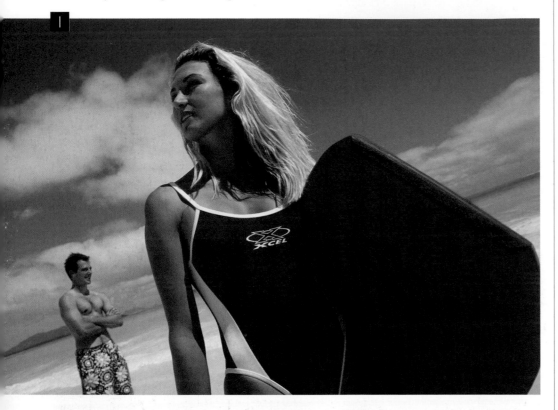

5 Using the Move handles, resize the motif to fit the full height of the canvas, then reverse it using *Image, Rotate > Flip Layer > Horizontal.* Drag it to the left-hand edge of the canvas (or, if you're working with your own picture, to whichever edge it needs to bleed off).

6 To fill the remaining white area, use the Rectangular Marquee tool (shortcut M) to select a fairly featureless strip at the side of the motif. Switch to the Move tool and drag the right centre handle across to the edge of the canvas, stretching the strip to fill the space and deselect (Ctrl/Cmd+D).

7 To make the motif look as if it's been stamped onto a piece of wood, first click the Foreground colour swatch at the foot of the main Toolbar, and choose a mid-brown colour. Then go to *Filter > Sketch > Reticulation.* Use the settings shown for the example image, or experiment with the settings for your own motif.

8 To add visual interest, select the Gradient tool (shortcut G). From the Gradient Picker at the left of the Options Bar above, choose Foreground to Background. Click the Angle Gradient (third of five icons on the right) and set Mode to Multiply. Click on the artwork and drag to add the gradient in an eye-catching position.

BEACH BOARDER

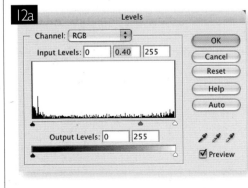

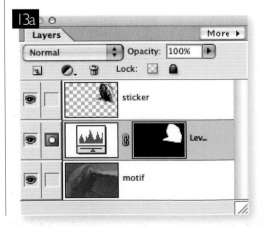

9 Now to turn the second copy of our motif into a sticker. At the moment, it's in the background layer, which we can't bring to the front, so click on the background layer in the Layers palette, then go to *Layer > New > Layer From Background*. It's converted into a full layer (call it 'sticker'), which we can drag to the top to bring it in front. Having done so, go to *Enhance > Adjust Lighting > Brightness/Contrast*, and increase both settings as far as possible without losing too much detail in the photo. Another way to do this would be to use a Brightness/Contrast adjustment layer, by clicking on the 'Create adjustment layer' icon in the Layers palette.

10 Using the Magic Wand or Lasso tool, select the actual subject of our motif, in this case the head, leaving out any background in the photo. The selection doesn't need to be precise. Invert the selection (Ctrl/ Cmd+Shift+I), then go to *Select > Modify > Contract*, and enter a number of pixels sufficient to make a generous border around the motif. Clear this area (shortcut Delete in Windows, Backspace on the Mac).

11 Use the Move tool to size and position our sticker. To make it look cheaply printed, use *Filter > Pixelate > Color Halftone*. Leave the default screen angle settings, but enter a small radius, such as 4.

12 Holding Ctrl/Cmd, click on the 'sticker' layer in the Layers palette to select the area of our sticker. Use the cursor keys to nudge this slightly down and to one side, then go to *Layer > New Adjustment Layer > **Levels***. Click OK to create a new layer ('Levels 1'), opting not to group it. In the Levels dialog box, drag the middle Input Levels slider to the right, to about 0.4, giving a darkening effect. Click OK.

13 In the Layers palette, drag the "Levels 1" layer down so that it's behind the sticker but in front of the motif, casting a dark shadow on it. Soften the shadow using *Filter > Blur > **Gaussian Blur*** with a radius of about 4.

14 In the Layers palette, create a new layer (here called 'beachboarder'). Set the foreground colour to black (shortcut D) and use the Type tool (shortcut T) to add some text. Make a selection by clicking its Layer thumbnail with Ctrl/Cmd, and use *Select > Modify > **Expand*** with a small value to enlarge it. Then on another Adjustment Layer (here Levels 2), drag the middle Input Levels slider all the way to the left to create a white border.

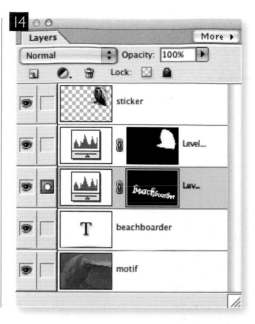

The final result could grace any skate or surfboard. Today, there are a number of specialist papers, such as heat transfer and inkjet decal paper, that a normal inkjet printer can print on, and which can be used to decorate just about anything, from T-shirts to bikes.

recreating

the masters

A WARHOL-LIKE PORTRAIT

Andy Warhol's series of tinted screen prints reached its peak with his portrait of Marilyn Monroe – and it's still an arresting image today. Here's a simple way to turn any image into a Warhol-like special.

1 Here's our starting image – a straightforward portrait. People with blonde hair tend to work better with this effect, and it always helps to be able to see a glimpse of teeth; but pretty much any portrait will work for this job.

2 Begin by separating the head from the background: select it, and make a new layer (call it 'face') from it using *Layer > New > **Layer via copy**.* Then fill the existing background with white. You don't need to worry about tracing each hair, an approximate cut will do.

3 Now duplicate the 'face' layer by dragging it from the Layers palette onto the "Create a new layer" icon at the top of the palette. Check the Lock button at the top of the palette: this stops any 'leakage' outside the layer's transparency when we paint on the layer later.

4 Now use *Filter > Blur > **Gaussian Blur*** to soften the layer. The exact amount of blur you use depends on the size of your image; the aim is to remove all the noise and grain from the skintones, without losing too much of the essential detail.

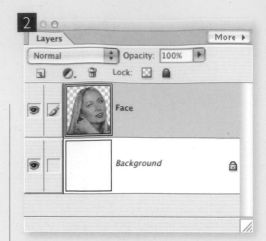

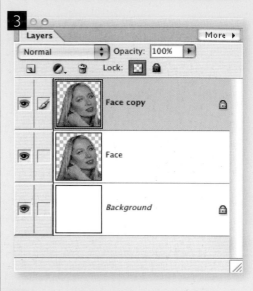

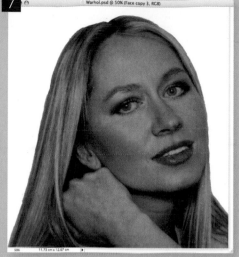

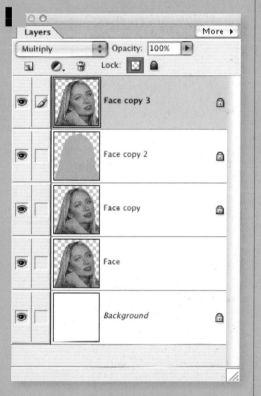

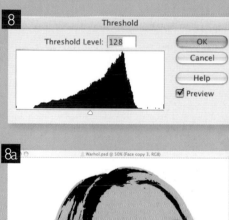

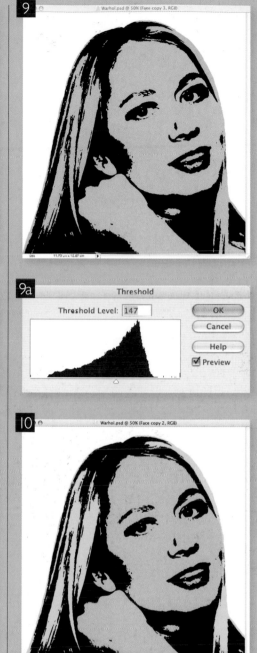

5 Make another copy of the 'face' layer, and choose a flesh-like colour. Here, we've opted for an orange tan, rather than an anemic pink. Press Alt/Option and the Delete key to fill with the foreground colour. Note how only the head area is filled: this is because we checked the Lock box earlier.

6 Now go back to the 'face copy' layer – the one we applied the Gaussian Blur to – and make another copy of that layer. Drag this one so that it appears above the previous, skintone-filled layer.

7 Change the mode of the 'face copy 3' layer from Normal to Multiply, using the pop-up menu at the top of the Layers palette. In this mode, the layer will only darken what's beneath: as it stands, the result is a warm orange effect as the skintones show through beneath.

8 Now choose *Image > Adjustments > **Threshold**,* which turns the image to pure black and white. As we can see, when the layer is set to Multiply mode, all the white disappears so we can see through to the fleshtone layer. As it stands, it's a little bright: we want to be able to see those lips in detail.

9 Drag the slider in the Threshold dialog to the right, and the image will darken. Keep going until the lips are seen in full (but not so far that we lose the highlight on the lower lip). This is the basis for our Warhol look.

10 Now return to the 'face copy 2' layer (the one we filled with our fleshtone tint), and choose a bright yellow from the Color Picker. Click on the Brush tool (shortcut B) and using a hard-edged brush, paint the colour in for the hair: since we're painting on the lower layer, the black detail remains from our 'face copy 3' layer.

A WARHOL-LIKE PORTRAIT

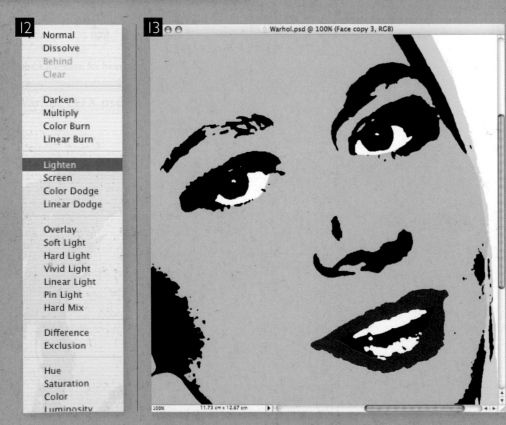

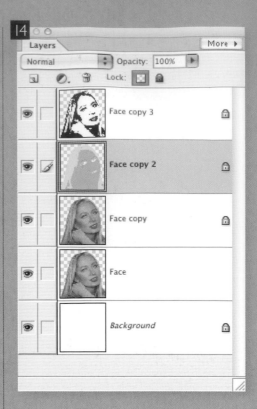

11 Now switch to white and, still on the 'face copy 2' layer, paint white into the eyes and teeth. Accuracy is not of prime importance here: Warhol's images often printed colours that were out of register, which lends the image a more hand-crafted appearance.

12 Now change the mode of the Brush tool from Normal to Lighten, by selecting it from the pop-up menu in the Options Bar. In this mode, only areas darker than the current ink colour will be affected.

13 Switch to the 'face copy 3' layer, and use a bright red to paint in the lip area. Again, you don't need to paint exactly: by setting the brush mode to Lighten, none of the white areas on this layer are affected by the painting operation.

14 Now change to the 'face copy 2' layer, choose a pale blue and paint in the eyeshadow above each eye – it's a touch that will give an authentic 1960s feel to the image. Remember that at this stage, we should be painting on the skintone-filled layer.

15 Now switch back to the 'face copy 3' layer, and paint the irises a dark blue (or whatever colour you choose to match to your original model). Remember to leave the black pupil in the centre!

Normal
Dissolve
Behind
Clear

Darken
Multiply
Color Burn
Linear Burn

Lighten
Screen
Color Dodge
Linear Dodge

Overlay
Soft Light
Hard Light
Vivid Light
Linear Light
Pin Light
Hard Mix

Difference
Exclusion

Hue
Saturation
Color
Luminosity

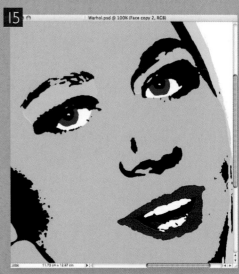

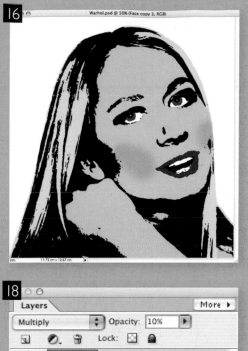

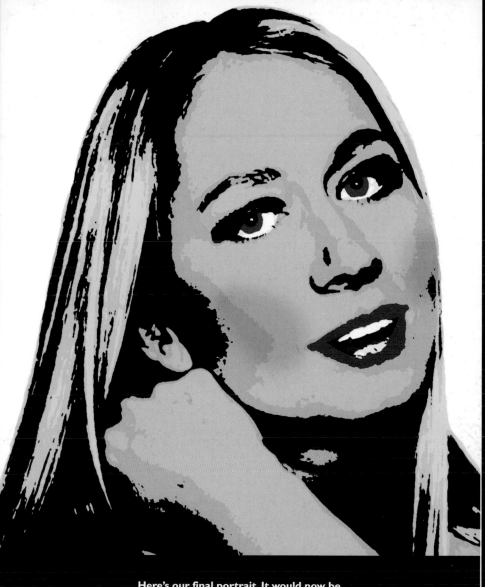

Here's our final portrait. It would now be
very simple to duplicate the image into a grid
for a real Warhol effect.

16 With the Brush tool set to a low Opacity, paint
some slight rosiness on each cheek. Without this, the
face is in danger of looking too flat and featureless.

17 The final step is to add a little more detail. Go to the
Layers palette, and move the original 'face copy' layer to
the top of the stack. Set its mode to Multiply, and lower its opacity
to around 10% so it only appears very faintly.

18 Now apply the Threshold adjustment once more,
moving it slightly further to the right than previously,
so that a little more of the image is darkened.

MELTING LIKE DALI

Creating your own melting clock masterpiece in the style of Salvador Dali is easy enough when you develop an understanding of how to employ a handful of Photoshop Elements features and tools. Clever usage of a relatively small number of functions will have you melting anything you like in no time at all.

1 Dramatic skies and barren scenery often set the mood for Dali's masterpieces. Let's take our first cue from him and use this image from an Irish coastal beach as the background image. Because this is the background, we want to soften the focus. Choose *Filter > Blur > Gaussian Blur* from the menu and blur the image slightly using a small pixel radius setting. Here, we've selected a 5-pixel radius.

2 Choose *Layer > Duplicate* from the menu and call the duplicate layer 'background image'. Change the blending mode of the 'background image' layer to Hard Light and select the Gaussian Blur filter from the menu again. This time, enter a larger pixel radius setting, for a more drastic blur effect. The image is a little pink, so to remedy this, create a new levels adjustment layer from the pull-down menu at the top of the Layers palette. Choose the Red channel from the pull-down menu in the levels box and drag the middle slider of the input levels to the right until the sky appears blue enough.

3 Create a new layer by pressing the 'Create a new layer' icon at the top of the Layers palette and call it 'gradient'. Change the blending mode of the new layer to Multiply in the Layers palette. Select the Gradient tool from the Toolbar. Choose the Foreground to Transparent option and the Linear method from the tool options bar. Hold down the Alt/Option key and click on a dark colour near the bottom of the image to sample it for use as the current foreground colour. Click and drag upward from the bottom of the image. Let go of the mouse button about one-third of the way up the image.

4 Select the Polygonal Lasso tool (shortcut L) from the Toolbox. Create a polygonal selection by clicking a series of points in the image window. To close the selection, return to your first point and click, or press Enter on your keyboard. Create a new layer (call it 'table colour') and click on the Foreground Color icon in the Toolbox to choose a brown colour from the Color Picker. Press Alt/Option+Delete on the keyboard to fill the active selection with the current Foreground Color.

5 Open up the 'table' image, and copy and paste it into the working file as a new layer called 'table'. Reduce the Opacity of the layer so that you can see the solid-coloured shape underneath it. Choose *Image > Transform > **Free Transform*** from the menu. Drag a corner point to reduce the size and make the wood panel more proportionately similar to the 'table colour'. Hold down Ctrl/Cmd+Shift on your keyboard, then click and drag upward to skew the rectangular shape.

6 Holding down the Ctrl/Cmd key only, click on the lower left point of the bounding box and drag it upward a little, distorting the shape so that the panels of wood mimic the false perspective of the 'table colour' layer. Apply the transformation and then Ctrl/Cmd-click the 'table colour' layer to generate a selection from it. Choose *Select > **Inverse*** (Ctrl/Cmd+Shift+I) and press the Delete key on the keyboard. Change the blending mode to Luminosity and reduce the Opacity of the layer to 40%.

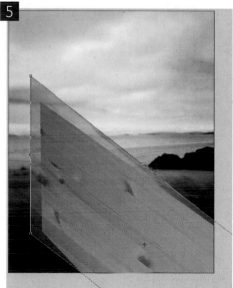

MELTING LIKE DALI

7 Invert the selection as we did before and create a new layer in the Layers palette; call it 'table shadow'. Change the blending mode of the new layer to Multiply and select the linear Gradient tool. Use the same settings as before. Click and drag to create a gradient within the active selection on the new layer starting from top left and running to bottom right. Use a dark colour, sampled from the lower area of the background as your Foreground Color. Choose *Select* > *Deselect* (Ctrl/Cmd+D) to deactivate your selection.

8 Create a new layer; call it 'table top'. Use the Polygonal Lasso tool (shortcut L) to draw another polygonal shape. This time draw a top surface shape. Select a similar brown foreground colour from the picker, perhaps a little lighter this time, and fill the active selection with it on the new layer. Paste the wood image in again, and use the exact same free transformation method to shape it to fit the top section. Then delete the areas that lie outside of the shape area as we did previously. Change the 'table top' layer's blending mode to Luminosity and reduce the Opacity to 41%.

9 Duplicate the layer ('table top shadow') and change the blending mode to Soft Light. Generate a selection from the 'table top' layer contents by Ctrl/Cmd-clicking the layer icon. Create a new layer ('table highlight') and select the Gradient tool. Using the previous gradient tool settings, with the exception of reducing the opacity to 50%, draw a dark gradient to the bottom right within the selection on the new layer. Then switch to the radial option in the Options Bar. Using a white Foreground Color, create a small, white gradient near the top left of the selected area on the new layer. Deselect.

10 Open the watch image and drag it into your working file as a new layer called 'watch'. Use the Polygonal Lasso tool to select the top half of the watch only. Use the edge of your wooden object as a guide for where to divide the watch in half. Use the Free Transform (Ctrl/Cmd+T) functions to distort, skew, and scale the selected area so that it looks like it is lying on the top surface.

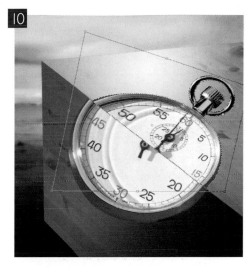

11 Apply the transformation by hitting Enter or by clicking the tick icon in the Options Bar and then use the Polygonal Lasso tool to draw a selection around the other half of the watch. Again, use the Free Transform functions to distort the shape of the selected portion of the watch until it looks as if it is pressed against the side panel of the wooden object. Try your best to make certain that the two halves meet in the crucial areas, like the face and the hands of the watch. When you are happy, apply the transformation and deselect.

12 Choose Filter > Distort > *Liquify* from the menu. Inside the Liquify filter, select the Warp tool (shortcut W). The Warp tool will allow you to push pixels with a brush tip. Specify a rather large brush size (we used 109), but use a very low Brush Pressure setting of around 24 so that the warping doesn't get out of control. Begin to click and drag on the face of the watch, pushing pixels with the Warp brush, to alter the shape.

13 Reduce the size of the brush considerably to around 48. Now, concentrate on the bottom of the watch while using the smaller Warp brush. Begin to pull areas of the bottom of the watch downward with the Warp tool. Then, begin to push the areas between the dripping areas upward using the Warp tool. You may have to click and drag a number of times within a single area to get it looking just right.

MELTING LIKE DALI

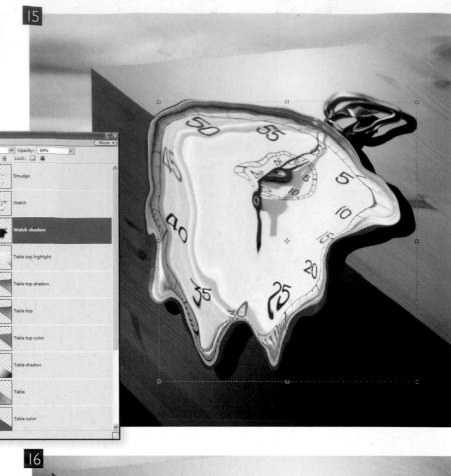

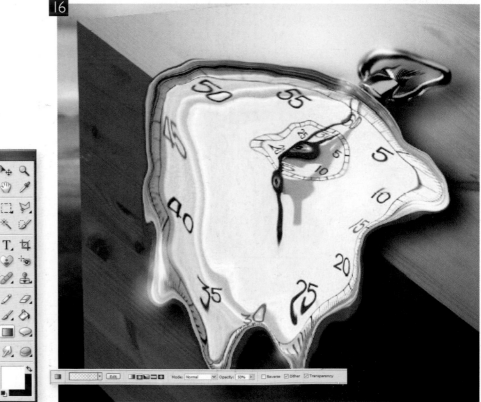

14 Click OK to apply the Liquify filter and return to the Photoshop Elements workspace. Zoom in close on the watch face. There will be a few areas here and there that do not match up perfectly. Create a new layer ('smudge') and select the Smudge tool. Choose a very small, soft brush tip preset and set the strength at about 50%. Click on Use All Layers in the Options Bar and begin to smudge together pixels on areas where the two halves don't meet up perfectly.

15 Ctrl/Cmd-click the 'watch' layer's icon in the Layers palette to generate a selection from the contents of the layer. Create a new layer ('watch shadow') and drag it below the 'watch' layer in the Layers palette. Specify a black foreground colour and fill the active selection with it by typing Alt/Option+Delete on the keyboard. Deselect (Ctrl/Cmd+D) and use the Move tool (shortcut V) to move the black shape to the right and down a little.

16 Choose *Filter > Blur > Gaussian Blur* from the menu. Enter a pixel radius large enough to substantially blur the edges of the black shape. Change the blending mode of the 'watch shadow' layer to Multiply and reduce the Opacity of the layer to 69%. Create a new layer ('watch highlights') and drag it to the top of the Layers palette. Specify a white foreground colour and choose the Gradient tool. Select the radial setting and be certain that it is set to foreground and transparent. Click and drag to create a small radial gradient on the new layer on top of each specular highlight on the watch.

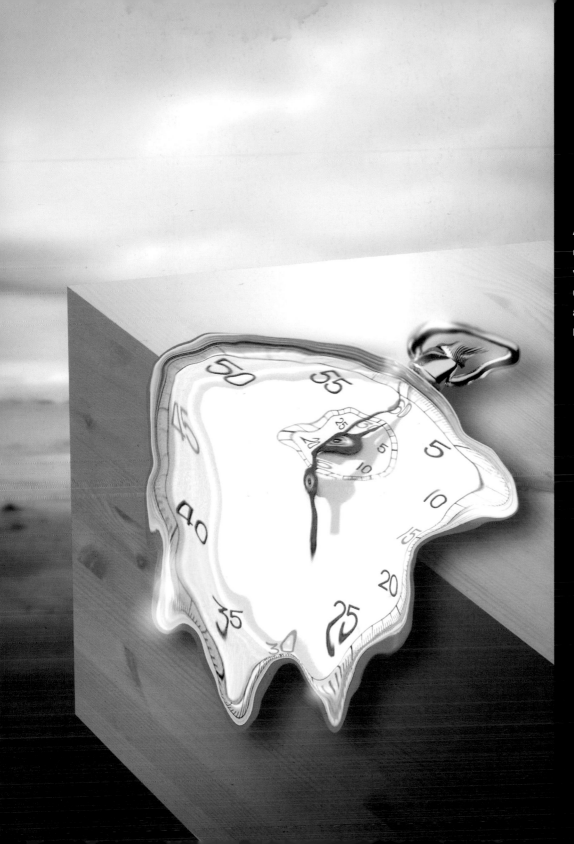

And here's time melting before our very eyes. There can be no mistaking to which artist we're paying homage here.

HOMAGE TO MILLAIS' OPHELIA

Sir John Everett Millais' 'Ophelia' (1851–52) is one of the most popular Pre-Raphaelite paintings, despite its less-than-cheery theme, drawn from Shakespeare's *Hamlet*. Recreating it in a more frivolous style is a useful exercise in combining images that involve water.

1 Where Millais' picture is dark and brooding, ours will be bright and kitsch, so first adjust our images if necessary for bold, saturated colours. Auto Levels (Ctrl/Cmd+Shift+L) does a good job on this one.

2 The model must be cut out from her background. Start by using the Magic Wand tool (shortcut M) to select the red fabric around the body. In the Options Bar, set the Tolerance to about 16, and tick Contiguous to prevent unconnected areas from being included. Click near the edge of the body, then hold Shift and repeatedly click again to build up the selection all the way around.

3 To finish off the cutout, use the Lasso tool (shortcut L), with Shift to add or Alt to subtract, to tidy up any tricky edges and extend the selection to all four sides of the image, so that everything but the model is included.

4 Use *Select > Inverse* (Ctrl/Cmd+Shift+I) to switch the selection to the model. With the Move tool (shortcut V), drag this onto the water image. As you can see in the Layers palette, it's added as a new layer called Layer 1; rename it 'model'. Drag the corner handles to scale and rotate the model to compose the picture, then double-click to finish.

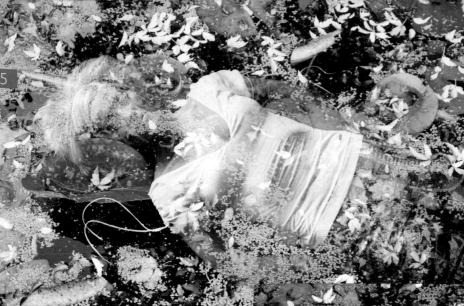

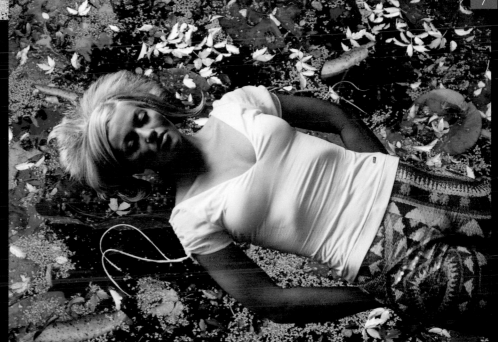

5 To make the model float below the surface of the water, click on the Background in the Layers palette and go to *Layer > Duplicate Layer* and call it 'water'. Click OK, then click the 'water' layer and drag it above the 'model' layer. Using the pop-up menu, change the 'water' layer's blending mode from Normal to Screen. The light-coloured flotsam and jetsam remain visible while the dark water becomes transparent.

6 The next step is to erase this layer from those parts of the model that should be above the waterline. You could do this directly with the Eraser tool, but a better method is to create a mask, which leaves the image content intact for later editing. Photoshop Elements can't apply masks directly to image layers, so instead create a Levels adjustment layer (*Layer > New Adjustment Layer > Levels*). In the first dialog box, tick Group With Previous Layer, so that the adjustment only applies to the 'water' layer.

7 When the Levels dialog box appears, click the white slider on the right below Output Levels and drag it all the way to the left (0). In Screen mode, this makes the content invisible.

8 Click OK. In the Layers palette, notice that the adjustment layer has two thumbnails. The right-hand one represents a mask that limits its effect to certain areas. This is outlined to show you're editing the mask. Press Ctrl/Cmd+I to invert it (like making a negative). Now the whole adjustment layer is masked off, and has no effect, so the flotsam and jetsam reappear.

9 Choose the Brush tool (shortcut B) and, from the pop-up menu at the left of the Options Bar, choose Airbrush Soft Round 65. Set the Foreground Color to white by choosing the default colours (shortcut D), then paint carefully over the areas you want to bring above water, starting with the face. This unmasks the adjustment layer, making the 'water' layer invisible.

10 Light areas such as the blonde hair aren't affected by Screen mode. To fix them, repeat steps 5–7 to make a second masked copy of the water. This time, however, set the layer's blending mode to Hard Light and reduce its Opacity to 50%. In the Levels dialog box, move the Output Levels sliders to the middle (it's easiest to type 128 into both boxes). Don't invert the mask, but instead switch the Foreground Color to black (shortcut X) and paint carefully over what you do want to affect: the outer part of the hair and any other obvious light edges.

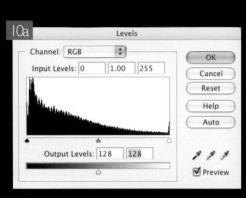

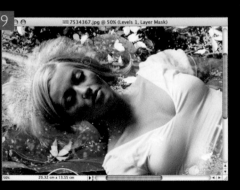

You may need a few extra tweaks to fit the
images together seamlessly. For example, the
string from the model's top should go under
the leaf on the left, so switch to the 'model'
layer and remove the relevant piece using the
Eraser with a small, hard brush.

MAGRITTE'S SURREALISM

The paintings of Magritte are certainly recognizable. The infamous figure in a bowler hat, the white fluffy clouds in unnaturally blue skies, and the often-present bright green apple. These are the elements necessary to create a Magritte-inspired masterpiece. It really isn't as complicated as you may think. Basically, all you need to understand is the process of isolating elements from their backgrounds, enhancing them, and combining them in a single, layered file. And here's how....

1 First, we need a suitable sky image; this will act as the main background for the layered image. However, this raw digital image is a little dull, so we'll need to increase the contrast and adjust the colour to make it more vibrant. From the pull-down menu at the top of the Layers palette, create a new Brightness/Contrast adjustment layer. Increase the contrast first, by about 40. Then increase the brightness by about 15.

2 Now, create a new Hue/Saturation adjustment layer from the pull-down menu at the top of the Layers palette. The contrast is looking good and so is the colour of the sky, but it needs to be a little more vibrant. So, to remedy this, drag the Saturation slider in the Hue/Saturation dialog box to increase the saturation by about 18. Leave the Hue and Lightness sliders alone.

3 Now that the background is looking good, it is time to introduce the main visual element. Here, we're going to use an image of two men in suits. Select the Polygonal Lasso (shortcut L) from the Toolbar. You will find it in the Lasso tool's pop-up menu. Use the Polygonal Lasso to create a rough and quick closed selection around the man to the right, but you won't need his head. Don't worry about having white areas or part of the other man within your selection border; we'll clean that up later.

4 Select the Move tool (shortcut V) from the Toolbar, click inside of the selection border, and drag over to the sky file. This will bring the selected area into your working file as a new layer (call it 'man'). Position the man's body more or less in the centre horizontally and then select the Magic Wand tool (shortcut W) from the Toolbar. Click in the white area that surrounds the figure to generate a selection from it.

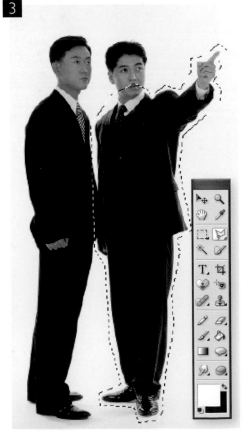

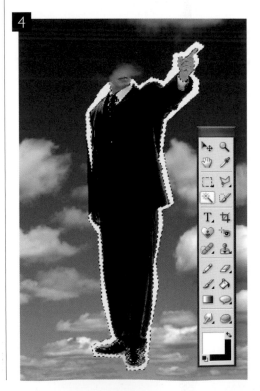

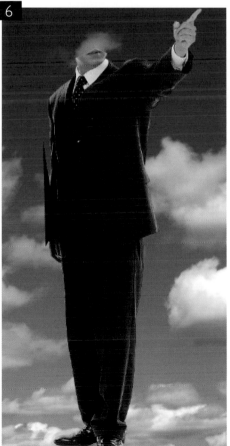

There is a handy Palette (accessed via Windows in the Menu Bar) that offers a number of features for quickly navigating the image window. There is a thumbnail of your image with a view box that outlines the currently visible area. Clicking and dragging this box repositions the visible area in the image window. There is a slider that allows you to zoom in and out of your image. On either side of the slider, there is a button that allows you to zoom in or out incrementally. And you can enter a precise amount by highlighting and typing it in the text field at the left.

5 The only problem now is that the selection strays into the collar of the man's shirt. We want to delete the white selected area but preserve the white area of his shirt. So, to modify the selection, select the Selection Brush tool (shortcut A) from the Toolbar and change the Mode to Mask in the Options Bar. Choose a small, hard, round brush tip from the preset picker in the Options Bar. Begin to carefully paint over the areas you wish to preserve, like the collar of the man's shirt and his cuffs.

6 Now select the Eraser tool (shortcut E) from the Toolbar. Selecting a different tool will automatically convert your mask to a selection. Press the Delete key on your keyboard to delete the selected white areas from your layer. Choose *Select > Deselect* (Ctrl/Cmd+D) from the menu to deactivate the current selection. Set the Eraser Opacity to 100% and choose a hard-round brush preset from the picker.

7 Zoom in very close on the area where the collar of his shirt surrounds his neck. Carefully erase any areas of his head and neck. Increase or decrease the size of the brush if necessary. When you have removed his head and neck, look at the rest of the image and erase any unwanted areas left over, like sections of the man on the left, or the shadows under his shoes. Do this until all that remains on the layer is the clothed figure and his hands.

MAGRITTE'S SURREALISM

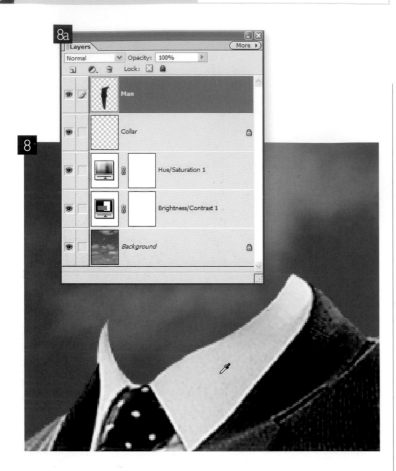

8 Create a new layer by choosing *Layer > New > **Layer*** from the menu and call it 'collar'. In the Layers palette, grab the 'collar' layer's icon and drag it below the 'man' layer. With the 'collar' layer currently selected, select the Brush Tool from the Toolbar. Hold down the Alt/Option key to temporarily access the Eyedropper tool and click on the collar to sample the colour.

9 Choose a hard-round brush tip from the Options Bar. With Opacity set to 100%, paint inside of the neck opening in the shirt. Paint a solid area that will define the inside of the shirt that should be visible because it is empty. When you have a solid area created, enable the Transparency Lock in the Layers palette so that any further painting will not extend beyond this area.

10 Next, select a large soft brush tip from the preset picker in the Options Bar, hold down the Alt/Option key, and sample a dark colour from his jacket. Reduce the Opacity of the brush to about 25% in the Options Bar and begin to add some shaded areas to the solid painted area that you created previously. This will add a little shadow to the inside of the shirt, creating the illusion of depth.

11

12a

11 Next, we found a suitable apple image for the composition. The file had already been extracted from the background, so all that we need to do is drag it into the working file as a new layer (call it 'apple') by using the Move tool, and position it above the open neck. Then, while holding down the Shift+Alt/Option keys, click and drag a corner handle inward to scale it down proportionately toward the centre of the bounding box.

12 Open up the bowler hat image and use the Move tool to drag it into the working file as a new layer called 'hat'. Drag it to the top in the Layers palette so that it sits on top of the other layers. Then reduce the Opacity of the layer so that you can view the other layers underneath. Hold down the Shift key and drag one of the bounding box corners inwards to scale it down proportionately.

12

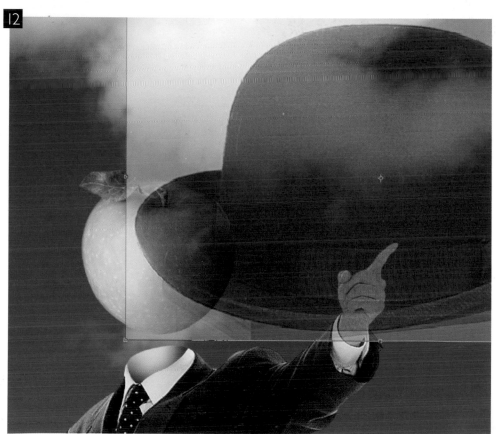

MAGRITTE'S SURREALISM

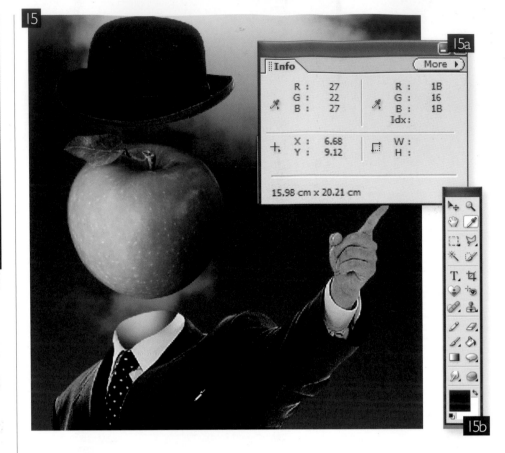

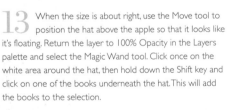

13 When the size is about right, use the Move tool to position the hat above the apple so that it looks like it's floating. Return the layer to 100% Opacity in the Layers palette and select the Magic Wand tool. Click once on the white area around the hat, then hold down the Shift key and click on one of the books underneath the hat. This will add the books to the selection.

14 Ranges of colour like the shadows on the books will probably still remain outside of the selection border, so hold down the Shift key and click in the shadow area to add it to the selection border. Use this method to add colour ranges to the selection until the entire area outside of the hat is within the selection border. Press the delete key on the keyboard and then choose *Select* > **Deselect** from the menu to get rid of the selection outline.

15 Use the Eraser tool on the 'hat' layer to remove any elements of background that are left behind on the layer. Choose *Window* > **Info** from the Menu to display the Info palette. Select the suit layer in the Layers palette and then select the Eyedropper tool (shortcut I) from the Toolbar. Click on a black area of the suit with the Eyedropper and make a note of the RGB value for that colour in the Info palette.

16 Select the 'hat' layer in the Layers palette. Choose *Enhance* > *Adjust Lighting* > **Levels** (Ctrl/Cmd+L) from the Menu. With the Levels box open, your mouse pointer becomes an Eyedropper when it is placed anywhere in the image window. Click on a black area in the hat and notice how it has a different RGB makeup in the Info palette. Select the Red channel in the Levels dialog box. Increase the input levels for the mid-tones in the Red channel. Click on the hat to check the RGB values as you make your adjustments.

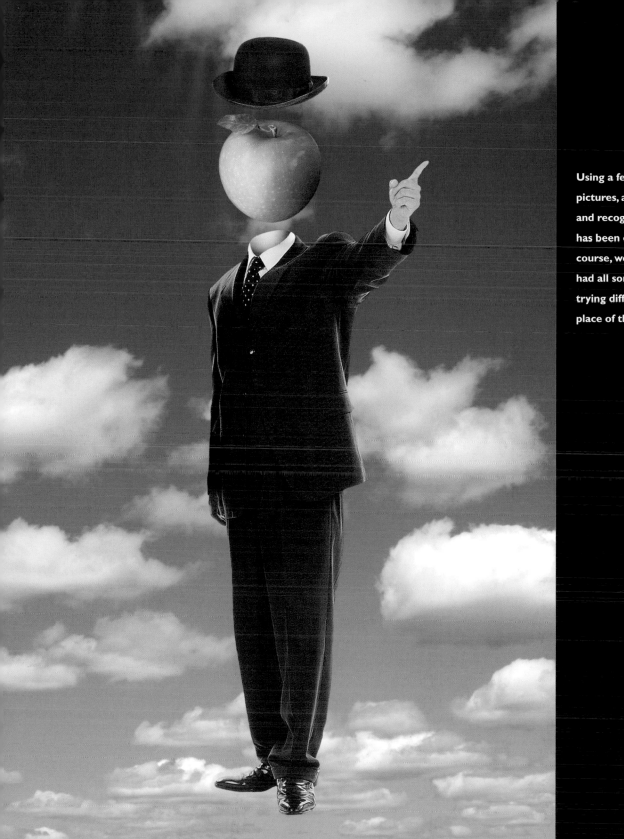

Using a few simple pictures, a very striking and recognizable image has been created. Of course, we could have had all sorts of fun trying different fruits in place of the apple.

INDEX

ACKNOWLEDGMENTS

The publishers would like to thank all the contributors for the inclusion of their work in this project:

DAVID ASCH

David has been digitally manipulating images for many years. He started when home computers had eight colours to work with and progressed to Paintshop Pro and finally to Photoshop and Elements. Specializing in photo-montage and fakery, his tutorials and images have been published in books, magazines, and also in the Internet community, on contest sites and forums. He doesn't consider himself to be an artist in the traditional sense but believes digital art and photo-montage shouldn't be the poor relation to the other styles.

ADAM BANKS

Adam Banks is a writer and editor specializing in digital design. Having experimented with computer graphics since 1983, he joined the publishing industry in 1990, coinciding with the release of Photoshop 1.0. As editor-in-chief of *MacUser* magazine, he championed the new wave in digital illustration at the turn of the twenty-first Century. *PC Gear*, which he launched in 2000, was one of the first newsstand magazines sent to press entirely via PDF. Adam's work, ranging from features and tutorials to in-depth reviews and trenchant opinion pieces, has appeared in more than 500 magazine editions as well as in books including *The Complete Guide to Digital Illustration* and *The Complete Guide to Colour*, both published by Ilex.

GEORGE CAIRNS

George Cairns has been using Photoshop to creatively push pixels around for more than a decade. After teaching Photoshop and video production to University students, he left to produce Photoshop tutorials for a wide range of magazines like *Digital Photography Techniques* and *Web Designer*. He also writes tutorials and features for books, and recently co-wrote *Designing DVD Menus* for Ilex Press. George is also a 3D illustrator, and created artwork for several issues of *SFX* magazine, as well as writing about 3D graphics for 50 issues of *3D World magazine*. A keen photographer, George hosts a regular two-page slot in *Digital Camera* magazine.

STEVE CAPLIN

Steve Caplin is a freelance digital artist whose work appears regularly in newspapers and magazines. He is the author of three books – *Icon Design* and *The Complete Guide to Digital Illustration*, as well as the best-selling *How to Cheat in Photoshop*. Steve also writes about digital imaging for computer and photography books, and gives lectures on Photoshop for photographic societies, art schools, and universities. Steve is a beta tester for Adobe Systems, and has been using Photoshop since its earliest days.

SIMON DANAHER

Simon Danaher has been working in the graphics industry for many years. His client base includes BBC Worldwide, numerous UK magazines and publishers, and international companies, such as Fujitsu and Isuzu. Simon contributes regularly to leading creative journals such as *Computer Arts*, *3D World*, and *MacUser*, and also teaches application-specific courses in 3D computer graphics. He is the author of *The Complete Guide to Digital 3D Design* and *Digital 3D Design*, in the Design Directories series

DEREK LEA

Derek Lea is an award-winning illustrator, photographer, and published author. Although his work often contains elements rendered within 3D applications, Photoshop really is the cornerstone to everything he does. Derek combines his background in traditional drawing and painting with his mastery of Photoshop and Photoshop Elements to simulate a tactile and realistic painterly style, which gives his digital art a sense of realism and timelessness. He works out of a home studio in downtown Toronto, Canada, where he can often be found round the clock, spending his time writing and illustrating. You can regularly count on finding articles and tutorials by Derek in magazines like *Computer Arts*, *Digital Camera Magazine*, and *Digital Photography Techniques*. To view a vast portfolio of his diverse body of work, visit his website at www.dereklea.com.

TODD PIERSON

Todd Pierson of Pierson Studios first became interested in photography after he was given a Polaroid land camera at the age of 14. He was amazed by the ability to see his images minutes after shooting them. His passion has endured for 25 years but has recently been fuelled by the digital revolution. Todd never liked the dark room but liked the control. Digital capture and manipulation has given him more than control. It has allowed him to create anything he can dream up without limitations, and Todd is now more excited about photography than ever. Todd's clients have included Lucent, Baxter, Six Flags, Motorola, Tiger Electronics, Square D, and many more. In recent samples used for promotional material, Todd has been more interested in using imaging as a secondary part of the image. Todd wants it to be 'part of the image without being the image. I want viewers to look and say, 'that looks real but it's impossible'.' Pierson Studios is located in Oswego, Illinois, USA. www.piersonstudios.com